ART & DESIGN

ACADEMY GROUP LTD
42 LEINSTER GARDENS, LONDON W2 3AN
TEL: 0171-402 2141 FAX: 0171-723 9540

EDITOR: Nicola Kearton
ASSISTANT EDITOR: Ramona Khambatta
ART EDITOR: Andrea Bettella
CHIEF DESIGNER: Mario Bettella
DESIGNER: Marie Carter

SUBSCRIPTION OFFICES:
UK: ACADEMY GROUP LTD
42 LEINSTER GARDENS
LONDON W2 3AN
TEL: 0171 402 2141 FAX: 0171723 9540

USA AND CANADA: VCH PUBLISHERS, INC
333 SEVENTH AVENUE, FIFTH FLOOR,
NEW YORK, NY 10001, USA
TEL: (212) 629 6200 FAX: (212) 629 8140

ALL OTHER COUNTRIES:
VCH VERLAGSGESELLSCHAFT MBH
BOSCHSTRASSE 12, POSTFACH 101161
69451 WEINHEIM
FEDERAL REPUBLIC OF GERMANY
TEL: 06201 606 148 FAX: 06201 606 184

CONTENTS

ART & DESIGN **PROFILE** No 49

ART & FILM

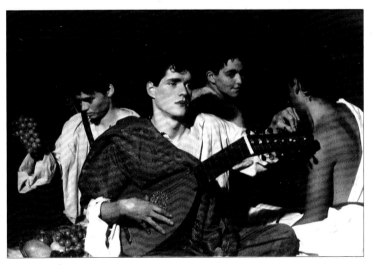

Derek Jarman,
Caravaggio, *1986*

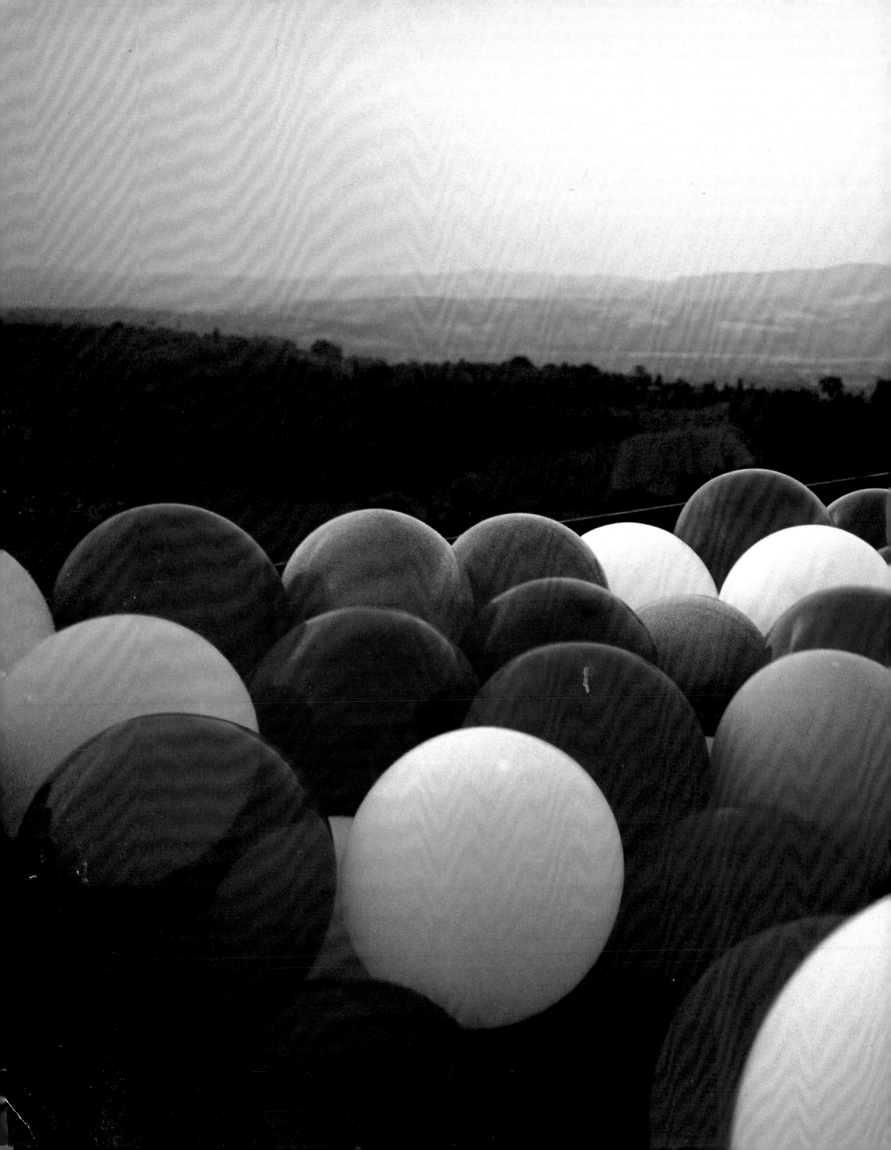

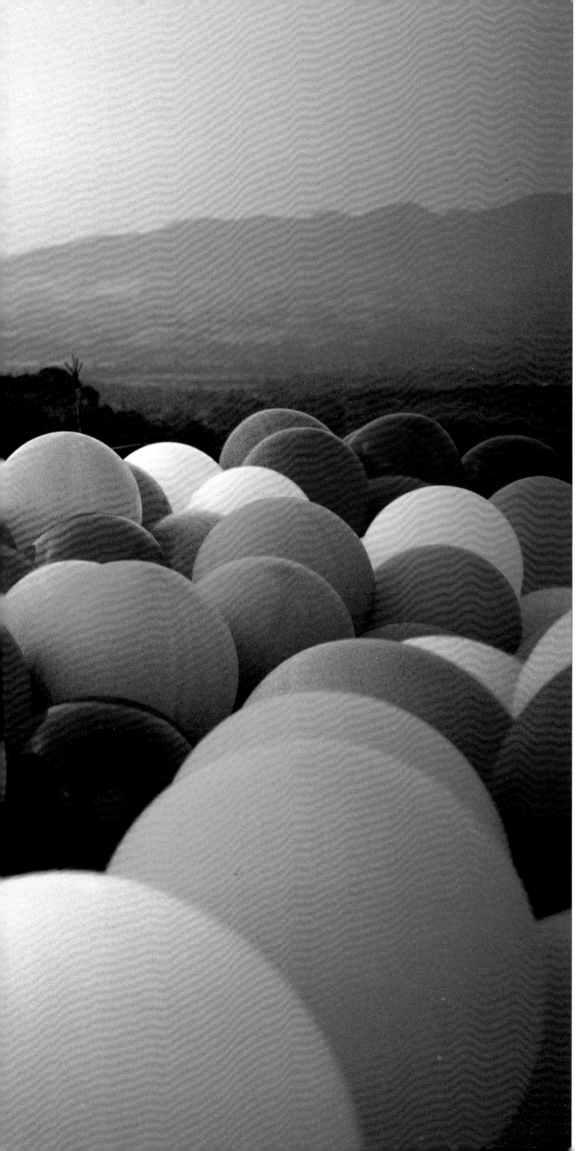

ART MEETS SCIENCE AND SPIRITUALITY IN A CHANGING ECONOMY

From Competition to Compassion

Compiled by Louwrien Wijers

'The essence of economy is: if I take care of you, others will take care of me.'
Joseph Beuys

'Everybody should be paid as a specialised worker.' *Robert Filliou*

'I don't think you have to worry about the future. It isn't here yet.' *John Cage*

'The earth is one household, let's treat it that way.' *David Bohm*

Art meets Science and Spirituality in a changing Economy is a permanent dialogue established by artists to bring some of the world's greatest thinkers together in discussion over major issues facing the world today. Presented here is the whole history of this unique organisation including panel discussions from its first manifestation at the Stedelijk Museum in 1990. This volume is published to commemorate the second meeting to be held in Copenhagen in August 1996 with interviews, essays and artworks featuring artists John Cage, Per Kirkeby, Robert Rauschenberg and Marina Abramovic, spiritual leaders HH Dalai Lama, Mother Tessa Bielecki and Huston Smith, economists JK Galbraith, Stanislav Menshikov, Paul Hawken, HJ Witteveen and Pinheiro Neto and scientists David Bohm, Francisco Varela, Karl Pribram and Fritjof Capra, among many others.

Paperback 1 85490 477 9
305 x 252mm, 240 pages, £35
illustrated throughout
August, 1996

Paul Perry/Jouke Kleerebezem, Customised Community, *1994, balloons with the keys to the private homes of the citizens of Civitella d'Agliano waiting to be sent off into the sky.*

incorporating BLACK PHOENIX

THIRD TEXT

THIRD WORLD PERSPECTIVES ON CONTEMPORARY ART AND CULTURE

Since its inception in 1987, *Third Text* has established itself as a major international art journal with a unique perspective. While analysing the theoretical and historical ground by which the West legitimises its position as the ultimate arbiter of art, the journal has provided a critical forum for the discussion and appraisal of the work of artists hitherto marginalised through racial, sexual and cultural differences. Dealing with a diversity of art practices - visual arts, photography, film - *Third Text* has addressed the complex cultural realities that emerge when differing world views meet, and the challenge this has posed to Eurocentric aesthetic criteria. The aim is to continue to develop a radical interdisciplinary scholarship, focused particularly through the fields of art criticism, art history and cultural studies; and to broaden the frameworks and criteria of what has become international contemporary art practice, in the light of the changing nature of our 'post'-colonial and technocratic world.

ART & FILM

Black Audio Film Collective, Testament, *1988, still*

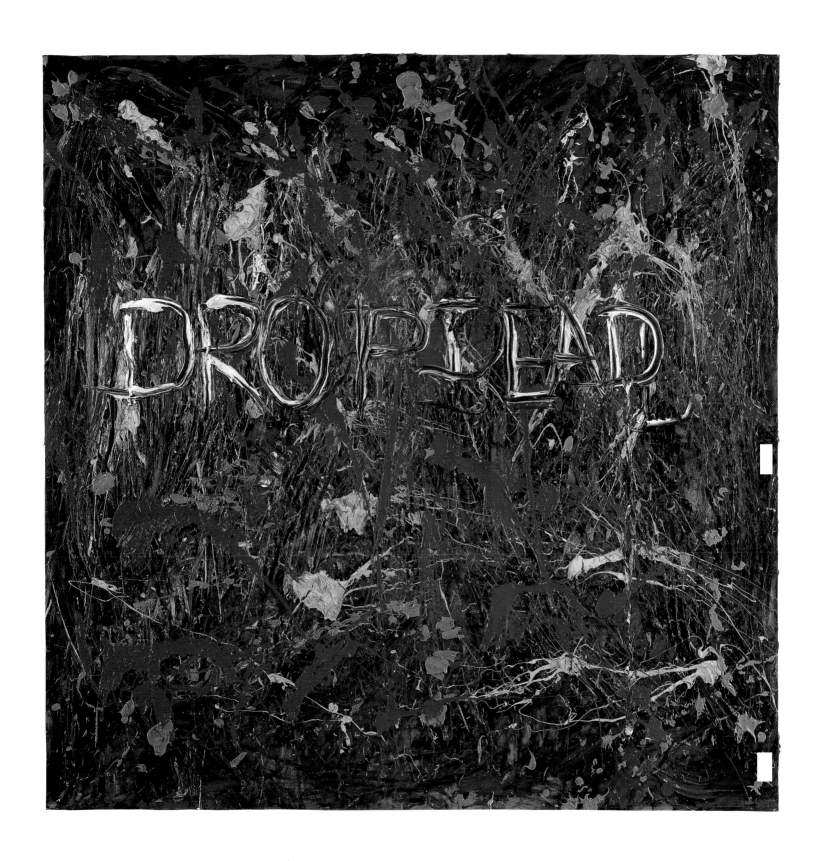

Art & Design

ART & FILM

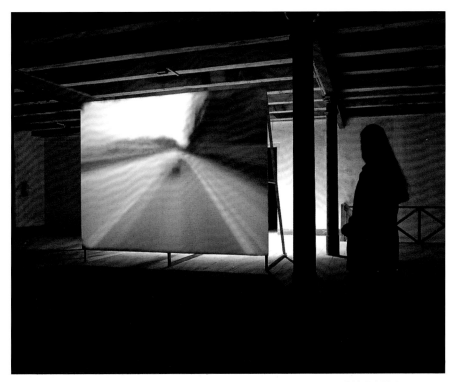

OPPOSITE: Derek Jarman, Drop Dead, *June 1993, oil on canvas, 213.5x213.5cm (photo Prudence Cuming); ABOVE: Graham Gussin,* Road Movie, *1993, still*

ACADEMY EDITIONS • LONDON

Acknowledgements

Unless otherwise stated, all images are courtesy of the artists: p2 Richard Salmon (London); p5 England & Co (London); **Disturbing the Surface** *pp8-15* p8 Lumière Pictures, p10 Pathé Pictorial newsreel, p14 England & Co (London); **Peter Greenaway and the Technologies of Representation** *pp16-23* courtesy of Peter Greenaway; **Derek Jarman, Peter Greenaway and Film Art** *pp24-31* p24 by kind permission of Don Boyd, Lexington Films, p28 BFI Stills, Posters and Designs, p30 Richard Salmon (London); **Tracing the Edge of Power** *pp32-41* The illustrations accompanying this paper were supplied by Beth B and the Laurent Delaye Gallery (London) p32 © 1978 Beth B and Scott B, p34 (Above) © 1979 Beth B and Scott B (Below) © Castle Hill Productions; **Luc Tuymans** *pp58-63* p58 Galerie Paul Andriesse (Amsterdam), pp60 and 61 Zeno X Gallery (Antwerp); **Mechanical Perception, The Media Arts, Diaspora and Sound** *pp72-79* Black Audio Film Collective, with thanks to David Lawson. (Sean Cubitt interviewed Trevor Mathison and Edward George at length, and though they may not recognise much of the result, he could not have written this without their example and their clarity. His thanks to them, as well as the other members of Black Audio Film Collective. He is also grateful for invitations to First Site in Colchester and to the British Art Show at Cornerhouse, Manchester, and to the audiences who helped him hone his ideas on sound. Black Audio Film Collective's works are available from BAFC, 7-12 Greenland Street, Camden Town, London NW1 0ND); **Film and Video Work by Contemporary British Artists** *pp84-92* p84 (Left) BFI Sills, Posters and Designs, courtesy Contemporary Films, London, (Right) The Arts Council Collection/The Francis Bacon Estate, with thanks to Marlborough Fine Art (London), p88 (Above left) Frith Street Gallery (London), p91 (Centre) Maureen Paley/Interim (London); **Inside Front and Back Covers**: Anthony Reynolds Gallery (London).

Contributors' Biographies

Steven Gartside is a freelance writer and lecturer based at Manchester Metropolitan University, currently working on an exhibition of the work of William Green; **Bridget Elliott** is Associate Professor of Art History at the University of Western Ontario. She co-authored a study entitled *Women Artists and Writers: Modernist (Im)positionings* with Jo-Ann Wallace (Routledge, 1994), and is currently working on a study of visual representations and voyeurisms in the late Victorian music-hall; **Anthony Purdy** is Professor of French at the University of Western Ontario. His last three books examined the body (1992), money (1993) and science (1994) in relation to literature. He is currently completing *In Praise of Dirt: Michel Tournier and the Critique of Modernity*. Bridget Elliott and Anthony Purdy are joint-authors of a forthcoming Art & Design monograph on Peter Greenaway to be published Spring 1997; **Paul Wells** is Subject Leader in Media Studies at De Montfort University in Leicester. He has made a number of fim-related series for BBC Radio, and has recently completed a book called *Understanding Animation*; **Jack Sargeant** lives in Brighton and has had two books published by Creation Books, London. The first, *Deathtripping: The Cinema of Trangression*, includes interviews with American 80s underground filmmakers such as Beth B, Richard Kearns and Tessa Hughes-Freeland; the second, *Born Bad*, focuses on contemporary juvenile delinquent films; **Nicholas Zurbrugg** is Professor of English and Cultural Studies at De Montfort University, Leicester, and his recent books include *The Parameters of Postmodernism* (Routledge, 1993). He guest-edited *The Multimedia Text* for Art & Design (Profile No 45); **Amanda Crabtree** works at Le Fresnoy, studio national des arts contemporains, a post-graduate school and contemporary art space in the north of France. She has researched public art for a number of years, set up several projects in France and was the guest-editor of the *Public Art* issue of Art & Design (Profile No 46); **David Moos** is a curator and art historian who received his doctorate from Columbia University, New York. He is author, together with Rainer Crone, of *Kasimir Malevich: The Climax of Disclosure* and *Jonathan Lasker: Telling Tales of Painting*. He is Visiting Professor at the University of Guelph, Canada and guest-edited *Painting in the Age of Artificial Intelligence*, Art & Design (Profile No 48); **Marie-Anne Mancio** is completing a D.Phil in feminist readings and contemporary live art practice. She lectures at the City Literary Institute, London, and performs. She is currently documenting Peter Greenaway's installation, *In The Dark*; **Sean Cubitt** (s.cubitt@livjm.ac.uk) is Reader in Video and Media Studies at Liverpool John Moores University. He is the author of *Timeshift*, *Videography* and a member of the editorial boards of *Screen* and *Third Text*; **Monkeydoodle** consists of undergraduates and recent post-graduate students on Sarat Maharaj's Richard Hamilton course at Goldsmiths' College, University of London. The project was coordinated by Louise Veryard, Stuart Brown and Emily Clark, and placed on the internet by John-Paul Thurlow (http://www.gold.ac.uk/~hs301lv/A.html); **Andrew Wilson** is an art historian, curator and writer on contemporary culture and art, he is currently completing a PhD at the Courtauld Institute of Art. Books include *Paul Graham* (Phaidon Press, 1996) and *Blast! Vorticism – The First Avant-Garde in England 1914-1918* (Sprengel Museum, Hanover, 1996). He is curator of a project for BBC2's *Expanding Pictures*, 'Four Artist's Videos'. He is a trustee of kd digital, a digital production and research facility for artists and filmmakers.

FRONT COVER: Annie Griffin and Franck Loiret, Skylark, 1990 (photo Chris Nash)

EDITOR: Nicola Kearton ASSISTANT EDITOR: Ramona Khambatta
ART EDITOR: Andrea Bettella CHIEF DESIGNER: Mario Bettella DESIGNER: Marie Carter

First published in Great Britain in 1996 by *Art & Design* an imprint of
ACADEMY GROUP LTD, 42 LEINSTER GARDENS, LONDON W2 3AN
Member of the VCH Publishing Group
ISBN: 1 85490 233 4 (UK)

The Publishers and Editor do not hold themselves responsible for the opinions expressed by the
writers of articles or letters in this magazine
Copyright of articles and illustrations may belong to individual writers or artists
Art & Design Profile 49 is published as part of *Art & Design* Vol 11 7/8 1996
Art & Design Magazine is published six times a year and is available by subscription

Distributed to the trade in the United States of America by
NATIONAL BOOK NETWORK, INC, 4720 BOSTON WAY, LANHAM, MARYLAND 20706

Printed and bound in Italy

Contents

William Green, Untitled, *1992, ink, varnish, enamel, acrylic, water on paper, 29.9x40.6cm*

ART & DESIGN PROFILE NO 49

ART & FILM

INTRODUCTION
POINTS OF CONTACT
Nicola Kearton

The centenary of film celebrated in France, home of the Lumière brothers in 1995, and elsewhere in 1996 has been marked by a plethora of exhibitions and books. These have included most notably 'Spellbound' at the Hayward Gallery in London which explored the relation between art and film in Britain through the work of artists and filmmakers including Damien Hirst, Ridley Scott, Paula Rego and Peter Greenaway; the major survey 'Art and Film Since 1945' held at the Museum of Contemporary Art, Los Angeles; 'L'Art et le 7ème Art', which drew on the collections of the French Musée du Cinéma showing the links between film and artistic movements such as Dadaism, Futurism, Cubism and Expressionism. This year also marks the occasion of an exhibition at the Barbican in London exploring the multifaceted work of Derek Jarman which gives prominence to his role as a painter as well as filmmaker.

Since its inception, film has interacted continually with movements in art and criticism, artists have been inspired by the fascination of the moving image, filmmakers have found their vision through the visual arts. Now in a multimedia era, film is seen as the ultimate visual art, an inseparable part of contemporary art practice and life itself. This issue analyses the subtle links between art and film through the work of a richly contrasting selection of artists and filmmakers. It looks in particular at the role of art history, used as a treasure trove by filmmakers such as Greenaway; the continuing influence of cinema and filmic codes on the visual arts; together with the structural role of sound as discussed by Sean Cubitt. Just as Greenaway plunders art history in order to enrich the present, so the Black Audio Film Collective have merged the overlapping musical traditions of the African Diaspora in order to structure their recent film *The Mothership Connection.*

The tenure of the issue is not on a nostalgic view of a century of cinematic greatness; although Alain Fleischer, with his particularly French passion for film, gives a wonderful description of childhood cycle trips through the Parisian suburbs, peeping into the film laboratories and dreaming of pictures filmed in some magical world beyond. It describes how artists and filmmakers are using and thinking about film now. The concept of the multimedia artist is completely established and is reflected in the changing nature of art education. Artists as different as Fleischer or Beth B have followed consistent aesthetic or polemical concerns in a range of different media going away from film then back to it, exploiting also the differing audiences offered by film, installation and photography.

As well as being a medium which is no longer confined to filmmakers, for artists in the 90s, film is another familiar area of experience on which to respond. The treatment is often ironic as instanced by Chris Nash's shot of Annie Griffin on the front cover, reminiscent of one of the most famous stills ever. Scarlett in *Gone With the Wind* is swept helplessly into Rhett's arms, but here, thoroughly in control she is laughing at herself, the pose and probably Rhett too. The aura of the female Hollywood film star is thoroughly unpicked by Annie Griffin in her unsettling treatment of glamour, just as the codes of filmic representation are destabilised by many of the young British artists written about by Andrew Wilson. As he points out artists of today who have grown up visually immersed in TV and cinema are not in general making work that is about film or video but are using its devices to new ends.

A number of the essays explore the overlapping yet differing concerns of painting and film. For instance, Stephen Gartside comments on how film helped construct the public image of Jackson Pollock by its inevitable emphasis on the physical process rather than the actual conceptual nature of his work. Movement, he suggests, is inherent in a photographic still with its implied before and after, whereas it is falsified in film where movement is achieved through positioning and cutting. Alain Fleischer in his *Film Cuts*, 1995, reveals the seam, the join where the film moves from one shot to another: 'Something is lost for the film to continue'. This falsification is also clearly commented on in the films of Peter Greenaway with his emphasis on cutting and framing, never allowing the viewer the seamless close-up of the Hollywood realist tradition. If a film still has an implied before and after then painting has the ability to condense the sequentiality of film time. David Moos takes up this theme in his exploration of paintings by Luc Tuymans: 'With Tuymans "story-time" falls away. We are put in the presence of the imploded present where the duration of the painting's narration continually circles back onto itself.'

This issue does not propose an overview of the subject but rather in the manner of previous issues such as *Painting in the Age of Artificial Intelligence* or *Photography in the Visual Arts* draws together a collection of writings which, whilst keeping alive the essential differences, illuminates certain areas where the mediums overlap and their boundaries blur. A fertile interaction which, in the context of the history of art, is still young.

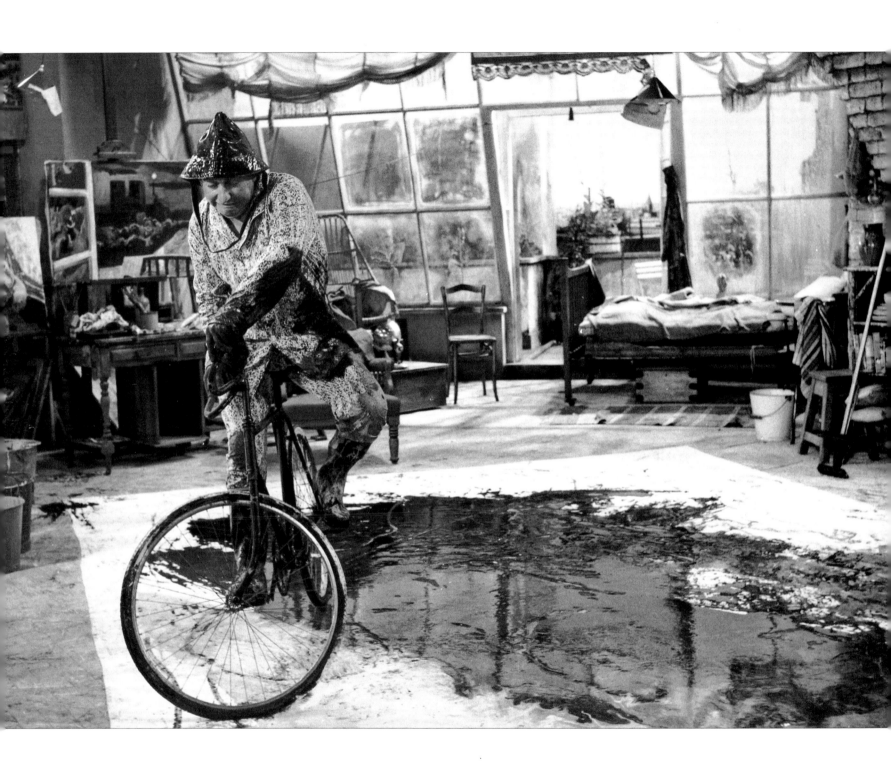

Tony Hancock, The Rebel, *1960, still*

DISTURBING THE SURFACE
WILLIAM GREEN AND FILMIC FASCINATION IN THE 1950s
Steven Gartside

There is a certain attraction in the idea of one visual form (film) involving itself in the presentation and interpretation of another visual form (art). Initial appeal, however, becomes tempered by the complexities that naturally arise.

Film has the ability to make the unknown, known. It provides the opportunity to access the artist's studio and also, seemingly, the creative process itself. The desired engendering of a feeling of privilege is one that is based on artifice, yet it is still compelling. With the image of the artist at work there is inevitably an appearance of the artist as personality. Whilst Hollywood films and documentary portrayals of artists would seem to operate in different cultural fields, there are, nevertheless, overlapping concerns.

In the cases of both William Green and Jackson Pollock media focus led to the artists often being represented through their own images rather than through the work itself.

Ken Russell filmed Green making an action painting in the Royal College of Art studios in 1957. In the next few years the film, like the artist, was to disappear from view. It was to be nearly 30 years before both artist and film re-emerged, separately, into the public arena. This disappearance of the film and its subject proved fertile ground for a growing mythology over the artist's status. The film was seen to have provided the focus for Green's propulsion into the position of media celebrity. Part of Green's working process – bicycling over the canvas – had been picked up by the media and then into the public imagination. This wider voice was usually expressed in the form of outrage.

It has been suggested that the attention Green received was the reasoning for the abrupt curtailment of his career.[1] The sophisticated, but misplaced, mythology that built up around the artist was based around a convenient irony. It was seen that Green, an artist who had incorporated the mass media into his work came to be swallowed up by the very machine he was interested in. Rumours of Green's faked death or of his emigration to Australia (a rather nice metaphor for artistic death) gave an added richness to this growing mythological status.

The reality of Green's disappearance from the art world was through the rather more pragmatic response of having to earn a living. Green had gone into teaching and it was only after his second retirement that he was coaxed back into the art world. Russell's film was also to emerge around this time.

In the many different forms that art on film exists, there is a consistent interest in documenting the artist's physical process in creating a work. This gives the viewer the opportunity of extending his or her interest in the art work through the witnessing of its creative construction, thereby removing the traditional museum-bound restrictions of only having access to the finished work. The fact that this access is still strictly limited does not tend to diminish interest.

An ideal account of the artistic process could only be realised through a minute by minute documentation, preferably without the artist's knowledge. Once the camera's presence is known, intentions become suspect and the work becomes part of a performance. In the case of William Green's work this was not inappropriate. One of the editions of *Ark* does actually provide the notation of Green's movements in the making of a work.[2] However, this link was rarely acknowledged in the film's wider dissemination.

The concentration on the capturing of the creative moment gives the indication that the performance is the essence of the creative process. This partial view can be somewhat misleading. Philip Hayward has commented:

this extreme fetishization of the *actual moment* of creation has resulted in the production of a number of film texts which, in attempting to record this moment in as direct a manner as possible, have merely served to highlight the shortcomings and contradictions of both their specific projects and the broad approach in general.[3]

The interest in capturing the creative process is based upon the premise of film's use as a vehicle for explanation. The message implies that by understanding the creative process artistic output is clarified. This is particularly the case with abstraction, where artistic intentions are seen to be made clear through observation of the placing of paint on canvas. This, however, completely fails to take into account the conceptual processes involved in the physical enactment. Acknowledgement of the conceptual then has to exist through text – read or displayed.

With the participation of Hollywood in the representation of the artist and its connection to a wider public arena, complexity of meaning is inevitably increased. The image of the creative artist genius has consistently provided narratives for the Hollywood film through both factual and fictional accounts.

The fluidity of the position of the Director-Auteur-Artist has been something of an attraction; the notion of genius becomes a transferable element. In Akira Kurosawa's *Dreams* (1990) there is a sequence which includes the figure of Van Gogh,

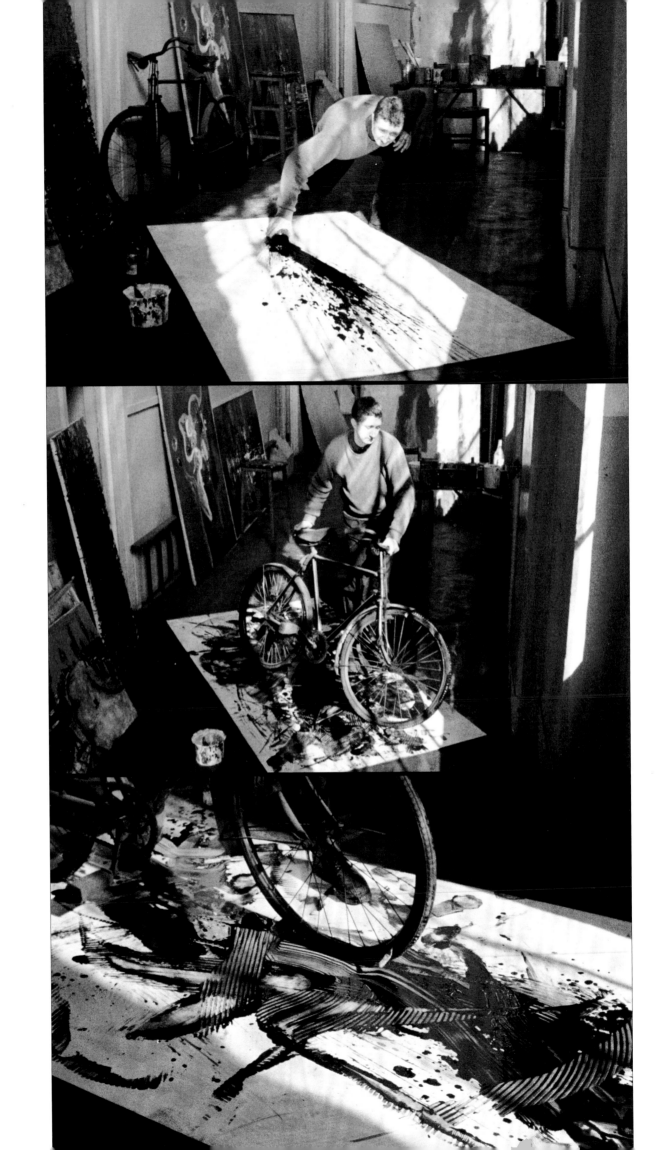

played by the American director Martin Scorsese. This interest in representing the artist on film was also pursued in Scorsese's own films: *After Hours* (1985), and in the short film *Life Lessons* from *New York Stories* (1989).

The Hollywood attraction of artist as subject matter lies in the interplay between life and art: life is presented as the explanation for the art. Also connected with this approach is the downplaying of the high culture status of the artwork to the more accessible methods of its production. The Hollywood film, to some extent, provides an alternative narrative to the institutional structures that hold most artworks. The museum imposes a definition of how art should be viewed; the Hollywood film takes art out of these confines and attempts to connect it more closely with life itself.

Irving Stone proved to be an interesting study for the Hollywood film in the 1950s and 60s. Both of Stone's novels, *Lust for Life* (1956) and *The Agony and the Ecstasy*, (based on Van Gogh and Michelangelo respectively) were bestsellers before being turned into films. Therefore, what is presented is a film, which is based on the novel, which is based on the artist's life.

Although *Lust for Life* was based on Stone's book, in true Hollywood tradition his screenplay was rejected and another writer was brought in to complete. For both films the focus of attention is on artistic relationships and through these the idea that by understanding the artist an insight is provided into the art produced.

A key difficulty in any portrayal of an artist is the notion of selectivity. With the Hollywood film certain key events which are used as the focus of the film come to take on a significance which is out of proportion to artistic output and the wider contexts of social and historical background. A problem that is almost impossible to resolve is the separation of fact from fiction. Most Hollywood films attempt to make a base around factual details which are then fleshed out with the fictional. It is here that artistic myth is continually reinforced. The final outcome of the Hollywood film is the setting up of a series of complexities that cannot easily be resolved. The incorporation of the factual elements in film legitimates the fictional. A more dramatic interpretation of artistic practice is encouraged which ultimately confirms the artist as representing difference. The basis of a film's authenticity can rarely be challenged in any direct way as it becomes difficult to separate the elements. Therefore differentiation between the authentic and the inauthentic does not occur.

In the actual documenting of artistic practice the Hans Namuth/ Paul Falkenburg film of Jackson Pollock (1951) proves to be of interest. The film's importance lay not in sudden impact but in the way that through the gradual process of its dissemination, the images became incorporated into the mythology of Pollock as an artist. The images of Pollock at work applying paint on canvas proved to have a certain iconic status. When combined with the number of photographic stills of Pollock at work

(by Namuth as well as many others) an unmistakable and easily identifiable image of the artist was set. So dominant was this image that it came to be included in exhibitions, books and news reports alongside the works themselves. This depiction of the image of Pollock as an artist came to be represented through the idea of action. Again there is the underlying notion of the physicality of the artistic process being reflected in the life.

The position of Abstract Expressionism in Britain was beginning to gain wider notice in the mid 50s. A chance to see works arrived much later than the knowledge of their actual existence, which had already been noted through a variety of magazines. Very few had actually had the chance to visit the United States, but those who had travelled in Europe, such as Alan Davie, had been able to see work at Peggy Guggenheim's gallery in Venice in the late 40s. There was an opportunity to see a work of Pollock's on display in Britain as early as 1947, the work was part of an exhibition in the somewhat less than artistically vibrant centres of Southampton and Winchester, and so passed many unawares. The exhibitions that gave the first real access were 'Opposing Forces', ICA (1953); 'Modern Art in the United States', Tate Gallery (1956); 'Pollock Retrospective', Whitechapel (1958); 'New American Painting', Tate Gallery (1959). Prior to this, access to Abstract Expressionism existed through text and reproductions.

The impetus for Pollock allowing Hans Namuth to film the artist at work emerged from the change in working techniques. This change in practice which occurred in 1947 – when Pollock began working on the floor – brought about a change in the works themselves and he felt that it would be useful for this change to be explained or documented in some way. Pollock's heavier reliance on the unconscious as part of his process led to wider confusion over intention and suspicion of the technique itself. Pollock hoped that the camera's entrance into the studio would give an insight into the actual methods and from there into the works themselves. Behind the concerns of enlightening the technical aspects of the work was the additional hope that the film would act as a promotional vehicle.

The conditions of filming soon dulled Pollock's initial enthusiasm. The shooting was done outside to save on lighting. The changing nature of the weather with its endless light variations increased the length of the project dramatically. There was also a further reshooting of scenes in search of the right angle and effort. As filming progressed Pollock lost some of the interest in the documentation process and became more and more interested in the methods of the representation of his own image. This also connected with Namuth's attitude, whose interest lay not so much in the work – which he initially disliked – but in the way Pollock made it. The film relies on Pollock's movement to create the visual image of the work's construction and not the actual controlled movement of the paint itself. The film distorts this process for an increased reliance on

physical effect. Namuth used a similar technique in the still photographs where by using a slow speed it gave the impression of increased physical expression.

Through the making of the film Pollock became the willing accessory to the mythologising of his own image. The slow process of the film's dissemination actually gave an added strength to its imagery. It was premiered at the Museum of Modern Art in New York in June 1951, after which it was shown as part of the First American Film Festival at Woodstock in the August of the same year. After these two showings it travelled the college circuit as a hire film. The growing attention the film gained was reinforced with the photographic stills which were being circulated. The photographs were to appear in magazines as diverse as *Life*, *Harper's Bazaar*, *Art News* and *The New York Times Magazine*.

The filmic and photographic representations of Pollock were to provide the basis of the mythology of Pollock's artistic position. The film was successful in documenting certain authentic qualities of Pollock's working process but at the same time it also exagerated the image of the rebel artist figure. The knowledge of Pollock's alcoholism further compounded this status – the rebel artist is also seen as tortured genius. The visual acknowledgement of Pollock's methods did little to allay fears that the pouring and dripping of paint indicated a lack of control and therefore an absence of skill.

The use of the visual image of Pollock was not something that was confined to the mass media. The same images were used in art magazines, books and also in exhibitions of Pollock's work. This accentuating and mythologising of the actual process of the work came to be the element that legitimised the art object. The original intention of the action images as an augmentation of the works was superseded by the filmic image becoming a central component of interest.

The status of the film and photographic images of Pollock has remained high throughout the post-war period. The film's position as an authentic document is rarely questioned, yet it was continually compromised by financial and directorial intervention. Both Namuth and Pollock came to be more interested in the image of the artist that was created than the process of the creation of the art work. The interpretation of the film often revolves around the idea of Pollock's actions being similar to that of dance. This fails to adequately take into account the main element of the work process which was the precise control of the paint itself. The film was more eager to follow the movement and progress of Pollock around the canvas than it was to follow the lines of paint which he directed.

The role of film in the work of William Green has been something that has taken a variety of forms as he used both its influence on him as a consumer, as well as its effects as a visual medium within the context of his work. The process was also reversed when Green became the subject for three short films on his working process. The first of these films was made by Ken Russell and shown on the BBC Tonight programme, and was followed by two short Pathé films. It was the Russell film that initiated the wider media interest.

Green was seen as one of the younger generation of painters in the late 50s, primarily based around the RCA. For the critic and curator Lawrence Alloway, Green was part of the second phase in the development of Pop, the first phase being the technologist Independent Group and figuration, the second phase an abstracted environmental response to the contemporary and the third being centred around the artists in the Young Contemporaries exhibition of 1961. Alloway's interest lay in developing new directions for art in Britain and as a promoter of art that was reflexive of the period in which it was produced. Alloway was dedicated to the kind of work that challenged the traditional hierarchical structures existent in British art institutions in the 50s. In *Personal Statement* he was to comment,

What is needed is an approach that does not depend for its existence on the exclusion of most of the symbols that people live by . . . All kinds of messages are transmitted to every kind of audience along a multitude of channels.[4]

Alloway's argument for a new kind of art was centred around the position of the mass media and its incorporation into contemporary practice. He believed that through this approach there could be a transformation of the way that visual art was produced and consumed. Any of the varied critical approaches of the likes of Berenson, Fry and Read were seen as being no longer relevant to the period. Alloway proposed a non-hierarchic, linear perspective as the basis for the most appropriate response to the visual arts. It was Alloway who was to invite Green to participate in the exhibitions 'New Trends in British Art' and 'Dimensions', both of which took place in 1957 whilst Green was still a student at the RCA.

It was also in 1957 that the young would-be film maker, Ken Russell, arranged to make a film of Green at work on a painting. Russell at the time was earning a living as a freelance photographer and so his film-making projects were independent and self-financing. He was aware of the work being produced at the RCA, which led to *Making an Action Painting*.

The film follows the work on one piece from beginning to completion. It opens with the bare board (Green worked with board rather than canvas) in the centre of the studio with the artist considering making a start on the new work. Paint is then thrown on to the board and spread over the surface. Green is then seen contemplating what to do next – with a cartoon-like gesture of hand rubbing chin, an idea is noted. The decision made, Green dashes out of the studio and is then seen riding a bicycle down the RCA corridors, into the studio and over his work. After more manipulation of the paint surface, the board is taken outside where more paint and sand are added. The board is placed on the floor, petrol added and then it is set on

fire. The film closes with Green and friends carrying the finished work out of shot.

Whilst there was a certain neutrality and even a positive humour about Russell's presentation of Green, the status of the film in its wider distribution was seen quite differently. The film's portrayal of Green came to provide a focus for a range of discontent with contemporary art. Even within the RCA there was a certain staff discomfort with the work of many of the students. The difference in viewpoint was seen most clearly in the clashes between Richard Smith and Robyn Denny against the ideas of the RCA tutor John Minton.[5] Carel Weight, Professor of Painting at the RCA, was also worried about the wider implications of putting students into the public sphere. There was a fear that taking the work out of its context would open the college to criticisms of its teaching methods.

Green's position as an artist was seen to combine the feared elements of American cultural referencing – both high and low – in his work, whilst giving the personal image of the disruptive Beat Rebel. The exposure the film gave to Green also outlined some of the concerns with contemporary art practice. Although he was less consciously rebellious than either Denny or Smith (who were a year above him at the RCA) Green was the only one in the public profile, hence he was left to take most of the pressure. In 1958 Pathé made two shorts on Green's work, *Eye of the Artist* (black and white), and the colour Pathé Pictorial, again with Green using the by now notorious bicycle to make an action painting.

Some of the uncertainties in mapping out high and low culture can be detected in the Pathé films. The Pathé Pictorial opens with images of the National and Tate galleries. Over background classical music the narrator talks of these institutions and the great art they house, pointing out the link of great art with the use of the paintbrush. The shot then moves to Green at work in the studio, the classical music is replaced by big band jazz and the narration lightens in tone as 'something really different' is introduced. The distinction of the contemporary is therefore clearly marked not just through subject matter and technique, but through its connection with a different cultural element – the jazz signifying American popular culture. The narration of Green's methods continues in the form of instructions, pointing out that a bicycle does not have to be used in making an action painting but 'don't, and I mean don't, use anything as heavy as a car'. This knowing patrician humour further confirms status.

Through the film treatments of Green the background to a work's creation is revealed. The press and public reaction, however, indicated the unwillingness to come to terms with these methods. Through the private becoming public there is confusion over meaning and acceptance of the finished work is displaced by concern over its process. Attempts at connecting the two elements of process and form were attempted by very few. More familiar approaches read, 'Asphyxiation – at

100 gns a Time', and 'Take a Painting, Set Fire to it – Earn Yourself 100'.[6]

The wider public construction of Green that was set in place was dependent on the use of the bicycle and the use of fire. These elements came to be seen as defining characteristics that summed up the nature of the contemporary without need for reference to the work itself.

In front of Green's work the connection to process and the artist's own affiliations act as allusive remnants of the whole. The titles to the works do not act as direct markers of content, they are more of a reference to personal interests and concerns. Inspiration for Green in the late 50s came from a variety of sources; he was equally happy around movies and the breaker's yard as he was with Abstract Expressionism and Continental Tachiste painting.

The scale that Green worked on was an important part of the process. The physical nature of the production methods necessitated a fairly large scale. The films of Green at work spreading the paint across the picture surface show the importance of making full use of the physical properties of both artist and material. Rosenberg's heavily used statement of the canvas as 'an arena in which to act' is nevertheless particularly appropriate to Green's work.[7] The creation of work for Green is much more of a performance than the linking of Pollock to primitivism and dance.

Scale in Green's work is also part of the connections to be formed between viewer and art work. Both Alloway and Roger Coleman had produced theories outlining the relationship between the viewer, the work and the gallery space. Again, the parallel with film is relevant. Amongst others, they were interested in film not just for its cultural value but also for the environmental and participatory qualities that could be used. The sensation of the widescreen format and its enveloping of the viewers' field of vision was of particular interest. There was also the connection of the experience as a non-hierarchic form of culture giving both wider access and reference. The spectator absorbs the visual, verbal and musical sensations of film – of whatever genre – as one experience. The references within are part of the film's sign system.

For Green widescreen cinema gave an additional opportunity for a more abstracted treatment of film. By sitting in the front row of the cinema, the film's visual effects would be markedly changed. Imagery was dissolved into vanishing abstractions, although the sensation of narrative impulse still remained. Green himself has commented that 'All painting is concerned fundamentally with disturbing the surface'.[8]

This conclusion can just as easily be applied to Green's experience of film as to his own work. A film also exists as a popular cultural referent, in Green's work the referent exists in the work itself, the 'disturbed surface' is a response to a more direct cultural experience.

There is something of a paradoxical relationship between

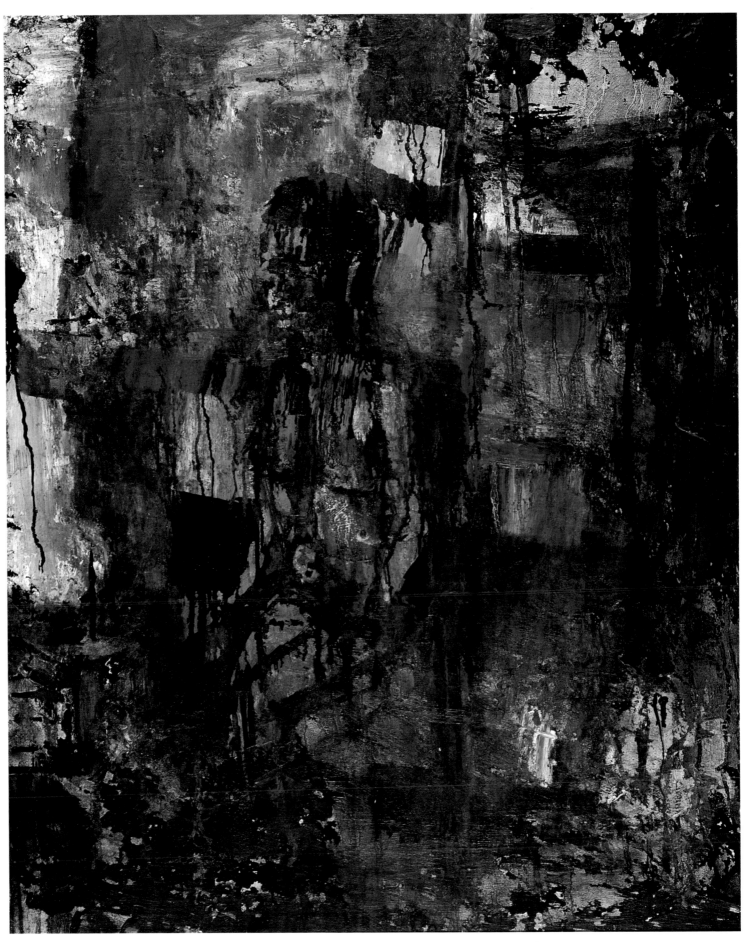

William Green, Nude, 1957-58, oil on board, 76.2x63.5cm

Green's work and the filmic representation of its creation. The inferred references within his work are part of the process of that work's creation. Yet, with the Russell and the Pathé films, by making the physical process clear, acceptance is clouded by the very process it shows. The use of plimsolls and a bicycle as artistic tools are not able to be recognised as such. Therefore, again the status of the artist's skill begins to be questioned. The fact that the works are abstract removes a seemingly direct mode of understanding; the films also make clear the absence of a conventional approach which reinforces this perceived disconnection from the actual art work.

With Tony Hancock's film, *The Rebel* (1960), further disconnection of audience from art is encouraged with a scene that parodies the work of both Pollock and Green. The film conflates periods and targets, running from 19th-century French avant-guardism, through Surrealism and existentialism to the contemporary art world. The techniques of both Pollock and Green are brought together in a scene where Hancock's character creates an action painting. With the canvas on the floor and the artist in rubber boots, gloves and hat, paint is thrown from buckets, walked over, ridden over on a bicycle, and sand thrown onto the canvas.

Hancock's portrayal of this scene is interesting in its referencing of the public perceptions of contemporary art. The scene plays on the idea of the artist as other, as outside of public experience. The film acts as an acknowledgement of the public perception of abstraction as being difficult. By parodying its methods there is comfort in the facts of the artist's unconventional nature. The film is by no means entirely negative in its approach, its existence itself marks an interest. There is also a playing out of a certain desire in artistic freedom. *The Rebel* really sought to mark out with humour the doubts and uncertainties about contemporary art that already existed in other film representations.

The concern with capturing the creative process of the artist on film will always remain an incomplete project. By attempting to provide an adequately documented record of artistic process, the role of the artist is altered; the existence of the camera turns the process into an event. The spectacle of the artist at work comes to be viewed in the same way as that of an actor on screen. Whilst for the actor the creation of any kind of reality lies in artifice, for the position of the painter, any reality is only possible outside the camera presence. Even if the process could be satisfactorily documented, the object itself would remain stubbornly absent. The more successful the capturing of the physical process, the more difficult it becomes to show the finished object with any assurance.

It is only when placed in the public sphere that the life of the photographic image begins. It is also here that original intentions have little meaning. With the photographic images of Pollock, it is their stillness which indicates movement. In the film images, only through carefully worked positioning and cutting can the same position – which is a false one – be achieved. With Pollock's death in 1956 – even here myth is reinforced – the film and photographic stills took on an added significance. The capturing of Pollock's physical nature is seen as being consistent through art, life and even in death. The status of the myth becomes complete. Whilst the art works themselves can operate as separate entities, there is also the image of Pollock that operates equally well outside the work.

With William Green there is a disturbance to the status of the artist image. With his return to painting in 1992 the relevance of the film and media image is undermined. They now become historical detail, still used, but only as a marker of a particular period and attitude.

The subtlety of the work on paper provides stark contrast to the filmic image of the artist. With the mythologising of a subject these contradictions are, of course, not allowed to occur. The concern with process is still present in the drawings but it is now carried out in more varied ways.

As a gesture to the past Green has made several 'ex-memory' paintings of earlier works. These are made using the techniques he was working with in the late 50s – primarily using bitumen and fire. This process acknowledges a disturbing of the historical surface, signalling Green's re-emergence into the contemporary art world.

Notes

1 See also Seago, Alex, *The Late Show*, BBC, 24.02.93; and Alloway, Lawrence, 'Developments in British Pop' in Lippard, Lucy, *Pop Art*, Thames and Hudson, 1966.

2 Lamb, Warren, 'Recording the Painter's Movement', *Ark* 24, Spring 1959.

3 Hayward, Philip, *Picture This*, Libbey, 1988 p8.

4 Alloway, Lawrence, 'Personal Statement', *Ark* 19, March 1957.

5 See Mellor, David, *Sixties Art Scene in London*, Phaidon, 1993, p28.

6 *The Star*, 8.01.58, and *Daily Express*, 29.07.58. These are just two examples from many.

7 Rosenberg, Harold, 'The American Action Painters', *Tradition of the New*, 1966, p25.

8 Green, William, *The Late Show*, BBC, 24.02.93

PETER GREENAWAY AND THE TECHNOLOGIES OF REPRESENTATION

THE MAGICIAN, THE SURGEON, THEIR ART AND ITS POLITICS

Bridget Elliott and Anthony Purdy

Towards the end of Peter Greenaway's *A Zed & Two Noughts*, the Deuce brothers, Oswald and Oliver – separated Siamese twins and the two noughts of the title – are trying to persuade Alba Bewick, legless and dying, to leave them her body for their scientific research. During the course of the film they have used time-lapse photography to record and represent the decay and decomposition of a series of animal bodies ranging from the swan which had crashed into Alba's white Ford Mercury (registration NID 26 B/W) in the film's opening sequences, killing the brothers' wives and claiming Alba's first leg, to a pregnant Grevy's Zebra, their most ambitious project in which several weeks of decay are compressed into a few minutes of time-lapse film. Now they want to take their investigation to its logical conclusion and film the decomposition of a human body. Oswald assures her that only the camera will be watching, to which she responds: 'What's the use of watching *me*? My body's only half here'. 'Then you'll fit better into the film frame', is Oliver's deadpan reply. Alba laughs: 'God, I should have known. Maybe you've always been in league with Van Meegeren. A fine epitaph: here lies a body cut down to fit the picture'.[1]

Apart from its black and white humour, which is typical of the film, this brief exchange is interesting for a number of reasons. Compositionally (alphabetically and geometrically), it draws our attention to the curious relationship between Alba and the Deuce brothers (an A and two noughts) in the context of the ZOO in which Oswald and Oliver work: take the legs off an A and you are left with a triangle, one of the principal compositional devices used by Greenaway in the film to produce a symmetrically framed look. In terms of the film's storyline, it recalls the three car crash sequences at the beginning of the film which contain so many textual and visual generators: the mythic narrative of Leda, who gives birth to the heavenly twins, Castor and Pollux, after being raped by Jupiter in the guise of a swan; the 26 letters of the alphabet (and the 26 canvases of Vermeer) which will be used in various ways as a structuring device; the black and white (B/W) animals and clothes which give the film much of its visual rhythm; the photographic image of the two dead women in the back seat of the car, one with her eyes open and mouth closed, the other with eyes closed and mouth open, an image which will be reprised at the end of the film with the shot of the two dead brothers. Thematically, it reminds us also of the central role played by Van Meegeren, the nephew of Vermeer's most famous forger, as a

surgeon specialising in Vermeer women (his lover has changed her name to Catarina Bolnes in dubious homage to Vermeer's wife) and whose surgery looks like an empty set for a Vermeer painting. (Greenaway, too, as arch cutter and stitcher of word and image, behaves like a Vermeer forger in his direction of the film, decorating some sets with framed reproductions of actual Vermeer paintings, recreating the feel and composition of other Vermeer paintings or combinations of paintings in his own shots, and initially instructing his cinematographer, Sacha Vierny, to reproduce Vermeer's lighting effects by lighting each tableau from the left with a source about four-and-a-half feet from the ground.)

However, beyond this constellation of elements which serve as formal or structural constraints in the generation of the film's images, themes and storyline, the conversation between Alba and the twins foregrounds in an amusingly graphic way an issue central to Greenaway's film-making practice. For what is being explored here is the role of technologies of recording and representation, both in the sphere of artistic creation and in our everyday experience of our lifeworld. This the scene does in two ways. In the background a colour television is showing the last programme in the series *Life on Earth*, a scientific documentary tracing the evolution of life on the planet which has been playing in a number of scenes throughout the film. By stark contrast, the film for which Alba is here being unsuccessfully 'auditioned' would have been the last episode in Oswald and Oliver's highly entropic visual narrative of decay and decomposition: unlike the micro-narratives of metamorphosis, growth or emergence (most typically, butterflies and flowers) to which popular scientific time-lapse photography has accustomed us, the stories told by the Deuces's camera are ones of disintegration, of loss of form, and of progressive indifferentiation (the brothers themselves, highly differentiated at the start of the film, grow more and more difficult to tell apart as they return to their Siamese origins). This device functions as a simple but visually powerful subversion (something akin to an electronically produced *vanitas* or *memento mori*) of metanarratives of evolution and the ideologies of human progress which subtend them.

More importantly perhaps, Alba and Oliver's wicked little joke about the body cut down to fit the picture or the film frame raises the crucial question of technological determinism. In painting, as in photography, we habitually think of the frame as being made to fit the picture; but, of course, as soon as we

deconstruct that customary disposition of priorities to think of the framing process as an integral and inevitable part of the composition, we become aware that we are dealing with a technical constraint which is deeply implicated in decisions of inclusion and exclusion, of what is and what is not to be recorded and represented, displayed or transmitted. This is made evident in Greenaway's first feature film, *The Draughtsman's Contract*, in which we are repeatedly exposed to the image, which functions as a kind of *leitmotiv*, of the draughtsman Neville peering through his viewfinder as he attempts to fulfil the terms of his realist contract by drawing what he sees of Compton Anstey and its grounds and *only* what he sees. Needless to say, his own attempts at framing the view are prejudiced and contaminated by the attempts of others to frame *him* by leaving tell-tale pieces of (allegorical) evidence strewn within the contracted limits of his frames. In his efforts to frame his own tale as he frames his own views, Neville is readily outwitted by more experienced conspirators and the framer is, indeed, framed, both by his adversaries in the plot and by Greenaway the filmmaker.

Here, as in *A Zed & Two Noughts* where both Vermeer's painting and Van Meegeren's cutting and suturing are represented and pastiched as emblematic of the filmmaker's own art of composition and lighting, editing and montage, what is an essentially artisanal process is recycled, recontextualised, and refunctionalised through a different (electronic) technology with its own norms and institutional apparatus of production and dissemination. The questions such a practice raise with respect to the broader issue of technological determinism, especially in cases involving an interface between different technologies, can be brought into sharper focus by mentally replacing the image of Neville brandishing his viewfinder with that of the technique of 'pan-and-scan' used in some countries to transfer film to video. This procedure involves a human operator manœuvring a three-by-four rectangle over the much wider film window in an attempt to 'capture' the most 'important' bits of the film frame. The image invites us, in turn, to frame a number of questions. How, we must ask, does the operator select what is 'important'? How do technologies themselves determine what is to be included or excluded by the way they frame their representations? What kind of agency do we have as creators and/or consumers of culture in a marketplace increasingly dominated by electronic technologies seemingly far removed from the artisan's traditional relationship with organic materials and human (and animal) bodies? What is the future of that minority culture we have come to think of as 'high' as it is confronted with the ever more successful marketing and penetration of a mass culture increasingly associated with new electronic technologies? Do we fall back on a cultural pessimism which seeks only to protect traditional forms of culture against the dominance of the new technologies or do we embrace those very technologies for the exciting possibilities they offer for the development of new cultural forms?

Such questions have troubled successive generations of 20th-century cultural critics, including, of course, Walter Benjamin, who explored art's loss of aura in the age of mechanical reproduction.[2] Starting from the observation that sounds and objects could now be recorded, photographed, and filmed, Benjamin noted that performances and artifacts were no longer tied to specific times and places. The new mobility of such mechanically reproducible art meant that its value was no longer based on cult or ritual but instead belonged to a new exhibitionary order independent of the work's conditions of production and intended context of reception. (A similar point is eloquently made by Greenaway in his 'Author's Note' to the published script of *A Zed & Two Noughts*, in which he explains why he is publishing the original full script rather than a slavish transcription of the text of the film as released: 'By the time you see the film it may very well be sub-titled, re-edited, shortened, even censored, and every film is viewed at the discretion of the projectionist, the cinema manager, the architect of the cinema, the comfort of your seat and the attention of your neighbour'.[3]) According to Benjamin, there were other ways in which art's loss of aura affected the artistic practice of those who adopted the new technologies. Contrasting the practice of the painter and the cameraman, Benjamin likened the former to a magician who heals a sick person by the ritualistic laying on of hands and the latter to a surgeon who cuts into a patient's body. The painter maintains a certain distance from reality, producing a seamless replica of external appearances, while the cameraman penetrates deep into reality's web, from which he assembles multiple fragments.

While recognising the historical and critical limitations of Benjamin's distinction, which seems to be based on a contrast between traditional realist painting and the new techniques of cinematic montage rather than, say, avant-garde painting and Hollywood realism, it nevertheless reveals Benjamin's optimistic faith in the radical potential of new technologies and offers suggestive parallels with Greenaway's own cinematic practice. The figure of the surgeon takes us back to *A Zed & Two Noughts* and the image of Van Meegeren, whose parodic cutting and stitching stands in for that of the postmodern filmmaker, namely Greenaway himself. The analogy is foregrounded in a curious image, reproduced in the published text of the film, which presents a typical shot of Alba in bed symmetrically flanked by the two Deuce brothers. At the apex of the pyramidal composition is a framed mirror in which Greenaway's disembodied head floats eerily over the scene, providing a spectral signature (or sovereign stamp of authority) for the highly artificial symmetry of the tableau. This self-referential incision produces a characteristically Brechtian alienation effect, emphasising the constructed nature of the scene or what Peter Bürger, who develops Benjamin's notion of allegory as

fragment for his own theory of the avant-garde, would call its nonorganic, allegorical qualities.[4] Here Greenaway seems to reject the role of the painter-magician (Vermeer) who leaves the world intact by copying its surfaces and producing the illusion of an organic totality of (symbolic) meaning; instead, he prefers to cast himself in the role of the cameraman-surgeon (Van Meegeren) who self-consciously forges his compositions from iconic fragments torn from their original context and arranged according to non-organic patterns which defy expectations and posit new (allegorical) meanings.

We shall come back to this distinction between magician and surgeon in our discussion of *Prospero's Books*; for the moment, we are left with the question of whether the availability of new technologies (involving, for example, techniques of montage and large-scale reproduction) warrants the cautious optimism of critics like Benjamin and Bürger, who argue that their relatively widespread use by avant-garde artists in the early 20th century facilitated a radical critique of bourgeois culture by drawing attention to the socially constructed nature of representation and the role played in patterns of artistic production and reception by institutional norms. (It is worth recalling that the radical promise of such new technologies lay in their potential for an unprecedented scale of cultural dissemination; while artists such as Velásquez and Goya had problematised the nature of representation well before the 20th century, their works were confined to relatively small audiences.) Of course, as both Benjamin and Bürger point out, the opportunity for critically mobilising such unfamiliar technologies was limited to the brief historical moment before they were tamed and absorbed by the capitalist society that had produced them. Hence Benjamin's warning that fascists were, if anything, better equipped than marxists to use the new techniques of montage to powerful effect in their visual propaganda and pageantry, since the 'aestheticisation of politics' was a cornerstone of their strategy for mobilising the masses. As we know, other members of the Frankfurt School, such as Theodor Adorno, remained deeply sceptical of the claim that the rise of the mass media contained any radical social seeds. Indeed, Adorno criticised Benjamin for assuming that technological developments would necessarily alter social relations and argued that art's loss of aura had more to do with its increasing commodification as part of the growing culture industry.[5]

In an essay on culture and technology first published in 1983 in response to the resurgence of such debates around what was perceived as another technological paradigm shift (this time to the electronic age), Raymond Williams urged his fellow marxists to abandon simplistic and culturally pessimistic critiques of the commercial media and turn their attention to exploring *how* the new technologies of cable and satellite might be redirected to more democratic ends. If such technologies were developed under the umbrella of public owner-

ship, as common-carrier systems rather than as private monopolies, various small production units and service providers could contract their programming for fees secured on a pay-as-you-view basis. Instead of programming emanating exclusively from large-scale, mass-market production companies in two or three privileged metropolitan centres, it could be produced in a wide range of new communities which need not be defined or constrained by physical location. As an educator, it is not surprising that Williams immediately suggested four new kinds of transmission, including a network for alternative film and video, an exchange network for existing television companies and independent producers of various countries, a backlist service which would provide materials stored by production units, and a reference or archive network for materials held in public trust. According to Williams, such improved access to multiple sources of information, art and entertainment would extend the practices of institutions like the Open University whose flexible, long-distance and part-time structure provided increasingly interactive learning in various locations at different times and speeds. Throughout the essay, Williams stresses that 'virtually all technical study and experiment are undertaken within already existing social relations and cultural forms, typically for purposes that are already in general foreseen. Moreover, a technical invention as such has comparatively little social significance. It is only when it is selected for investment towards production, and when it is consciously developed for particular social uses – that is, when it moves from being a technical invention to what can properly be called an available *technology* – that the general significance begins'.[6] He also emphasises that for cultural forms and technologies to be truly democratic, individuals must have access to their production as well as reception.

At this point we want to take up some of the issues that Williams raises in order to better situate Greenaway's cinematic practice. Clearly, in his case, we are dealing with a style of alternative European filmmaking in the tradition of Bergman, Renais and Godard. Over the years he has consistently stressed the difference between his own cinematic concerns and those of Hollywood, arguing that his films are metaphorical rather than straightforward, formulaic, linear narratives. He insists his cinema is non-organic, artificial and highly theatrical, deliberately distancing the audience by the use of static frames and complex soundtracks, while avoiding close-ups and the kind of extensive editing used to produce the seamless look of Hollywood realism. Like Brechtian theatre, Greenaway's devices deliberately solicit a detached, intellectual and contemplative response rather than an emotional or psychological identification. For example, one of his aims in working with actors is to explore the human form as 'a body, an object, a bulk, a form, a shape, something that throws light and makes the floorboards creak'. This fascination with aesthetic considerations stems from his early training as a painter,

an experience which he claims also made him highly aware of a long tradition of artistic self-reflexivity.

Greenaway himself readily admits that by foregrounding a kind of baroque visual excess and playing with non-organic structuring devices and (frequently aleatory) principles of ordering (for example, colours, numbers, names, letters) he runs the risk of being accused of dehumanising cinema and of trading in 'elitist knowlege and intellectual exhibitionism'.[7] And indeed there have been many complaints about the 'prurient detachment', 'obsessive parades of humanity', as well as 'the fondness for lists, the savage misogyny, [and] . . . casual degradation and violence' which one reviewer claimed would be familiar to 'anyone who knows Greenaway's recent films'.[8] As another writer has observed, '[f]launting their erudition and relishing overt staginess, Peter Greenaway's films divide audiences. There are those who are prepared to entertain his conceits and play the game, and others for whom a Greenaway film is about as exciting as a guided tour through an ancient museum where the catalogue has been lost'.[9] Such assessments lead one to wonder what a willingness (or, for that matter, a refusal) to play Greenaway's cultural games signifies in the 1990s when the hegemony of Western 'high' culture and its narratives is increasingly being challenged as narrowly Eurocentric, nostalgic and elitist.

For some, Greenaway's preoccupation with the Western cultural tradition (those endless parades of paintings, architecture, books, costumes and cuisine) raises the spectre of a reactionary nostalgia, summed up by Raymond Williams in terms of the pessimistic attitude that says 'there is nothing but the past to be won'. Williams argued that in the 1980s such attitudes were becoming increasingly pervasive in the sector he described as the privileged minority arts (including much of the middle-brow television of the BBC and Channel 4, institutions that have sponsored some of Greenaway's work) as that sector sought more and more private and corporate sponsorship to offset dwindling public revenues. This nostalgia was most evident in

> contemporary reproductions of the more graceful and elegant ways of selected periods of the past; in country houses and an old 'pastoral' order; in 'classical' literature and music; in biographies of the once dazzling and powerful; in the taste for playful or suggestive myth.[10]

At first glance, this list could describe the frame of cultural reference and some of the main settings of Greenaway's feature films: the country houses and aristocratic families of *The Draughtsman's Contract*, the monumental architecture of Rome in *The Belly of an Architect*, the English landscapes and Dutch still lives in *Drowning By Numbers* and *The Cook, the Thief, His Wife, and Her Lover*, the use of Greek myth in *A Zed & Two Noughts*, the poetry of Shakespeare's *Tempest* (as voiced by John Gielgud) in *Prospero's Books* with its parade of male and female nudes drawn from Titian, Giorgione and the later Bellini,

not to mention Michael Nyman's trademark scores which recycle the music of Purcell and other Baroque composers.

While there is undoubtedly a good deal of 'high' culture in these films, we need to look very carefully at the claim made by some critics that this culture is nostalgically reproduced or even fetishised. After all, Greenaway's draughtsman is caught in a web of aristocratic intrigue and corruption which results in his brutal murder at the hands of his cultural masters; Stourley Kracklite is devoured by the carnivorous architecture of Rome, crushed by the weight of a cultural heritage and the money of its late 20th-century merchants, while the most prominent architectural feature of *Drowning by Numbers* is the Goole water-tower, hardly an emblem of endangered cultural privilege; Albert Spica, the owner of the gourmet restaurant and its paintings in *The Cook*, is an East End thug and a bully, intended by Greenaway to epitomise the aggressively resentful philistinism of Thatcher's Britain. In all these instances Greenaway tends to dwell on 'high' culture's often crudely material underpinnings, particularly the sources of wealth and power that manipulate and control its production and circulation. This is nowhere more apparent than in *The Baby of Mâcon*, Greenaway's most theatrically Brechtian film, where competing ecclesiastical and secular forces struggle to control the marketing rights to the 'miracle baby' they have created and end up consuming it in a ritual sacrifice and dismemberment. The ironic recycling of Mouret's Masterpiece Theatre theme music at the beginning of the 'play within the film' should alert the audience to Greenaway's take on the high-cultural nostalgia boom of the 1980s and 90s. *The Baby of Mâcon*, whatever its faults, is no Merchant-Ivory production.

Ultimately, the cultural exhibitionism of Greenaway's films seems more engaged with the present than with the past. As with his curatorial work (see, for example, the catalogue of his 1992 Louvre exhibition[11]), the films invite us to re-read our culture, proposing eccentric and irreverent trajectories to take us through the hundreds of artifacts obsessively collected and juxtaposed in celluloid museum displays animated by a wry humour. (One of Greenaway's early films, *A Walk Through H*, is a filmic tour of 92 'maps', framed and hung in a gallery; the visual tour is accompanied by a narrative voice-over, the surreal absurdity of which drily undercuts the detached authority of Colin Cantlie's reassuringly paternal BBC-style delivery.)[12] To some extent, an aesthetic based on a practice that has been variously described as 'high-art mongering' and as a constant raiding of 'art history's vast image bank' can be seen as a response not only to Benjamin's mechanical age of reproduction (which, of course, relied on photography) but also to a new age of electronic reproduction based on digital imagery and computer graphics.[13] Like the collections of imagery on CD ROMs and in the virtual museums at Internet websites, Greenaway's art history is made available for recontextualisation and rewriting, as artworks and monuments from different peri-

ods and places intermingle promiscuously with the details of daily life in our own postmodern world.

As a filmmaker Greenaway has enthusiastically embraced the idea of incorporating new technologies into the production of cinema, partly as a result of his experience of working for television, where he first discovered the seductions of the Quantel Paintbox while producing *A TV Dante* for Channel 4. *Prospero's Books* grew out of this experience as an attempt to marry the technologies of the digital paintbox and high-definition television on 35mm. When discussing the possibilities opened up by the new combination, Greenaway sounds almost like a McLuhanite techno-optimist:

> The script of *Prospero's Books* calls for the manufacture of magical volumes that embody their contents beyond text and conventional illustration. Prospero, 16th-century scholar and magus, would no doubt call upon the most contemporary state-of-the-art techniques that the legacy of the Gutenberg revolution could offer. The newest Gutenberg technology – and to talk of a comparable revolution may not be to exaggerate – is the digital, electronic Graphic Paintbox. This machine, as its name suggests, links the vocabulary of electronic picture-making with the traditions of the artist's pen, palette and brush, and like them permits a personal signature. I believe its possibilities could radically affect cinema, television, photography, painting and printing (and maybe much else), allowing them to reach degrees of sophistication not before considered.[14]

However, while he says that no special technical ability is necessary to operate the machine and that competent familiarity can be achieved quickly, Greenaway acknowledges that 'its potential, as always, depends on the audacity, imagination and pictorial sophistication of the user'. This is a point he makes even more strongly in an interview with film critic John Wrathall: 'The actual technology *per se* doesn't necessarily make a product that is valuable, of course; it's the imagination and resources that are put into it. And you have to be careful that it doesn't become all technology and nothing else. Technology should just be the tool and not the master'.[15]

Greenaway's position here resonates with a number of other arguments we have heard in our consideration of the politics of representation in an electronic age. We recall Raymond Williams's arguments against a technological determinism which would see our social and cultural agendas as being set by the technologies available and not by the social and economic relations in which such technologies are used. We might also remember Peter Bürger's strenuous refutation of Adorno's claim that it was possible to ascribe fixed political meaning to an artistic procedure or technique; instead, Bürger prefers Bloch's conclusion that 'the effects of a technique or procedure can vary in historically different contexts' and that 'procedures are not semantically reducible to invariant meanings'.[16] Surely it is

time to reject once and for all the kind of hysterical reaction that, on sighting a high-cultural reference in a film, runs for the shelter of the nearest anti-elitist bunker; or the kind of self-satisfied cyberchic that believes that 'being digital' is sufficient in and of itself; or the kind of lazy thinking that makes any form of ludic self-referentiality necessarily 'narcissistic' or necessarily 'critical', whether it comes from Peter Greenaway or Arnold Schwarzenegger. The use of technologies, like the use of procedures or techniques, must be judged on a case by case basis in full consciousness of the historical and social circumstances of their deployment.

What is left for us to examine in the statements by Greenaway around the use of a new technology in *Prospero's Books* is the implicit claim that in the last analysis, the artist is, indeed, a master: 'Technology should just be the tool and not the master'. Such an assumption would seem to fly in the face of Raymond Williams's contention that, for it to be truly democratic, a new technology should enable the ordinary individual to be a producer rather than just a passive receiver of culture. Indeed, the entire structural premise of *Prospero's Books* would seem to contradict such a position, since the film turns around the figure of an all-powerful magician-illusionist – as embodied variously in Prospero, Shakespeare, Gielgud, and Greenaway – and his ability to make worlds out of word and image, to create a virtual reality in which others will be caught and, if necessary, disciplined. Moreover, Greenaway's enthusiastic embracing of the Paintbox technology is not without its ambiguities, since what the electronic paintbrush makes possible is a return to an earlier, more artisanal form of artistic production: 'I started life as a painter and I still believe painting is the supreme experimental visual art form. But there's a way that this [Quantel] not only combines the languages of television and film but also brings back painterly values, which is very exciting. The Paintbox, as its name suggests, links the vocabulary of electronic picture-making with the tradition of the artist's pen, palette and brush. Now I know that cinema is not painting and vice-versa, but there's a whole language there that can be used in cinematic terms and that can make the cinema a thousand times more exciting and interesting'.[17]

In proposing what might be seen as a synthesis of Benjamin's figures of the magician and the surgeon, the painter and the cameraman, through the digitally artisanal Paintbox, is Greenaway simply seeking a way to resuscitate Old Masters who have little or nothing to say to our times, to reinscribe the techniques and values of a nostalgic and conservative 'high' art in the infinitely reproducible forms of electronic culture? Or is he attempting a serious exploration of the politics of cultural technologies, a stocktaking and diffusion of cultural archives,[18] and a questioning of the necessity and sufficiency of technical mastery and its relation to political and artistic vision? Prospero is, in this respect, a curiously ambivalent figure, since, for all his colonising ambitions, he comes to recognise his limitations

Prospero's Books, *1991*

as a magician and a man, a point which is underscored at the end of the film when he drowns his magic books and turns, in close-up, to the audience, thereby breaking any last remains of filmic illusion, and appeals to us to release him from the world he has created:

Gentle breath of yours my sails
Must fill, or else my project fails,
Which was to please.[19]

Whether Greenaway pleases or not is ultimately for us to decide. What mastery he has is over materials, not minds.

Notes

1 Greenaway, Peter, *A Zed & Two Noughts*, Faber and Faber, London, 1986, p107.

2 Benjamin, Walter, 'The Work of Art in the Age of Mechanical Reproduction', in Hannah Arendt, ed, *Illuminations*, trans Harry Zohn, Schocken Books, New York, 1968.

3 *op cit*, Greenaway, p9.

4 Bürger, Peter, *Theory of the Avant-Garde*, trans Michael Shaw, University of Minnesota Press, Minneapolis, 1984, pp68-73.

5 A number of Adorno's essays on the subject have recently been collected in JM Bernstein, ed, *The Culture Industry: Selected Essays on Mass Culture*, Routledge, London, 1991.

6 Williams, Raymond, 'Culture and Technology', in *The Politics of Modernism: Against the New Conformists*, Verso, London, 1989, p120.

7 Taken from an interview conducted by Brian McFarlene, published in *Cinema Papers* 78 (March 1990), pp38-43, 68-69. Greenaway also outlines his views on Hollywood cinema in an interview with Gavin Smith published in *Film Comment* 26/3 (June 1990) pp54-56, 58-60.

8 Clements, Andrew, 'Horse's Tale', *Guardian Weekly* (20.11.94), p27.

9 Barker, Adam, 'A Tale of Two Magicians', *Sight and Sound* (May 1991), p27.

10 *op cit*, Williams, 'Culture and Technology', pp123, 129.

11 Greenaway, Peter, *Le Bruit des nuages/Flying Out of This World*, Éditions de la Réunion des musées nationaux, Paris, 1992.

12 In fact, the film, made in 1978, has two 'fathers': its subtitle is *Reincarnation of an Ornithologist*, an allusion to Greenaway's own father who had recently died and who had been an amateur ornithologist.

13 De Feo, Ronald, 'Fantasy in Crimson', *Art News* (March 1990), p31 and Amy Fine Collins and Bradley Collins, 'Drowning the Text', *Art in America* (June 1992), p55.

14 Greenaway, Peter, *Prospero's Books*, Chatto & Windus, London, 1991, p28. This quotation comes from an excellent section which describes in detail how the film's paintbox images were made (pp28-33).

15 John Wrathrall interview with Peter Greenaway, 'Mosaic Mindscapes', *Screen International* (Sept 13-19, 1991), p18.

16 *op cit*, Peter Bürger, pp78-79.

17 *op cit*, Wrathall, p18.

18 Greenaway frequently makes strong claims for painting: 'The history of painting is one of borrowing and reprising, homage and quotation. All image-makers who have wished to contribute to it have eagerly examined what painters have done before and – openly acknowledged or not – this huge body of pictorial work has become the legitimate and unavoidable encyclopedia for all to study and use' (*Prospero's Books*, pp12-13).

19 *op cit*, *Prospero's Books*, p164.

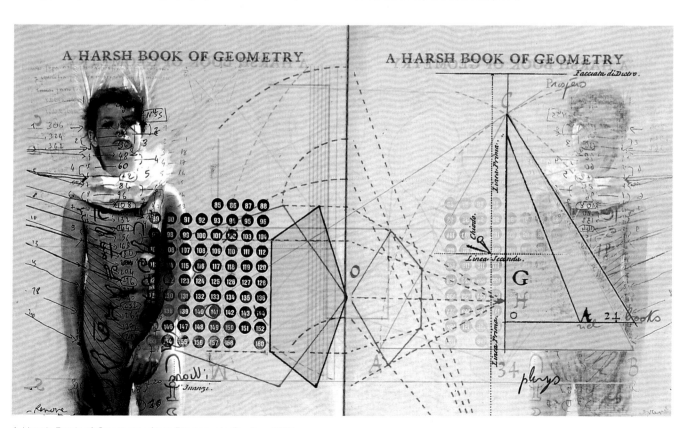

A Harsh Book of Geometry *from* Prospero's Books, *1991*

Portrait of Derek Jarman by Angus McBean, London, 1987

COMPARE AND CONTRAST
DEREK JARMAN, PETER GREENAWAY AND FILM ART
Paul Wells

Peter Greenaway and the late Derek Jarman are probably two of the finest British filmmakers of their generation. Often compared, and notably contrasted, Greenaway and Jarman have created some of the most artful imagery in British Cinema; imagery predominantly related to their backgrounds as painters and their ambition to work in a way that deviated from, and often subverted the 'realist' tradition in British films. The following extracts are taken from separate interviews conducted with Greenaway and Jarman for two radio series – the first, an eight-part history of British Cinema entitled *Britannia – The Film,* the second, a series profiling eight British film directors called *Calling the Shots*. I spoke to Greenaway in his hastily converted London cutting rooms, and Jarman in his Dungeness beach front home – the former characterised by gurgling pipes and dripping water, the latter by tides that washed up boxes of oranges and pieces of jewellery into Jarman's 'garden'!

On who I am . . .

Derek Jarman: I'm not a film director, I'm a filmmaker and artist.

Peter Greenaway: I'm sometimes described as a filmmaker, but it's a definition I sometimes have difficulty with, as I believe I am a painter or a writer who just happens to be working in cinema.

On starting out

DJ: I escaped to London at the age of 18 and collided with a completely new world, partly at university at King's College through a very young teacher there called Eric Mottram, who introduced me to all the beat poets and writers he was very keen on, like Alan Ginsberg and William Burroughs, and partly when I went to the Slade, where I started to paint. Concurrent with this was a sort of break up of all the old patterns of behaviour, dress and expectation between 1963 and 67, so you had this vast change which we remember as 'swinging London', and it's a legacy that really has changed lifestyles, so even now people have lifestyles forged in those years.

PG: Around the age of 14 or 15 I had somewhat under-developed ideas about one day being somehow associated with the world of painting. I was encouraged to paint and draw. I suppose I had a modicum of talent but this is not so unusual as I sincerely believe that we all have a certain degree of talent as far as draughtsmanship is concerned. I went to a minor art school in East London called Walthamstow School of Art and

did a very orthodox four year course aligned very much with mural painting – some people have since regarded that as particularly relevant, as mural painting is painting on a very large scale, vis-à-vis large painted wall indicates 'the silver screen'. However, I think virtually within three or four weeks of being at art school I had an experience which from the very beginning changed my attitude to the visual arts in general. This was seeing Ingmar Bergman's *The Seventh Seal*, which I think I went back and saw 14 times. I spent probably as much time and ingenuity and imagination when I was at art school with a growing interest in cinema as I did in regard to painting.

On influential movies and movie-makers . . .

DJ: *The Life and Death of Colonel Blimp* is one of my favourites. To have made *Colonel Blimp* at the height of the War and to have made a very sympathetic portrait of the enemy seemed to me to be very sophisticated and daring. One got used, after the War, to seeing so many films where the Germans were just archetypal 'meanies', and you realised, as I realised much later – for instance, when I made *The War Requiem* – that this couldn't be so, and that foot soldiers, whatever they were fighting for, were often victims and should be seen in this way. This is exactly how Michael Powell, the director of the film, developed the relationship between the young British officer and the young German officer across the span of the whole 20th century. It's an epic; the film is wonderful.

I love Tarkovsky's films – they're very different; there's something extraordinary happening. There's a sort of rustling of a supernatural wind through some of his work. I like *The Wizard of Oz*! I'm very broad minded. *Brazil is* a great modern British movie. I don't just like smaller films, or what are known as 'underground films', and I think it's a pity that all films are not integrated and that people don't see Kenneth Anger or Andy Warhol as just part of 'cinema', instead of some sort of odd area which isn't linked to the general commercial structure.

PG: I'd seen a lot of American cinema and a lot of British cinema, but *The Seventh Seal* struck me as quite extraordinary. Here was a film that dealt not only in very strong narrative situations that involved you dramatically and emotionally, but concerned itself with an extremely strong metaphor. It was a film about history, which was one of my favourite subjects, and had a use of actual imagery which I was familiar with from central European painting. From that point on, I decided, at the very least, to involve myself in a crash course of what

Bergman had to say, and from then on, the whole gamut of European Cinema. What initially attracted me to *The Seventh Seal* was that it had values and characteristics which I was familiar with in other art forms, most notably, the European novel and certain forms of English drama, and indeed, in relation to my rather academic interest in history – not 'history' in the normal sense, but *history as a form of entertainment*. It might be a very unfashionable view but I believe that history is an amazing bank or reserve area of plots, characterisations, extraordinary events etc. It may be a very underdeveloped view of history but it's stayed with me ever since. My approach then became influenced by Alain Renais and Jean-Luc Godard, and the films of the *nouvelle vague*. It seems to me that cinema has sprung not only from theatre and literature but out of painting as well – which is supposed to be a medium for visual communication. I've always enjoyed and been amused by the paradoxes involved in cinema because an awful lot of cinema is not essentially visual but more associated with a literary or textual context. The majority of cinema is text first, pictures second. Very largely, commercial cinema concerns itself with finding some art form, either a novel or play, and converting it into cinema. My heroes in a European context would not do this. Some one like Godard, for example, would conceive an idea as a cinematic proposition right from the very beginning, and it's that sort of cinema that I particularly move towards.

On other heroes . . .

DJ: My influences are painters mainly, but people like Ken Russell, people you've worked with, are of course very important. Ken taught me a great deal, without actually being 'a teacher'. Just sitting in his living room during the year when we made *The Devils*, I was asked to design the film and help re-write it. There would be moments when he would ask me what I thought of things and very often he would quite wickedly do the opposite! Heathcote Williams was very influential when we made *The Tempest*. Pier Paulo Pasolini influenced me not in a direct way but by being one of the 'household gods' as it were. Michaeli Caravaggio is the most interesting painter. Many art historians and painters as well as myself would put him at the very top as one of their favourite painters. He did something quite extraordinary – he took the saints off the walls and made them ordinary people. So his Mary Magdalene she was just an ordinary prostitute who lived in Rome; this was an immensely significant gesture, because until that time, saints had been idealised, abstract or invented people, but poor Caravaggio, he had no imagination – or so his critics said – and all he could do was show people with all their warts, spots and everything that was wrong with them, and say that this was a saint, and of course, that was what the whole thing was about! You can take a painter like Caravaggio – no one had heard of him before I made my film but then you could find him talked about all over the newspapers as if everyone knew, and

it was very exciting to think that one had actually helped to point people towards a painter that hadn't been seen, and who I really dearly loved.

PG: Somebody suggested that my films are dissertations or theses dressed up in narrative form. I don't have any particular wish to be polemical or didactic; I don't have a 'message', but what I do thoroughly enjoy are those works of art, not necessarily in the cinema, but in the other arts as well, which have an *encyclopaedic* world. These films or these novels or these plays sometimes mock the very idea of the concept of 'total data banks'. One of my heroes, almost necessarily from what I'm saying, of course, is Borges, who is a supreme master of doing this – being a data bank – and the beauty of this economy is that he could have written *War and Peace* in three or four pages; who knows, it might have been a better book.

With a background in painting, I had certain heroes – one of them would have to be Marcel Duchamp, another would be John Cage – who were trying to overthrow orthodox procedures of creativity in lots of different fields. I remember coming across a record called *Indeterminacy*, which I think John Cage had put together in the 1940s, where he had the problem of organising many narratives. What he did was to create over two sides of a gramaphone record, a whole series of very scrappy, maybe one line, one paragraph narratives, but he put them together systematically in a process which would suit methods – and this is very important for me since most of my works are very self-reflexive and relate intimately to the way that they are made – by which they would fill two sides of a gramaphone record. He read very short stories very slowly so that they would fill exactly 60 seconds of time – one minute – and those stories which were longer, he gabbled extremely quickly so that they would fit. I made a very bad mistake; I miscounted these scraps of information on the record as 92, and in continual homage to this man who had been so influential to me, I began creating or constructing my own films on this so-called 'magic' number of 92 – it's back to Godard's 'cinema is truth 24 times a second' idea – but when I eventually made a film about John Cage and met him, I explained this to him, and he found it very amusing because there are only 90 stories on the two sides of the record, and I'd based three years of my filmic career on this mathematical error!

On my first film . . .

DJ: A friend of mine arrived with a Super-8 camera at my studio. I've always been hopeless with technology. I've never been able to read light meters and things. I was always frightened when I saw a camera because I could never use them. I couldn't believe it when Mark, my friend, just pressed a button, put a cassette in, and a week or two later there was a film there, and he had hardly done anything. So I thought that I might be able to do that too. There were no pressures, I started off by making a film of the studio, just recording it, and to my

utter surprise, it came out. It was a three minute cassette, and it was edited in the cassette.

PG: I was an editor at the Central Office of Information for about eight years and I suppose it was inevitable that their methods and modes of film-making would in some senses rub off on me. This culminated for me in a very, very short film which I made in 1974 called *Windows*. I think all the characteristics are there: a concern for statistics, a concern for the English landscape, a wry sense of black humour and I suppose, the subject which persistently and continually I am associated with, considerations of death. This little film told you everything about everything.

On Art History in films . . .

DJ: I use signs and symbols, mainly unconsciously, but there is conscious symbolism sometimes, for instance, at the end of *The War Requiem* there is the resurrection of Piero della Francesca; I mean this is a direct art reference, but actually I don't think that's a very interesting way of making films. Obviously, in *Caravaggio* we did have to show art references, but I distrust movies where art references are made overtly because it means the person doesn't have a vision of their own. Maybe you can see references but it shouldn't be constructed like that. Peter Greenaway does this but I think we are very, very different and some of my attacks on him are just trying to make that difference clear to people because we were always being grouped together as two filmmakers of the same generation who had come out of roughly the same area. What impresses me about Peter's work is that he makes films oriented towards Europe rather than the States which is actually very valuable. His audiences are much bigger than mine but those conundrums and manipulations of art history don't really interest me.

PG: My own particular cultural baggage is as a painter and it strikes me that all the problems that have ever been set by somebody else for a painter to solve, or any problems that any painter has set for himself and solved, have been done time and time again in the 2,000 years of European visual history; those same problems come up in terms of cinema. There's obviously a slight difference as you have to contend with ideas like sound and movement which a painter doesn't have in his vocabulary – but constantly for me, the whole 2,000 years of European painting is a vast encyclopaedia for dipping in, for making comparisons, for seeing what other people have done under the same circumstances. With such a fantastic, rich, ready source of reference, it seems to me that filmmakers are doing themselves a disservice if they do not look back and see what other people have done.

On rejecting 'dominant cinema' . . .

DJ: I suppose I am a *director* but the ways my films are formulated without a script or a particular narrative, means people are freer to use the spur of the moment. It's very associative and free, but audiences interpret those non-narrative films in different ways, whereas in narrative films you're saying 'jump' here, 'cry' here, 'giggle' here, if you're being successful and manipulating the audience in a much more direct fashion. I've no idea what I want, I'm not sure that anyone really does, but they always tell everyone that they know. I think that when one is creating something you really don't have any idea how it's going to end up. Not until we've done the dub, put the music on and the titles are there on the film do I really know what has been made, and even then I rely on audiences to tell me and adapt their best guesses, as it were.

PG: It seems to me that dominant cinema seems to require an empathy or a sympathy between the film and the audience which is basically to do with the manipulation of the emotions, and it seems to me again – and this is a very subjective position – that most cinema seems to trivialise the emotions, sentimentalising or romanticising them. Now, the relationship a viewer has with a painting is somewhat different. You don't go into the National Gallery of any famous capital city and cry, sob, laugh, fall about on the floor, become very angry – it's a completely different reaction. It's a reaction which is to do with a much more composed sense of regarding an image; it's a reaction with a thought process as opposed to an immediate emotional reaction. It's my contention that there is no reason why we cannot bring this sort of reaction over into cinema. All my films are somewhat experimental, they are all, each one, taking a certain amount of risk, but there's always the basic assumption that we should be able to appreciate the cinema as much with the mind as we can through emotional empathy. Sometimes it works, sometimes it doesn't.

A Funny Thing Happened . . .

DJ: I had the most extraordinary experiences in trying to make *Caravaggio*. We had a possible sponsor, a very strange man, who made his money by having a lira on every petrol pump in Italy. He was a film producer and a friend of the Pope's, lived in what looked like an Italian coffee machine and owned very vicious dogs! I also worked with Suso Cecchi D'Amico who wrote all the Visconti scripts and many scripts for other great Italian films. She turned *Caravaggio* into a great Italian epic at one point, with me. I came back here knowing that we had little money so it was necessary to make it in a warehouse in the Isle of Dogs! Much later it opened in Italy in the Capitaline museum, with a special grand reception, and people asked when it was over, 'Where abouts in Italy did you make this film?' We used an Italian church towards Wills Farringdon and a Greek centre in Wood Lane!

PG: I made, for a London Television company a programme called *26 Bathrooms* – it was going to be a series of programmes but it ended up as just one – which was about the ways in which people behaved in their bathrooms. It was about

where people put the soap on one level, or the colour of the bathroom curtains, the acoustics, about whether you sang in the bath, and it was structured very simply on the alphabet. We had a man and a woman who arrived one by bus, one by bike, to come and demonstrate for me, in front of the camera, how a jacuzzi operated. I asked both of them to take their clothes off because obviously you don't get into a bath with your clothes on. They hesitated, but eventually their dressing gowns came off and they got into the bath. They had never met one another before. Six weeks later I got an invitation from these people that I had brought together so perculiarly in this jacuzzi – they were planning to get married! I understand that now they have three children.

On being provocative...

DJ: For most of my life I was condemned by heterosexist society to be looked upon as a pariah, and I, like David Hockney and others of my generation, wasn't prepared to accept that, so it became very important when we came to do *Sebastiane*, our first feature film, for all the people who were involved in making that film to make a homoerotic film. I don't know whether the film is very good but it was very important because for 15 per cent of the population, or whatever the homosexual population is, it provided a point of focus and solidarity.

On the surface *Jubilee* was a punk film made in the mid-70s. One part of *Jubilee*, though, was a study of violence with role reversal, for example, traditional scenes of violence in the cinema – with 'ketchup' and things like that – but perpetrated by a gang of young women. Because it was unpleasant and most violence in the cinema is titillating, it was seen to be more violent than any film that you could imagine. Also, of course, the violence in this film, was on decidedly *British* streets. The odd thing about *Jubilee* is that an awful lot came true. It was a *fantasy* when I made it. The fact that churches *did* become discos; the fact that Adam Ant was a complete unknown and *did* become a star; and the fact that the sanitised 'County' England where everyone had sold out *did* become Margaret Thatcher's Great Britain a year or two later was the oddest thing. When the film played in 1985 and after, it was a very different film to the one I had made. It seemed a direct assault on a tangible *reality*.

I, and many other people, grew up with a good deal of self-hatred. What happens if all the images you have about your innermost self are negative? You're taught to hate yourself and it becomes extremely difficult to have self-respect, so in gay movies you often find pent-up violence.

Last of England was a rail. Things had gone hopelessly wrong: there were just simple things where cities were being destroyed; poppy fields and hedgerows were eradicated; gradually year by year the country became uglier and uglier, spiritually and geographically. And of course, like many people, I was deeply disturbed by what Mrs Thatcher was doing.

PG: I think it is really important to be in some way *provocative* – either intellectually or viscerally – in the films one makes. *The Cook, The Thief, His Wife and Her Lover* was a preposterous melodrama, taking place in a 20th-century Western European or American restaurant, where the central theme is cannibalism. What I wanted to do was to try and convince an audience that cannibalism could happen in a refined restaurant among civilised people in the Western world – a provocation in its own right, but for me, also a metaphor for all the discussions and conversations, somewhat angry, about the circumstances and traditions of Thatcherite Britain. A land of extreme consumerism, of self-interest, a remarkable lack of self-knowledge and an incredible amount of consumer greed. I took the premise that when we have finally eaten everything that exists in the world we would end up eating each other.

It was received with very mixed opinions. In America, it became involved in the Fundamentalist Puritanical Movement's campaign for censorship in the arts, and was caught up in the so-called 'Mapplethorpe Crisis'. It was re-addressed to the American Board of Film Censors, who created a new certificate which allows films of this nature to go out as adult films but not ones associated with pornography, which their old 'X' certificate very much categorised such movies as. The movie does employ extremes of violence and is often sexually explicit, but this is done with serious intent. Dominant commercial movies do engage in violence in a very superficial way, for a cheap thrill, for a *frisson*, without necessarily associating cause and effect. *The Cook*... tries to demonstrate the real circumstances of when you do enter into violence in all its forms. Albert Spica, 'the thief', played by Michael Gambon, is a racist, sexist, fascist thug of a man, with extremely poor self knowledge – he cannot see himself from the outside. He is given a dialogue, a language, which is extremely crude. He cannot open his mouth without the lavatory coming out. He is an appalling man in all senses. You know that there's a tradition in the cinema of creating bad characters who are attractive; well, I tried to create a character that you couldn't love, you just had to hate him.

On The Tempest...

DJ: I've always been very old fashioned in my filmmaking and quite traditional. I think of myself as the most traditional filmmaker of my generation, as my films are all based upon the traditional values I was brought up with. I had a particularly formal education and I remember *The Tempest* back at school, and then carried on through college where it was the set book, and then when I got to the Slade, I designed it. I made my own designs for it to be staged at the Roundhouse – I flooded the Roundhouse and built an island in the middle of it in my imagination, and then as the years went by, imagined it as a Super-8 film where Prospero was playing all the parts and was locked in a version of bedlam. It was going to be a sort of 18th-

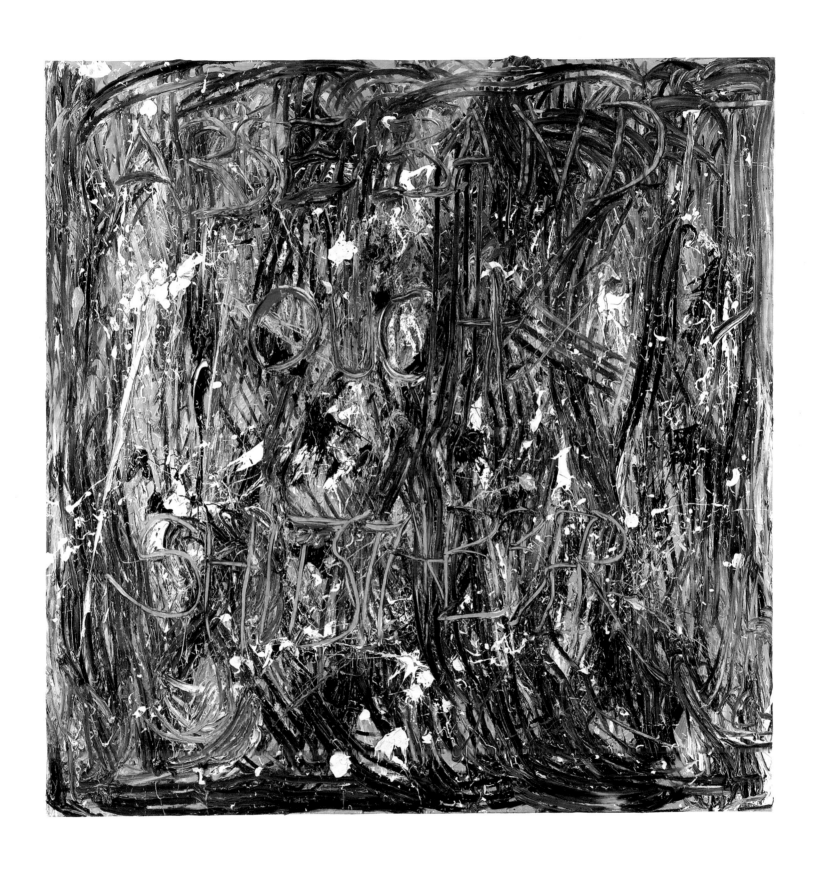

Derek Jarman, Ouch-Arse Bandit-Shit Stabber, *1993, oil on canvas, 213.5x213.5cm (photo Prudence Cuming)*

century film where people came to look at this madman who was playing Caliban and Miranda. It went through a lot of changes but it was one of those works that remained with me all through my conscious life, and fortunately, it was one of the few Shakespeare plays that had never been filmed.

It was absolutely wonderful doing the film. We were stuck in Stoneley Abbey, which is a large stately home, just outside Coventry, owned by John Leigh. He was very sympathetic to us. He came in and said 'If you want a Rembrandt on the wall, we'll just bring one in from the next room', so the props in *The Tempest* are all exquisite – the chairs, for example, in the ballroom scene are some of the finest late 18th-century Venetian chairs in the world, which some of the camera crew sat on! There was deep snow outside and all the blinds were drawn; all the chandeliers were twinkling in this great 18th-century house with all its marvellous furniture; people wandered around in costume. It was absolutely magical. We didn't know where to put all the extras and improvised beds all over the place. We all ate in the refectory, had excellent food, and everyone used to entertain each other in the evenings. There was some great cabaret – especially Elisabeth Welch singing. It was like giving a wonderful party. I realised with *The Tempest* that you could do anything; up to then I had felt rather constricted.

PG: My version of *The Tempest* is called *Prospero's Books* because in the narrative, when Prospero is ousted by a *coup d'état*, his aged friend, Gonzalo, threw some books into the boat in which he was cast out. Shakespeare doesn't tell us what those books are, but I've had the cheek, the audacity, to indicate that myself. If *The Cook*... is a film about 'you are what you eat', I was intrigued by the proposition that in this film, the axiom was 'you are what you read'. We have elaborated upon the 25 books in the bottom of the boat and created for 1611, 'a little library', if you like, which represents all the known knowledge of that particular time. There's a book on cosmography, a book on pornography, a herbal book, a book on beastiary, a book about how to bring up the three-year-old Miranda, who he is stuck with on the island, and Christ's diary, which represents certain attitudes about the fact that Shakespeare never once mentions his religious beliefs in the whole of his 36 plays. The play is about 'magic' – cinematic magic

like that of Jean Cocteau, in *Beauty and the Beast*, which is beautiful and restrained; electronic magic like that of *Star Wars*; the 'magic' of what an actor can make you believe, here chiefly, the voice of John Gielgud; and painterly illusionism – how the eye can be tricked. We tried to combine these four forms of 'magic'. I was particularly interested in the way that television technology could be employed in cinema to explore what was called in the late 70s, 'Expanded Cinema' – what happens *after* cinema. I wanted to invest the extraordinary language and richness of what cinema stands for with the new electrical, technological excitements for picture making. I sincerely hope to continually marry these various languages to create something for me which is even more exciting, even more stimulating and more entertaining than cinema as we know it now.

And in conclusion . . .

DJ: Ultimately, I think it is important to make films that are about love and it is certainly important for me to make films which express love between men. I don't really make films as a film director. I'm not really interested in 'film' but I am interested in sexual politics and the ways in which different media can express these ideas. *Angelic Conversations*, for example, is a film about love between two young men, and I think it is late night viewing and very much like poems. Very few people read poems and although I think it is probably a spurious analogy, films like *Angelic Conversation* or *The Garden* are poetry as opposed to prose; most cinema I see is just prose.

PG: I think that films or indeed any art work should be made in a way that they are infinitely viewable; so that you could go back to it time and time again, not necessarily immediately but over a space of time, and see new things in it, or new ways of looking at it. Film is such an extraordinary rich medium which can handle so many different modes of operation, combining together in the same place all these extraordinary disciplines which may be executed in their own right – music, writing, picture making of all kinds, and I often feel that some filmmakers make films with one eye closed and two hands tied behind their backs.

TRACING THE EDGE OF POWER
A BRIEF INTRODUCTION TO THE FILM AND ART OF BETH B[1]
Jack Sargeant

Communication and information are power.
Beth B, *Day Of Hope*, November 1992.

The central theme of Beth B's work as filmmaker, sculptor, artist and writer is power. Through a wide range of texts, Beth B has attempted to trace the various manifestations of power which construct the experiences of 'individuals' and communities predominantly, although not exclusively, in contemporary Western society. Power, as it is described throughout B's work, is a flux of forces, emerging from a complex web of relationships from which there is no possible escape to an external zone. Power does not *merely* control people, nor does it necessarily come 'down from above' as *modus operandi* of the oppressive state, although this form of state power is undoubtedly a feature of B's work. B also traces the relationship between 'individuals' and power, a relationship which can take various forms such as sadomasochism (sexual and social) with the continual exchanges of power inherent in such relationships; the willing acquiescence of personal freedoms to the power of narcotic addiction; and the recurring abuses transpiring within the very psyche of the 'normal' family. In addition to this exploration of power over the 'individual', B's work also demands that the subject constructed by and through narratives of power can take control via an investment of power within their own daily existence, their own body, their own community. The questions and demands of empowerment – as a survival strategy – are as much B's themes as the negative oppressive forms of power.

These explorations of power are played out in Beth B's work through the recurrent usage of themes such as addiction, sexuality, violence, mind-control, discipline and punishment, mental illness and familial abuse. The presentation of power within B's work is never simplistic and resists offering dialectical solutions, and this unwillingness on B's part to either preach or explain – an act which would make the artist into a new authority figure and hence encourage the audience's disempowerment – has resulted, especially early on in her career, in misunderstandings of her work and accusations of being beholden to power.

Beth B grew up in the 60s on the South Side of Chicago, where she was influenced by 'guys with cigarettes hanging out of their mouths, and women with ratted bouffant hairdos; it was the dark side that fascinated me, the poor white trash that I always felt in life with'.[2] The neighbourhood, and more impor-

tantly the street, was where life could be experienced; where philosophies and behaviours which existed contrary to those of mainstream society could be played out. The street acts as a site in which information can be presented – and taken in – as raw experience, with an immediacy which remains unmediated by the traditional barriers of 'good taste', and 'value'. Much of B's work reveals that the street and the normally hidden 'dark side' still hold a fascination for her, as both a source of inspiration and as a zone in which to operate.

Beth B was encouraged in the arts from an early age, initially studying at the Art Institute of Chicago as a child, an experience she was later to consolidate by studying at the University of California at Irvine and the School of Visual Arts, New York. While studying at the School of Visual Arts, B was able to take a year abroad, which enabled her to study in Holland and in Germany where she worked for three months as Assistant Curator at the Ingrid Oppenheim Gallery. This experience of the 'art world' left Beth B feeling 'frustrated with the state of the arts' and on returning to New York she decided to investigate filmmaking, and began to co-direct a series of super-8 movies. This antagonism to the 'fine arts in particular' was due to the limited, and perhaps exclusive, audience that they reached. In contrast to this, film offered a method of communication which would enable a larger, and more diverse, audience to be reached.

Beth B's first six films were collaborations with then partner Scott B. The initial 'B', an edit of Scott's surname Billingsly, served to signify a shared interest in low budget B-movies, and their 'generic'/'populist' aesthetic of sex, violence and melodrama. The name also, undoubtedly, reflected the punk minimalism of the time. The Bs were part of the re-birth of New York underground film, which also saw similarly punk-influenced super-8 films being produced by Vivienne Dick (*Beauty Becomes The Beast*, 1979), Amos Poe (*Blank Generation*, 1976), Michael Oblowitz (*X-Terminator*, 1979), and James Nares (*Rome '78*, 1978), among others. The movies produced by these filmmakers were described by *The Village Voice* as 'para punk' film. These early films were largely inspired by the aesthetic of self-affirmation propagated by the artists and musicians of the downtown punk scene and especially by the exceptionally abrasive, nihilistic and short lived, No Wave scene: 'It was during a time where it very much went along with the rock and roll attitude of anybody could do it, so I just picked up a little super-8 box camera and started shooting'. The films were cast

with various luminaries from the local underground scene; musicians such as Arto Lindsey, Pat Place, Richard Hell and John Lurie acted alongside Bill Rice and John Ahearn, as well as the performer, writer and 'confrontationalist' Lydia Lunch.[3] Jack Smith, the legendary Lower East Side performer and 'first generation' underground film director,[4] even appeared in the B's work.

The early super-8 films that Beth and Scott B directed; *G-Man* (1978), *Black Box* (1978), and *The Offenders* (1979) were produced on the most minimal of possible budgets, funded from Scott's employment as an occasional construction worker and Beth's work as a receptionist and typesetter. Stylistically they were a combination of *film noir* and classic B-movies, and were shot in the shortest possible time, with the bare minimum of time spent on rehearsals. The films were 'text book' exercises in the punk aesthetic; *Black Box*, for example, was scripted, rehearsed, shot, edited, scored, publicised and screened in less than a week. *The Offenders* was similarly produced, with the additional slant of being screened as a regular serial at the club Max's Kansas City (the cast and crew would complete and screen an episode of the narrative every week).[5]

Beth and Scott B screened their films in the zone of the night club rather than the (relatively) bourgeois space of the art house cinema or museum, which further categorised the punk aesthetic of the B's movies. The Bs decided that by screening the films within the zone more commonly delineated by rock music and live performance, they would be able to radically break with the avant-garde cinema's traditional exhibition spaces in which the audience was compelled to sit on uncomfortable chairs, unable to drink, smoke or eat: 'you sit and analyze; you intellectualize'. The punk clubs offered a space and an audience that, at least at the time, existed antithetically to the *established* avant-garde.

The central theme of these early super-8 films was the construction of the individual through power and the multiplicity of relationships between individuals and various control systems. Sadomasochistic relationships, oppressive state apparatus and street survival become recurring themes within these early narrative movies. In *Black Box* – the best known film of this period – a young man, out buying cigarettes, is kidnapped and taken to a secret location. Here he is savagely beaten and tortured, before being finally imprisoned in the black box, a torture device which bombards the victim with extremities of light/dark, heat/cold and noise/silence. Stylistically a punk/*noir* hybrid, the film merely depicts events with no simplistic moral tongue-clicking. Rather than preaching the obvious horrors of torture, the Bs were more interested in depicting a ten minute climax of the nude Bob Mason suffering in the black box. The film ends with the youth still being tortured and with no comfortable narrative resolution: he is neither killed, nor does he escape. The film demands that the audience thinks about what it has seen, and question it, rather than be spoon-fed answers and solutions. *Black Box*, despite being a work of fiction, was based on an actual 'coercion device' called the refrigerator; the film thus serves as a method of disseminating information. Although having renounced the arts in favour of film, the Bs exhibited the black box used in the film to coincide with its launch. Similarly, the promotional campaigns undertaken by the Bs on the street were also engaged with the visual arts. As Beth B states: 'We used to strip twenty foot, huge, billboard-sized things across buildings in New York, with times of our film screenings, but they became works of art themselves'. However, rather than gallery-based art, these were public, designed for the streets and designed for gaining attention; it was a tactic Beth B would return to.

During this period Beth and Scott also produced the short *Letters To Dad* (1978), a film which depicts 'talking-head' shots of various members of the B's 'regular' cast, each of whom is talking to the camera about the power of 'Dad' in their lives. The film appears, on first viewing, as almost comical, as various actors stumble through phrases such as 'Dad is the best thing that ever happened to me – he can make you feel so big and so small'. It is only at the film's end that the audience learns that the patriarch to whom the cast was speaking was the Reverend Jim Jones, who in 1978 encouraged his followers to consume cyanide-laced orange juice in the terrifying mass suicide of 993 members of The People's Temple cult at their 'utopian' community in Jonestown, Guyana. Each actor's lines were direct quotes from the letters of Jones's congregation, chosen by the member of the cast because the phrase related – in some way – to their own lives. Each speaker is directly facing the camera, and therefore the audience's collective gaze, enabling the film to position its viewers as the 'Dad' whom the cast is addressing. The audience are thus constructed as integral to the text. Instead of being 'voyeurs' of disparate events constructed 'narratively', the audience becomes an 'active' part of the text. Such a strategic device became increasingly important in Beth B's later solo video and film work.

In 1987 Beth B produced her first 'solo' feature film; the 35mm *Salvation* (aka *Salvation! Have You Said Your Prayers Today?*) a ruthless, grimly humorous examination of the growth of the Religious Right, Moral Majority, TV-evangelism and the effects of a TV-evangelist on one white trash family.

Salvation! was followed in 1993 by the 35mm *Two Small Bodies*, funded by German and French television companies, ZDF and Arte. Beth B's most powerful and concise film to date, *Two Small Bodies* was adapted by Beth B and Neal Bell from Bell's stage play of the same name. *Two Small Bodies* is an exceptionally oppressive, claustrophobic and dark film which focuses on the relationship between a police investigator Lieutenant Brann, and strip club employee and single mother, Eileen. The claustrophobia of the narrative is emphasised by the location of the film, which is set entirely in Eileen's house.

FROM ABOVE: Bob Mason in Black Box, *1979 (Beth B and Scott B); Suzy Amis and Fred Ward in* Two Small Bodies, *1994*

Brann is investigating the disappearance of Eileen's children, and assumes that she – as an archetype 'scarlet woman' – is responsible for their murder. The appearance of Eileen's guilt is emphasised, to Brann, by her strangely unemotional response to their disappearance. Eileen is aware of Brann's interpretation of her as a fallen woman and hence potentially guilty of infanticide, and knows that Brann is sexually attracted to her, in part because of her apparent amorality. In order to obtain a confession, Brann invades Eileen's house; having manipulated (either emotionally or legally) his way in he engages in a series of complex psychological power plays – ranging from barely suppressed threats to attempts of seduction – in order to break Eileen's resolve and force her into a confession. Eileen, however, retaliates by similarly engaging in these confrontations to challenge Brann's assumptions of her guilt and her anti-maternal status, as well as forcing Brann to confront his own sexual desires for her. Whereas the generic form of the *noir* thriller exposes guilt and then consolidates the narrative with a return to order, *Two Small Bodies* plays with the very notion of order and exposes the very construction of the power plays between the protagonists. Beth B stated: 'what I found interesting about it is how they . . . really beat each other down in this sadomasochistic ritual, within this sort of microcosm of the rest of the world, into this place where they start to become much more honest and see each other as human beings'. *Two Small Bodies* was screened at various film festivals, including the London Film Festival (1993), the Swiss, Locarno Film Festival (1993), the Toronto Festival of Festivals (1993) and the Sundance Film Festival (1994).

Alongside these two feature films, Beth B has also directed a series of videos which have been screened at alternative/independent screening spaces, as well as on television. This move to shooting on video was in part dictated by finance, however the move was also a response to working with the narrative structure and length of feature films. The short video/experimental films enabled B to be 'a lot more direct and hard hitting, with more brevity of time. And also [to] explore things . . . [because] in a feature film you are more bound by narrative structure. I think I was beginning to feel limited by that structure'.

In 1989 Beth B also collaborated with the artist Ida Applebroog on the video *Belladonna*. Similar to the earlier collaboration with Scott B, *Letters To Dad*, the film presents a series of talking-head shots of people making various apparently disjointed statements, such as: 'They made me out to be a monster' and 'I tried to be invisible'. These build up into a collage of phrases which, as the film progresses, begin to establish a meaning and a context. Throughout the text the phrases are regularly punctuated with a child's refrain: 'I'm not a bad person'. The video maintains an almost hypnagogic hold over the audience, as the faces of the actors and the spoken statements they make become increasingly juxtaposed and repeti-

tive. These are intercut with dreamlike architectural images and brief shots of Applebroog's paintings. As the video progresses the images of architectural landscapes mix over the speaker's faces. Finally the screen turns black and all that is left is a voice, speaking in the darkness. The closing credits contextualise the spoken phrases, excerpts from Freud's key essay on infantile desire and sadomasochism, *A Child Is Being Beaten*, the survivors of Auschwitz's Dr Mengele's 'medical' experiments and a statement by Joel Steinburg, a lawyer convicted of murdering his child in 1988. Through these texts B and Applebroog explore the construction of an oppressive power over people who are unable to escape it. This relationship occurs primarily within the family, and is manifested at its most extreme in violence towards children. This is emphasised by the repetition of the child and by the quotes of powerlessness, all of which are contextualised by the end quote from Freud's text, an essay which explains childhood fantasies within the context of a repressed desire to be punished, thus serving to normalise punishment as a sign of paternal affection. *Belladonna* was initially screened in continual projection at the Ronald Freeman Gallery, New York, before being broadcast on various television stations. It remains one of Beth B's most haunting video works to date.

Beth B directed *Stigmata* in 1991; ostensibly a documentary, the video depicts talking-head shots of various individuals describing their lives and the increasing sense of hopelessness they have felt as a result of disempowerment due to various events including familial crisis and domestic violence. As the video progresses the speakers describe their increasing dependency on drugs and consequently their servitude to the monotonous controlling rituals which demarcate addiction. Finally, the speakers describe the eventual end to their physiological addiction via an investment of power in their own lives. The recurring emphasis on talking heads facing the camera/audience gaze, which is repeated across these texts, creates a confrontation between the person who is the subject of the film and the audience. The confrontation creates a feeling of disorientation in the viewer, as the shear relentless returning gaze of the speakers demands that the audience pay attention and attempt to understand.

These short film and video pieces were an attempt by Beth B to explore new ideas, ideas which eventually lead her back to the arts. This 'return' to the arts from film was also due to B's desire to 'get back to the streets'. Like the earlier move into making and screening film at punk clubs, which was motivated by a need to reach a different audience, so by returning to the streets Beth B sought to appeal to a wider and different audience. This was due partly to a 'frustration with film', a feeling almost certainly borne out of an over-familiarity with the medium, and a desire to work within a different space, but it was also due to the 'realization that the most important thing is not the medium but the ideas I want to deal with'.

The first of Beth B's art pieces was *Surgeon General's Warning*, a series of stark propaganda style posters produced by the public arts organisation, Creative Time, in 1990. *Surgeon General's Warning* consisted of a series of bi-lingual (English and Spanish) posters concerned with contentious political issues such as AIDS, censorship, abortion, housing and racism. Fly-posted city-wide, across the whole of New York, the posters sought to disseminate raw information on a street level: 'use condoms and don't share needles', 'seek abortion information', 'homes not hell', etc. As B observes, the graphic posters 'aren't ambiguous. I was greatly influenced by John Heartfield, I think he was a genius in the way he dealt with politics and images. For me there were certain issues . . . [and] it was really important to be direct, subtlety doesn't work on New York City streets. You have to be really aggressive'. *Surgeon General's Warning* used the physical geography of New York City as a space in which to reach an audience, and thus played with the city itself as a zone of confrontation and communication. 'I used to do postering a lot when I first came here, stencils on the street, posters for film shows, but also just images', says B, 'I wanted to get back [to that] because, especially in New York, you can really reach a large number of people on the streets, that cannot be reached in galleries or museums. *Surgeon General's Warning* was getting back into that idea of reaching a large number of people'.

In a similar vein to the *Surgeon General's Warning* posters, Beth B edited and coordinated an 80-page bi-lingual tabloid-sized newspaper entitled *Day Of Hope*. Published in autumn 1992, 40,000 free copies were distributed throughout New York via vending machines, shops and street hawkers. Once again the focus of this project was the dissemination of information on the streets. The newspaper – funded by the National Endowment for the Arts – contained contributions from a diverse range of sources, including writers (Carlo McCormick, Tessa Hughes-Freeland), performers (Diamanda Galas, Annie Sprinkle), gang members (the united Cripps & Bloods) and community activists (Frank Morales, Lower East Side Needle Exchange, Eviction Watch). The paper sought to erase the differences constructed by society (us/them, black/white), instead attempting to explore, through a series of heterogeneous voices, questions of empowerment and community and suggest positive multi-cultural dialogues and 'an overall sense of hope for the future'.[6]

Simultaneous to producing the *Surgeon General's Warning* and *Day Of Hope* pieces which were designed for the zone of the city, Beth B also returned to the more specific site of the museum/gallery, producing a series of installations. The first of these, *Amnesia* (1991), consisted of a one minute video (initially commissioned by the Whitney Museum and the American Centre, Paris, and subsequently broadcast on MTV) depicting talking-heads shots of people iterating statements such as: 'they take our jobs' and 'they spread disease'. This repetition

Surgeon General's Warning, *1990, posters*

FROM ABOVE: Salvation! *1986; Carl Fudge in* Amnesia, *1992, video tape, one minute, colour*

of statements concerning an unnamed 'them' makes it explicitly clear that 'they' consist of everybody who is not 'us', and thus exposes the construction of an 'other' on whom 'our' (as both individuals and as a society) own insecurities can be focused. The film thus depicts the very fascism inherent within exclusionary/binary language itself. Alongside this short video the installation positioned pictures, including vast reproductions of posters designed by the Nazi's propaganda machine, which depict graphic derogatory images of Jews and Blacks, and are similarly engaged with the question of the creation of an 'other'. Around these stereotypical images of the racial 'other', graffiti details the horrifying list of colloquial terms used to describe each picture's constructed 'other'. The installation acts as a vivid depiction of the creation of racial hatred and the birth of fascism.

Following *Amnesia*, Beth B produced *Under Lock And Key* (1994), originally as an installation at the Wexner Centre for the Arts. The installation consisted of a freestanding structure, revealed on inspection to be four claustrophobic isolation cells fashioned from black steel and positioned in the centre of the gallery space. Each cell contains a small mail box style observation slit in the door, a drain hole, a metal slab cum bench and a bare caged light bulb. Hidden speakers in the ceiling play a tape of Jack Henry Abbott's book, *In the Belly of the Beast* (read by actor Fred Ward, who also starred in *Two Small Bodies*). The audience/visitors are invited to sit in the cold gloom of the cells and listen to Abbott's indictment of a life both created and wasted in prison. On the far wall, past the cell structure, a dual video projection depicted talking-heads shots. One image depicted an actor reading from a text culled from quotes by serial killer Ted Bundy, while the other depicted a series of five people (Nan Golden, Tomas Gaspar, Philip Horvitz, Robbie McCauley and Jerry Kearns) describing their experiences as the victims of violence (child abuse, domestic violence and 'queer bashing'). Each of these descriptions takes the form of an imaginary 'letter' to the individual's brutaliser. As each 'letter' finished so that image would fade to black, and the Ted Bundy image would begin, cutting back and forth across the two projections.[7] In this video the visitor to the gallery is asked to act as a witness to an act of empowerment; each 'letter' read out in the film by the 'victim' addressed to their tormentor/s becomes an act of catharsis and empowerment to the reader, a way by which they can return the attack on themselves. Meanwhile the cells which make up the installation enable the visitor to experience the psychological entrapment of the 'victims' and the physical confinements of those found guilty of violent crimes, thus exploring the very prisons – both literal and metaphoric – that define our daily experiences. Hence the installation serves to create a complex series of emotional responses in the visitors, as they experience the physicality and anger of entrapment articulated by the imprisoned killer on the one hand, and the fear

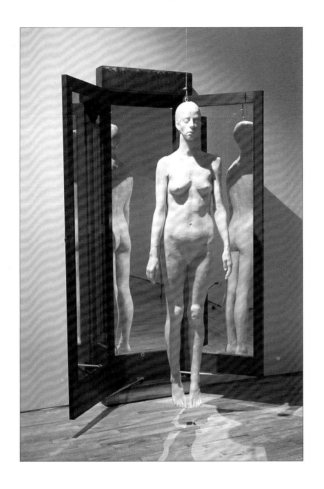
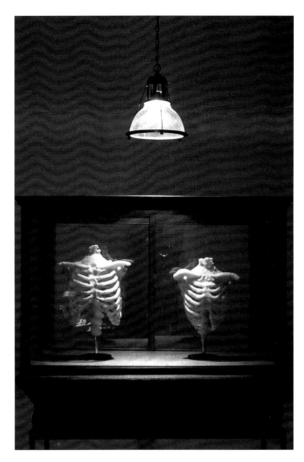
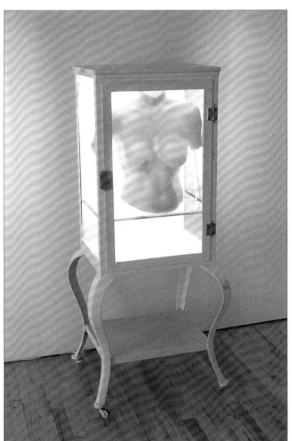

FROM ABOVE, L to R: Trophies # 7, *'Anorexia Nervosa', 1995, wax, resin, steel, wood, mirrors, dimensions variable;* Trophies # 8, *'Corseted and Normal Rib Cages', 1995, detail, wax, resin, wood, glass, steel, 177.8x127x61cm;* Trophies # 3, *'Silicone Breast Implants', 1995, wax, steel, glass, back-illuminated with halogen light, 142.3x61x43.2cm;* Trophies # 5: *'Vagina Hypertelica', 1995, wax, steel, glass, light, 162.6x51x33cm*

and anger of the 'victims' of violence on the other. The installation offers no solutions, nor does it moralise, rather it places the audience in a series of 'uncomfortable' positions and demands that they make their own judgments.

A Holy Experiment (1994) was a site-specific installation designed by Beth B at the now disused Eastern State Penitentiary, Philadelphia. This penitentiary was designed and administered by the Quakers in 1829 and at the time of its completion was viewed as the latest and most successful in a series of penal models developed by the religious order. The Quaker's believed that their 'humanitarian' philosophy which dictated austere temporal management, solitary confinement, hard work and rigorous religious instruction would lead to the convicts reforming. The regime at the Eastern State Penitentiary, while following these guidelines, also engaged with a systematic abuse of the prisoner's physiology and psychology, by confining the convicted men, savagely depriving them of human social contact and demanding that they meditate and seek God. Such an emphasis on contemplation/incarceration/reformation is still played out within the contemporary penal system.

Beth B's installation at the penitentiary consisted of a cell in which the visitors were locked, for four minutes: 'some people got totally freaked out . . . there was a panic button inside, if they got really scared they could press it and get out. Other people really liked the experience . . . to be forced into that situation, because otherwise they would not have gone in there'. Inside this cell the visitor would hear a series of religious exaltations and instructions, played on concealed tape machines. After spending a brief period locked in the cell the visitor is able to leave; in an adjoining cell they are invited to watch the incarceration cell via a monitor. If the first cell echoes the prison design introduced by the Quakers, then the second cell, designed for observation purposes, serves to remind the audience of the second 'enlightened' feature to be introduced to make prisons more 'humane': Jeremy Bentham's infamous Panopticon. The installation, in part, traces out the historical roots of the penal system, from the 19th century to the birth of the audio-visual panopticon of the modern prison. Such an engagement with the histories of the carceral institution were reiterated in B's next installation.

For B the prison has become a central metaphor, incarceration has played an important part in her work since *Black Box* and in these two installations it became increasingly explored, as did various other psychic-prisons such as fear in *Belladonna*, racism in *Amnesia*, addiction (to narcotics) in *Stigmata*, and to dogmatic religious belief in *Letters To Dad* and *Salvation!* As B states, the theme is central because:

> I think that, to varying degrees, that is the kind of society we live in: locked up. There are so many different types of prisons we live in, whether they are in our own minds and how we control our behaviour, or [whether they are] ac-

tual institutions. I just think there are so many misuses . . . of institutions like that. It comes back to the original question, which is not 'how do we get rid of these people that are so fucked up?' but 'why are these people so fucked up?' A lot of my video-tapes are about those questions: 'what is it that people are going through?' 'why is it that people have violent behaviour?' 'what is the hope?' . . . 'where is the responsibility?' It is the whole system that is set up that is very circular, as opposed to prisons which are a negative solution which doesn't work: it never looks at the source of the problem. So much starts from infancy, from childhood, to what you are exposed to, what kind of situation you are in. Prisons are political statements against certain sections of society, if you can afford an incredible lawyer you will not go to prison, if you are some poor guy on the street you are going to go to prison. It is a system that is completely unjust. It's sort of insoluble in a way, and so for me it continues to provoke questions, it is an on-going investigation.

B's most recent installation is *Out of Sight/Out of Mind* (1995) which follows on from the previous themes of incarceration. *Out Of Sight/Out Of Mind* focuses on the discourses of 'insanity', and the 'treatment' of those individuals who are deemed to be 'mentally ill', within the confines of the asylum, from its foundation in the Enlightenment to the present day media discourses concerned with questions of mental health. Once again the installation utilises a reproduction of the site of incarceration; with a construction consisting of six padded isolation cells, each terrifyingly small cell containing a two-foot-wide bed and nothing else. Inside each cell concealed tapes play readings of texts by those artists deemed to be 'insane' (and, of course, possessed by genius), Van Gogh's letters and Antonin Artaud's textual experiments. A second feature of the installation is a 'rotary machine', a device designed in the late 18th, early 19th century by Maupertuis, Darwin or Katzenstein, for asylum doctors to 'treat' mental illness. The patients would have been strapped to a suspended chair and spun, at up to one hundred revolutions per minute, in order to 'treat' their 'insanity'. In *Histoire de la Folie* (1951), Michel Foucault suggests that the device was also utilised as a form of punishment, noting that with the rotary machine's implementation, 'medicine was now content to regulate and to punish'. The final feature of the installation is a video projection, depicting various publicity stunts which could be deemed as 'crazy', edited with footage of a body plummeting into oblivion, and footage from television discussing a fourteen-year-old murderer's 'insanity' versus his 'criminality'. The political ramifications of the installation are clear despite the veneer of humanitarianism: mental health 'care' is still engaged with questions of confinement and punishment, to be anything other than healthy is to be a criminal.

Throughout all of Beth B's work, but most clearly apparent

in her installations, is the question of audience. B's work attempts – on various levels – to engage interactively with the audience. In the film work this engagement comes via the manipulation of the voyeuristic gaze in *Letters To Dad* or *Two Small Bodies*, as well as the use of painfully 'confessional' narratives in *Stigmata* and *Under Lock And Key*. In the installations this engagement comes from the direct participation of the audience who are seduced into becoming physically involved with questions of confinement and 'insanity'. As Beth states, participation demands reaction:

> if they decide to participate that's active, if they decide not to participate that's just as active. It's giving the audience a decision, they have to make a choice. I find it very exciting. But I think that participation has not been that well investigated in regards to the arts, and to give the audience the chance to make a decision, especially with *Out Of Sight/Out Of Mind*, they have the freedom to participate or not, [but] people who are in mental hospitals don't. We don't always have choice.

Simultaneous to *Out Of Sight/ Out Of Mind's* New York premier, Beth B also exhibited a series of sculptures entitled *Trophies* (initially at Manhattan's PPOW Gallery, and then chosen to be the premier exhibition at the Laurent Delaye Gallery in London). These sculptures depict – in an anatomical detail more familiarly regarded as the singular domain of medical texts – a series of multi-cultural and historical gender-specific body manipulations, designed for the purposes of 'beautifying' the female body. The 'beautification' processes described by the waxen sculptures of *Trophies* include three different – and increasingly extreme – forms of female circumcision, as well as *anorexia nervosa*, the skeletal results of 19th-century corseting techniques, Oriental foot binding, vagina hypertelica (aka Hottentot Apron), and breast implantation surgery and its potentially disastrous long term side effects (rupture, gel bleed, etc). These sculptures are displayed in a variety of ways surrounded by mirrors, in an old vending machine, and in wooden cases with brass plaques describing their contents, further emphasising a medico-scientific aesthetic. Beth B said: 'I think

it had a lot to do with me in my own body, certain things I was feeling and conflicts I was having about my own body and my representation as a woman in this society, and I think that is what inspired it, it was a very personal thing'. The sculptures which make up *Trophies* present an exploration of the construction of the female body as a site on which discourses primarily of medical technology, but also of artistic representation, continually seek to 'define' and 'know' the very 'undefinability' of the female form. This is emphasised further by the sculptures' lack of names, instead each piece is a numbered trophy, with the medical description of the work in parenthesis. B states: 'In terms of medical representation I think it's always in that context in terms of what happens to women, because they end up suffering, physically. That is what it is also about, a physical manifestation of a concept of beauty, but it ends up having medical repercussions. It is the medical side of it in the exhibition [which] represents the paternal establishment'.

Through tracing the mechanisms of power as it affects daily existence, and exposing its workings through the oppressive institutions and discourses of confinement, punishment and discipline, Beth B has created a series of works across a variety of media which are the beginning of a potentially vast genealogical 'cratology'. By exploring our own abilities to master power, and to survive, her work recognises the possibilities inherent in all of us to gain a measure of control over our existences. By consciously engaging in various forms of media, B is able to reach audiences as massive as the population of New York and as specific as the visitors to an installation, yet each perspective member of an audience who is able to experience her work will emerge stimulated into thought (be it positive or negative) by her probing political questions. Finally, for Beth B the work provides a forum for her to explore her own ideas and her own struggles, and disseminate ideas and histories, both general and specific, to a variety of audiences: 'I feel like, at this point in my life, I don't want to have the limitations of the medium, [I want] to be able to travel between film and art and whatever else I have in here'.

Notes

1 Beth B was interviewed specifically for this paper in January 1996 and consulted regarding the finished text. Other citations attributed to Beth B, unless otherwise noted, come from an interview conducted with her in December 1994 and subsequently used in *Deathtripping: The Cinema of Transgression* (Creation Books, 1995) and personal conversations conducted in February 1996.

2 Smith, Lesley, 'The Film: Two Small/Bodies, the Filmmaker: Beth B', *Visions Magazine*, Fall 1993.

3 Lunch became something of a 'star' in the 'para punk' film movement of the 70s and punk-influenced The Cinema of Transgression 'movement' of the 80s, and appeared in many key cinematic texts.

4 Jack Smith is best known for his 1963 celluloid celebration of heterogeneous sexualities and multiple gender possibilities, *Flaming Creatures*, which was famously seized by law enforcement officers and subsequently became something of an underground *cause célèbre* in the 60s.

5 The film version of *The Offenders*, which runs at 80 minutes, is an edit from the longer serial.

6 *A Day Of Hope*, Press Release.

7 A single image edit of this video also exists, with fade outs between each of the victims of violence cutting to the Ted Bundy text.

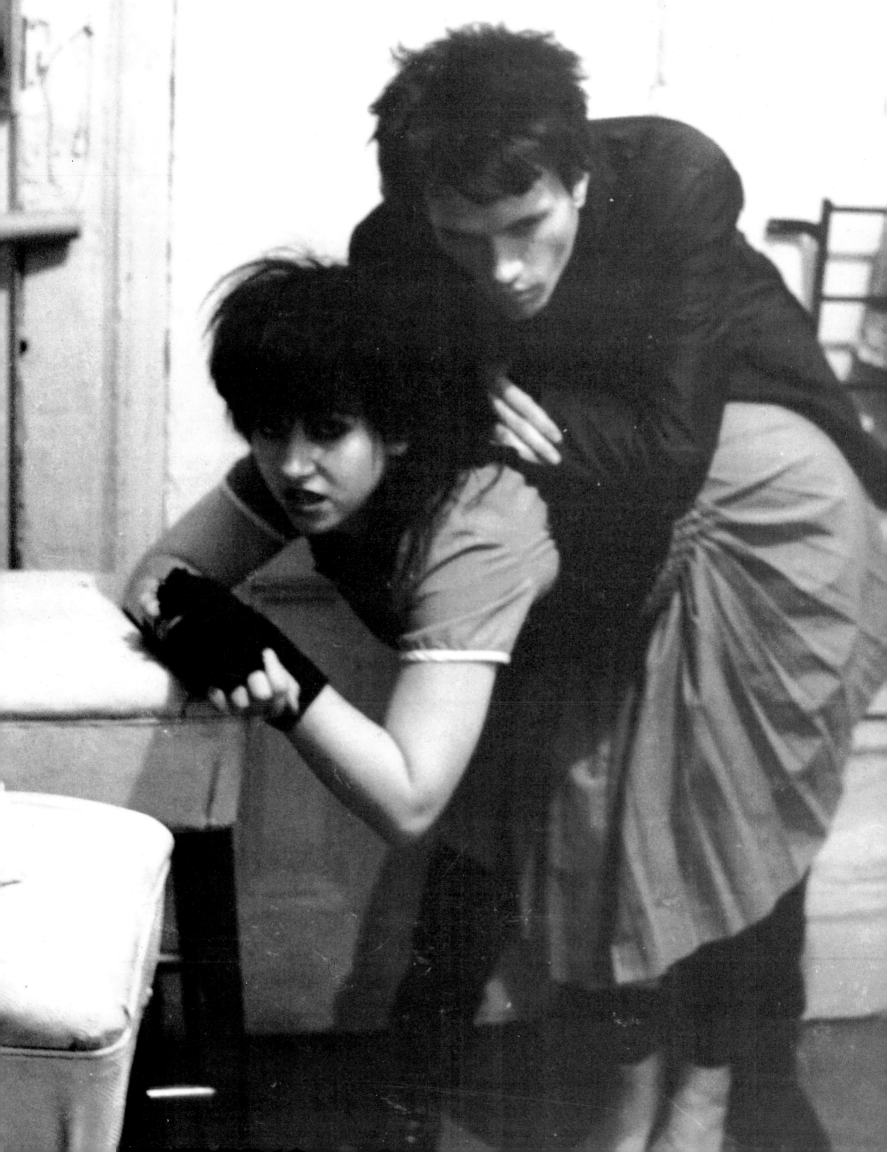

NICK ZEDD
LIVING/PERFORMING/FILMING TRANSGRESSION
An interview with Nicholas Zurbrugg

Nicholas Zurbrugg: Could I begin by asking you how you began making films? What sort of landmarks did you have – were there any particular artists who provoked your work in any way, or was it more of a reaction to a particular situation?

Nick Zedd: I started making films when I was 12 years old for fun and to tell stories – I wasn't influenced by anyone because nobody else was making movies that I knew. My father had a movie camera, so I'd shoot movies with my friends. When I was 14 I did a couple of science fiction movies. Then I went to New York and did this movie called *They Eat Scum* in 1979. This was the same time that Beth and Scott B were shooting and I remember being pleased that there were other filmmakers shooting films in super-8; I was glad they were showing these movies in an environment like Max's Kansas City, a rock-n-roll place with a bar, instead of a museum or a regular movie theatre. It seemed like it had more validity because it was more threatening, more of a risk and was being seen by people who wouldn't necessarily be art aficionados; it was reaching more of a general audience.

Then I showed *They Eat Scum* at Max's Kansas City. It was interesting because there was a critic at the *Village Voice* who did a big article on these other super-8 filmmakers, which came out before my movie was completed, and basically this writer decided to lump all these filmmakers together and call them 'para-punk cinema'. I thought this was a very arbitrary label to try and corral a bunch of filmmakers who didn't really have much in common. I was completely excluded and at that point realised the arbitrary nature of the way the media define movements and trends in general and I felt I did not want to be a victim of the censorship of omission that occurs when journalists decide they will make history. I felt I could make history, so I formulated this concept of 'The Cinema of Transgression' but I knew it was premature to use that term in 1979 because there were no other filmmakers who were making transgressive film. I believed that *They Eat Scum* was transgressive but I thought the films of other filmmakers like Eric Mitchell and the Bs were derivative of the 60s – I felt there was a generation gap between my state of mind and theirs. I waited until 1984 when Richard Kern and Tommy Traitor started making films – I wanted to see if they would produce anything significant enough to warrant the announcement of 'The Cinema of Transgression' which I then did in 1985 when I put out *The Underground Film Bulletin* using pseudonyms from 1984-85; that was when it was publicly announced.

Zurbrugg: What did you find insufficiently transgressive in what was going on? Did you find Warhol unsatisfactory?

Zedd: No, I always enjoyed Andy Warhol's films, especially the ones with Paul Morrisey. But I felt that the elements could be integrated in a more powerful way, in a more confrontational manner, that they could be more succinct in a different style. I think the music of punk rock and No Wave had some kind of influence – the songs are really short and direct and loud, and that's the way the films, I thought, should be.

Zurbrugg: Were there any other artists or performance artists that you thought managed to work with that kind of transgressive energy and impact? Did you find other allies elsewhere, if not in film-making?

Zedd: Yes, GG Allin, who else? I was also impressed with Diamanda Galas.

Zurbrugg: What did you like about Galas's work in particular?

Zedd: The effect it had on my bowels!

Zurbrugg: A gut-reaction?

Zedd: Yes, I was impressed. She'd start the music, and I'd have to run to the bathroom and take a shit, I don't know why.

Zurbrugg: Presumably you're not just trying to create shit-art? Do you want to affect the bowels of your audience, or worse?

Zedd: It's always nice to get a surprising response. I mean, I make my movies for myself really, to astonish myself. I cry sometimes, when I see my own films, or laugh. I like to get an emotional response from the audience. Sometimes it appears to be indifference, so maybe that's shock or silence. I'm not that concerned with the audience really – I do it to please myself. But I do think it's like a performance when I screen these movies – I don't want the audience really to notice me, but usually there are so many technical problems that I'm always moving around. I try to give the projectionists help because I don't think they know what they're doing usually.

Zurbrugg: So there's a sort of performance going on behind the projector?

Zedd: Yes, perhaps like a DJ.

Zurbrugg: Have you done performance art? Do your films overlap with performance?

Zedd: I used to do expanded cinema performances. I did one called *Me Minus You* in which I used this movie that I did with Richard Kern (*Thrust in Me*) as a dream sequence. At the time, in 1985, I had very little money, I couldn't afford to buy film and shoot anything, so I thought I'd write this thing and perform it live – it'd be like a live movie. So I did that, and then I used this movie that I made with Richard Kern. We made it together and shared the financing of it – it didn't cost that much because it was a short film. I put that on maybe five times at different locations with different people. Tommy Traitor was one of the actors in it with me – I performed in drag as the lead female role. In 1985 I also did something called *She* which was a performance thing I wrote with Lydia Lunch – well, I don't call them performances, I call them ordeals – it was an ordeal that I wrote with her. She originally performed it on TV in Holland and I did it at the Downtown Film Festival with Richard Hell narrating it and me performing it on stage. I also did it once in a place called the Limbo Theatre where the smoke machine went out of control and filled up the theatre forcing the audience to run out onto the street – that was nice.

Zurbrugg: What was this 'ordeal'? Could you tell me a little more about this performance?

Zedd: It was a really excessive kind of monologue praising this woman – it was based on my feelings of adoration for Lydia at the time, because I was in love with her. I guess I loved her more than any other woman and put these feelings into words, and then she modified it. It was pretty much like a 50-50 collaboration – she had a very high opinion of herself so it pleased her immensely to receive this thing. At the end of it the guy is so obsessed with this creature that he wants to stab her and devour her completely.

Zurbrugg: What was Lydia Lunch's component of the ordeal – what did her protagonist say or do?

Zedd: In the original performance she's on a bed, writhing around and squealing while one guy's going on about how he'd like to nail her palms – like crucify her – to the bed, and then the guy comes with a knife and attacks her and then the lights go out and there's silence – that was it.

Zurbrugg: Did this kind of performance differ from the effects you were trying to achieve in your films?

Zedd: Yes, it was different – I mean, I noticed that in live performances such as *Me Minus You,* especially the original one which was done at The Pyramid with Rick Strange, who has changed his name to Eric Prior and is now a TV evangelist, but who back then was just like a maniac. He played the lead character. He showed up drunk and didn't remember any of his lines; I handed him the script on stage and he ripped it up, you know, on stage, and then it became an improvisation. I knew my lines pretty much, and Bunny Atlanta had the script

right in front of her face; meanwhile, Rick was ripping up the set and I got so mad at him that I threw him off the stage. He didn't get mad though, he always admired me, and I admired him in a way because I felt he really epitomised transgression. He had no morals, he was like both good and evil at the same time. Everybody I knew hated him and wouldn't talk to him, except for his girlfriend who was this spaced-out hippy. We then went backstage and he went upstairs during the screening of the dream sequence of *Thrust In Me*, looking for his knife – for this bonehandled knife that he had lost by the stage. He was going through the audience saying, 'Who the fuck stole my knife? Which one of you motherfuckers stole my knife?' which was very intimidating for the audience. That wasn't scripted, but I was pleased that it occurred.

Zurbrugg: What did he want to do with this knife?

Zedd: I don't know – maybe he wanted to kill me with it? Maybe he just thought he needed it to defend himself against the audience – I don't know – although the audience wasn't really hostile. They were sort of bemused up to that point, but when he started looking for the knife I think they became alarmed and started to complain to the bouncers. So I'm backstage and somehow he ended up backstage with me, and the bouncers came in and said 'You have to leave', and he said 'Fuck you, niggers' – he was just a maniac, he didn't respect anybody's feelings – so the bouncers physically carried him out and threw him out on the street. The audience, exiting the performance, had to confront Rick on the sidewalk, standing right outside the front door, saying 'Where's my fucking knife, man?' By then his shirt was off and he was dead drunk but he told me someone came up to him and said 'Excuse me, are you Nick Zedd, can I get your autograph?' He gave it to them. When I came out afterwards he was terrified I was going to kill him for ruining *Me Minus You*, but I was very pleased. It was great – there was total chaos, the whole thing deconstructed before my very eyes in a really amusing way, and nobody got hurt, so that was OK. Maybe some people's feelings were hurt, like the bouncers, but they're used to being called names and pushing people around.

Zurbrugg: Have you also collaborated with Lydia Lunch in films as well as in performance?

Zedd: Yes, I made one movie with her, *The Wild World of Lydia Lunch*. She's really good at portraying strength and resistance to authority. In this movie it's like two opposite poles – like magnets that repel each other. She was trying hard not to co-operate with the movie because she didn't know why I was shooting it. I had this taped narration of her telling me about her feelings when she went to England which I only heard in New York after I had shot the film in England and Ireland. When I heard the tape, which was of letters she'd dictated into a tape-recorder expressing her feelings of confusion about

the state of our relationship at that time, I felt it would be a really good narration for the movie. I also used music – with the lyrics taken out – from an album she was working on which I think reflected both our states of mind at the time.

Zurbrugg: So there are three levels: the backing track of the album, her correspondence on tape and then your images.
Zedd: Right. The images are of her wandering around in London and in the countryside in Ireland by some burned out castles with sheep – it's like a portrait you know.

Zurbrugg: What general effect were you looking for in that film? Was it a different sort of effect to *Police State*, *Whoregasm*, *War is Menstrual Envy* and *Son of a Whore* aka *Smiling Faces Tell Lies* – the films you showed last night?
Zedd: Yes, totally different. It was more like a portrait, a moving portrait of someone I was in love with. I never did another movie like that. I'm not very romantic, I don't think that's very good for your self-preservation. I've had different motives for each one of the films.

Zurbrugg: What was the motive for *Police State*?
Zedd: Revenge against the police. The thing is I found great humour in the interactions that occurred when the police tried to harass and intimidate me – there'd be real humour there.

Zurbrugg: Were you often intimidated by the police?
Zedd: Well, I wasn't – I was supposed to be, I know they were trying to scare me but it was so funny, the conversations we would have, it was give and take but then at some point they made it really clear that if I kept joking like that I was going to get the shit beaten out of me. At that point I always was mad because I felt, 'Why does their sense of humour just suddenly disappear?' Because their intelligence wasn't up to my level, and they couldn't win a verbal battle, they had to resort to twisting the handcuffs, and saying 'OK, your wrists are going to break now – is that funny?' and that really angered me. And I felt, 'Well, the humour is there, I remember the dialogue, I'll make a movie about that. What would happen if the guy wasn't even afraid of getting hurt and he just kept insulting the cops right back, how far would it go?'

Zurbrugg: In a way that's another sort of risk performance, almost like a kind of dangerous Fluxus piece along the lines, 'Argue with a cop, and just keep going'.
Zedd: Yes. One time I was modelling in an art class on Statten Island (I had a room mate that made a living doing that) and I thought that there were going to be repressed kids – art in the suburbs – but they were OK. I was sitting there naked, nobody was giggling or acting silly or stupid, they were doing the drawings, the teacher was OK, I got paid, walked down the hall, I'd done my job, and some asshole fucking teacher came

out and said 'Where's your hall pass?' So I said, 'I don't need a hall pass, I'm not a student here', and kept walking. 'Wait just a minute you're breaking the rules.' 'I'm like 28 years old, so why do I need a hall pass?' She chased me down the hall and said: 'You come right back here'. 'Fuck you, I'm going home.' I'm walking out the door, and she gets a cop – they had a cop on duty in the high school, who comes and grabs me, chases me into the office, handcuffs me, takes everything out of my pockets in front of these secretaries who're looking the other way as if nothing's happening, and I'm being threatened with arrest and bodily injury, just because I didn't recognise this petty authority. It was then that I realised I was in a Police State. The cop was threatening to break my wrist if I didn't stop joking around with him – I stopped joking around. At some point you have to stop smiling and pretend you're intimidated, otherwise you get hurt, so they let me loose and that was one of the incidents that made me want to do this movie. Another was the time 20 cops descended upon us after Rick Strange broke a window on a newstand with a chainsaw.

Zurbrugg: I haven't heard these kinds of accounts of police intimidation from the other New York poets I've met, though I recall that in *Burroughs: The Movie*, Burroughs describes the way in which he carries about eight different weapons.
Zedd: That's good.

Zurbrugg: Although he also unexpectedly adds that he hopes he doesn't have to use them, because 'I don't like violence'.
Zedd: I hate violence.

Zurbrugg: You hate violence? Surely there are a lot of violent images in your films?
Zedd: I hate violence in real life, but I enjoy fake violence – I really enjoy professional wrestling. But in real life I need to get some better weapons, I guess, because the last time I got into a fight in the subway, I pulled the Mace out and shot the guy with it, and it had no effect at all. This stranger was making an observation about the tightness of the dress of the girl I was with, I felt it was insulting, I didn't like his attitude and so slammed a subway car door on him and got into a big fight. It was interesting though – the train was moving and these passengers were sitting there, trying to dodge us as we bounced around the car. The guy was trying to demonstrate these kung fu moves but didn't know what he's doing – he'd seen them in a movie – he was trying to do this kick and missed and I said 'You missed that time' – that was somewhat amusing. Neither one of us got hurt that much, maybe a bruise here or there, and meanwhile his scrawny crack-junkie girlfriend stood there saying, 'Leave him alone motherfucker! We're calling the cops on you!' plus my girlfriend was saying 'Nick, stop, stop, it's not worth it! It's not worth it!' and people in the car were saying 'Don't use the Mace! Use your fists, man!' It was scary and

funny at the same time, but not that funny – I felt I was too old to be doing those sorts of things. Shortly after that I got a car, I think it's maybe a better form of transportation for me.

Zurbrugg: Returning to the images in your films, could we discuss your most recent film, *Son of a Whore* aka *Smiling Faces Tell Lies*, in which you've got the quite disturbing juxtaposition of a scene from an operation and a scene I think from a building site and a subway.

Zedd: That film is also a union of opposites because it's two movies that have nothing to do with each other being run simultaneously. I first worked on the section on the right as a dance movie for Emma Diamond, an English dancer. It's been called a structuralist film. I'm pleased with the way I showed the subway train cutting into itself – it's two shots of the subway train, but I cut it in such a way that you get this real conflict and visual assault. That particular sequence is beautiful. It's also very metallic, sharp and urban. And then on the left I contrasted this with homosexual pornography and open-chest surgery.

Zurbrugg: That reminds me a bit of some of John Giorno's poems, when he's got two columns of simultaneous or inter-weaving narrative – rapid collages of different registers or materials. Are you consciously trying to present something that the audience can't look at? I found myself very reluctant to look at the surgery, though at the risk of being very simplistic, I suppose one might argue that it wouldn't be too difficult to plan or predict this kind of perceptual contrast – a shot of intestines here, or a shot from a baked bean factory there, as it were, though this is obviously easier said than done. All the same, do you find it entirely satisfying working with such conflicting images? And is this becoming increasingly difficult – do you find that once you've done that, the next step's going to be even harder – to find something even more chilling, even more pornographic, even more mechanical?

Zedd: That's the challenge, to always go further. I mean, I want people to be less timid, I want people to look right at what's happening. I think the next step is to go beneath the surface of the bodies, beyond pornography, into internal organs. I met a forensic pathologist in a bar and he gave me his number. He said he does autopsies and that I could shoot the corpses. I'm hoping that maybe I'll be able to shoot the whole corpse – I think it's arbitrary that only the outside of the body is seen as erogenous. Maybe people will be turned on by internal organs.

Zurbrugg: Presumably you don't want to encourage the disembowelment of casual victims?

Zedd: No, no. It's just that it's going on all over the world so much and people don't really consider this. When there's war, you know, this is what happens – people's insides come out

and there's all this destruction of bodies. I think if people were more aware of that they would not support this government's policies. What bothers me is that someone like Colin Powell is seen as a viable presidential candidate when he's a war criminal. It would have been a positive step having a black president but I think it's negated by the fact that he is a war criminal. Also, I think Clinton should be impeached for the Waco massacre. If they'd had cameras there showing those people – those children – burning to death, the American people would have been so shocked and horrified that Clinton would've been impeached. But of course the government is very good at covering up their atrocities.

Zurbrugg: Have you been tempted to make explicit exposé movies with that sort of footage? It strikes me, from what you're saying, that if you're making analogies to ongoing contemporary atrocities, you might be misinterpreted as someone who's simply pushing their snout into the trough of pornography and then encouraging others to do that in rather a prurient manner.

Zedd: I'm a mirror, I'm reflecting life in the 20th century. I'm just not shying away from it. It's what Goya did.

Zurbrugg: Do you want your work to have an explicit critical edge, or do you think there's an implicit critical edge to your work? For example, I think Goya's *18th October, 1808* has been discussed as being a more forceful portrayal of the horror of this event than Manet's evocation of such executions. Are issues of critical realism something that's on your mind?

Zedd: Maybe Hieronymous Bosch is closer to what I do.

Zurbrugg: I was thinking that when I was watching your films last night, that maybe this guy is a kind of contemporary Bosch. But do you feel that you're sufficiently Boschish or Goyaish?

Zedd: I'm sufficiently Zeddish.

Zurbrugg: I suppose what I'm trying to phrase are questions about the relationship between the intensity of images, the ambiguity of images and the clarity or quality of critical vision in your work. Do you think your recent work has to some extent moved away from the explicitly or overtly critical vision of *Police State*, which seems a fairly accessible piece of obvious satire? Does it worry you at all that some of the other films may not be as explicably critical?

Zedd: No. I mean, ambiguity has strengths too. There are different levels of interpretation that occur and it can be more thought-provoking for people to try to decipher the meaning. I don't want to have to lower myself to the lowest common denominator and pander to a general audience. I think it's more fascinating when there's mystery involved.

Zurbrugg: Yes, that's what Robert Wilson says about his work. He says that he rehearses a production and if it seems too

clear he re-orchestrates it in order to allow a sense of haunting mystery to remain with the audience. Does it worry you that your work might also be misinterpreted as simply offering a heady mixture of violence, sex and shock effects?

Zedd: There'll always be misinterpretation. And if there wasn't any misinterpretation it would be propaganda, and I'm not going to make propaganda – I am against that.

Zurbrugg: What about the distribution of the work, is that a problem or an annoyance? Has it ever been shown on TV or been given mainstream distribution?

Zedd: I think in the future maybe my movies will be on regular television. Who knows? I mean, I did predict that this critical recognition would occur in ten years, but then I thought, 'It's not going to happen', after being ignored for so long. And then this book – Jack Sargeant's *Death Tripping: The Cinema of Transgression* – comes out! So I now see it as possible that my movies could end up on normal television, even though it seems strange that it would ever occur. What surprised me about this book was that I thought they would get it all wrong, but I think it is pretty close to what my original vision was. Maybe Jack's very good at paraphrasing my concepts!

Zurbrugg: Are you surprised that it's an English critic who's written this book?

Zedd: I don't know, I think I am. I wasn't sure whether recognition would come from Europe or from America first. I'm still pretty much ignored in America.

Zurbrugg: Presumably this leads to distribution difficulties and increases the difficulties of financing new work.

Zedd: Right. I had an investor on my last big film, *War is Menstrual Envy,* but that investor is now unable to give me more money.

Zurbrugg: Do you find it difficult to get into an editing-suite among other things?

Zedd: Yes! Sometimes I'm lucky and I can get in there for free if I know somebody, like in Sweden when I did *Whoregasm* on tape. I was invited to show movies in Gothenberg and while I was there Radium wanted to put out a tape of *Whoregasm* and *Police State* and got me access to a studio.

Zurbrugg: You edited *Whoregasm* there?

Zedd: Yes, the right and left sides into one screen, going in and out.

Zurbrugg: John Giorno told me he had plans to release *Whoregasm* on his Giorno Videopaks, but I don't think that's happened has it?

Zedd: No, I'm wondering what happened to that, it never came out. I guess maybe he's busy with people dying of AIDS – he has an organisation that gives cash to people with AIDS. That's probably more important to him than putting out this tape.

Zurbrugg: Are you still doing performance work in addition to film, and does performance still feed into your films? Or again, does film feed into performance?

Zedd: Yes, my last film did. The right side of *Son of a Whore* aka *Smiling Faces Tell Lies* was originally presented under the title *Lock Stock and Barrel*, in a performance by Emma Diamond at St Mark's Church. It was projected onto the rear of the Church – onto the curve of the wall. It was really big with the girls dancing in front of it. I would like to do it with nude dancers though. Actually I was thinking I would really like to project my movies onto animals like an elephant or a warthog. I'd get a bunch of little animals and project my movies onto them, that would be really nice.

Zurbrugg: Do you envisage these things continuing?

Zedd: Yes, they evolve, change.

Zurbrugg: Do you have any new major directions?

Zedd: Completing the novel I've been writing. I'm sure that'll be done by next year.

Zurbrugg: What's that novel?

Zedd: Its tentative title is *No Guilt . . .* it's . . . I can't reveal what it's about.

Zurbrugg: It's interesting – you said that one of your collaborators, Rick Strange, had no morals, and there's the title *No Guilt.* To what extent are you an amoralist? It's a big question which none of us can answer, but would you say that your vision is that of a moralist or an amoralist?

Zedd: I think morality is a human invention. I think it's unnecessary, it's a value system imposed by another authority but I have a sense of ethics – I don't believe the strong should hurt the weak. I think the smart should take from the strong.

Zurbrugg: In a nutshell, perhaps, what do you think you want your art to do, ultimately?

Zedd: That's not for me to say.

Zurbrugg: I'm wondering whether you see yourself more as an *agent provocateur* or whether you have the kind of agenda evoked, say, by Meredith Monk, who's in another area altogether, who says she wants to create visions of harmony or some version of balance, whereas Burroughs might say he wants to make people think or rethink. I wonder whether you had any particular preferences – or maybe several all at once?

Zedd: I resist putting it into words. I think putting it into words limits it. To know the answer, you have to watch my movies.

London, 10th November 1995

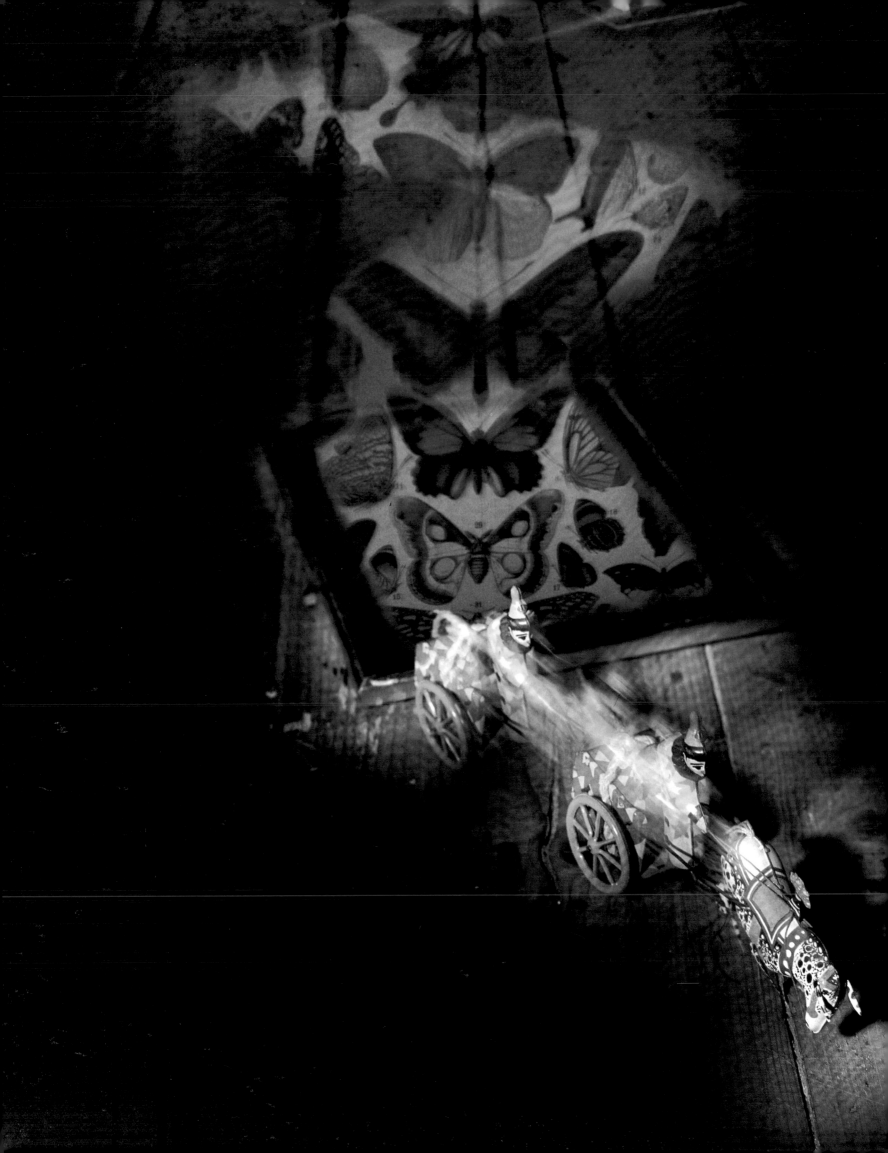

ALAIN FLEISCHER
FABRICATING THE VISIBLE
An interview with Amanda Crabtree

Alain Fleischer is in turn and for a time, a novelist, a film-maker, a photographer . . . but each of these practices is not forgetful of what has been learnt from the other.

A mixed background of cultural influences, a Hungarian father, a half-French, half-Spanish mother enabled him to acquire early a sense of nomadism among languages which is why he lives in two countries and two cities and perhaps explains his capacity to go from one artistic practice to another, from literature to photography, photography to the cinema, the cinema to the visual arts . . . Alain Fleischer likes to explain that as a child he wanted to be an explorer and this tendency to have a foot in several camps has enabled him to investigate a wide range of artistic terrains but he insists that each idea springs to life from a certain practice, inside its field and vocabulary: 'The cinema immediately struck me as the most complete, direct language there is, the language that offered me the broadest possibilities for exploration and inventions'. A chance meeting with the French artist Christian Boltanski introduced him to the idea that there were no limits between the cinema practised freely beyond the commercial network and art. Alain Fleischer has never limited himself to imposed constraints and has always avoided being classified. Artist, photographer, filmmaker, he plays on his identity as a means of escaping specialisation. Gaining recognition as a photographer by the photographers and a filmmaker by the filmmakers has permitted him to push the game further and his relationship with these practices becomes simply a relationship of illusion of identity.

The abundance of production which characterises Alain Fleischer is simply a consequence of this attitude. Exhausting an idea only comes from an accumulation of attempts. There are no limits to his explorations and he never limits himself to a tool, a media, a register. But in spite of this Alain Fleischer is an artist who, with different techniques, has followed a single, unique quest. There is a unity, a coherence to be found in his treatment of the representation of time and movement, the essential motives of these images which play on the vocabulary of photography and cinema. Perhaps most important of all is his use of the mirror in its capacity to reflect the world and the elements that entice him, the way it deals with the subject, the space around the subject and the space facing the subject which is the position of the spectator.

Games, mirrors and projections are the reoccurring devices explored simultaneously by Fleischer. Photography, un-like painting, is an image that can appear by projection anywhere since anything can make a screen. This is demonstrated in his installations from 1980 onwards, with film projections or photographs and different systems for circulation, fragmenting and redistributing images often within the obscurity of the museum anti-space, which is his imaginary space.

Alain Fleischer fabricates the visible, he does not record it and in this renders tribute to the magic powers of photography, its uncertain status, its fragility; a way of revealing an invisible world but a world condemned to disappear.

In this, Fleischer is at the heart of film. A recent series of photographs *Film cuts*, 1995 ('Raccords cinématographiques') reveals where the film moves from one shot to another, the join, the seam, the link. Something is lost for the film to continue. If the film is well made, it is a place that is not seen, an abyss in the continuity of the visible.

Alain Fleischer: I am not sure anymore if my interest in photography and then in film came from my fascination for the objects which enable us to capture pictures and reproduce them: the camera and the cine camera which, when I discovered them (at about the age of eight for one and twelve for the other), were like mega-toys to me, more sophisticated, more mysterious than the others; or if, on the contrary, it was the desire to make pictures that attracted me to these objects, to these toys. What I am sure of is that in the practice of photography and cinema, the relationship between these objects, these machines for taking views, is very strong. In a way it is enough to acquire a camera in order to have access to the possibility of making images and in order to become a photographer or a filmmaker; therefore, even if it is naive, I think there is something true in the attitude of the amateur who thinks that it is enough to buy adequate equipment to take photos or make films. However, owning equipment, even of professional quality, is not enough and technical know-how is no guarantee of artistic capacity – far from it. But using the equipment is a necessary condition. You have to start by using a camera to take a photograph or to make a film, even if the photo or film starts as an idea. What I noticed immediately and what I wanted to make the most of straight away, is that cameras are magic and infer special powers on those who own them and know how to use them – particularly the power to arrange stage and light objects, scenery and people. A camera gives the right (or the pretext) to say to a young woman:

'I would very much like to photograph you nude' (this is just an example, you understand!). With this magic equipment – that can be compared, on another level, to a car with its power of enclosing, carrying away, transporting – photography and then film seemed to me less a means of recording the visible reality, than a way of making visible what was not visible to the naked eye; inventing, producing images (and thus the situations to realise these images), making a mental vision, one of desire, producing the visible which at first, is only present in the imagination, like a dream.

Amanda Crabtree: How can one make visible what is not visible to the naked eye?

AF: Let me tell you an anecdote: a school friend, the son of a camera-wholesaler, taught me the rudiments of taking pictures and laboratory techniques. One day he said that his father had just received a new type of film which was sensitive to infra-red light and enabled one to photograph through nylon garments. So we experimented with the film in question on one of my friend's cousins whom we convinced to pose in her nightdress, and on the swimmers in bathing costumes at our local swimming pool. The results were quite convincing and I consider these photographs my first nudes . . . This is perhaps rather a simple and crude way of illustrating what I mean by 'seeing what is not visible to the naked eye'! I was only twelve at the time but it was a decisive step as far as my relationship with photography was concerned. Since then I have invented other ways of achieving this end, and the ends themselves, without denying their origins, have also evolved.

AC: At what point did you start becoming interested in film?

AF: The move from photography to film took place in London where, as an adolescent, I learnt English, and where I swapped the old Rolleicord that my father had given me for a little Bell & Howell camera that I'd found in an area not far from Soho where all the second hand camera dealers were. I then discovered that unlike the photographer who never leaves his pictures from taking them to printing them, the filmmaker must separate himself from the pictures he has taken and send them to film laboratories where he has no access. When I was making my first films and at the same time discovering those of the great masters (Fritz Lang, Eric Von Stroheim, Carl Dreyer, Josef von Sternberg, Ingmar Bergman and so on), I spent a few Sundays of my adolescence on cycle expeditions in the Parisian suburbs where the big film laboratories were hidden amongst the metal and chemical factories. There, a long way away from the sun lamps and the glitter, the cinema is an industry like any other. And in front of the closed gates where sometimes a production van would arrive loaded with negatives to be developed, I would dream of pictures filmed far from there, in the most beautiful cities in the world or in the middle of the virgin forest, with famous actors and actresses,

pictures which had wound their way there to the depressing suburbs, filmed during the day and revealed at night. Through a ventilation grid or some open window of these laboratory castles, I sometimes caught a glimpse of a pile of round metal boxes or a developing tank. In the cinema, it is there, in the laboratory that everything ends up, that everything happens (and today it is still there, that's where the difference between film and video lies).

AC: Is this when you started to hang round film studios, waiting for your lucky break?

AF: I was less attracted to the studios and film sets because the shooting and takes were not particularly mysterious for me as I knew, at my level, what that was all about. With fewer technicians, no famous film stars, very basic lights and equipment, a shooting is always pretty much a shooting.

So I made my first films as an independent filmmaker with very little money, helped by friends and totally free regarding where I took my inspiration from and what I did with it, as opposed to industrial and commercial cinema. I first devoted myself to feature films (of one to two hours) and I was quite close, without knowing it, to the research being carried out by the American underground cinema with perhaps a specifically French theoretical superego; at this time I had started studying linguistics, semiology and anthropology at University with Claude Lévi-Strauss, Algirdas-Julien Greimas and Roland Barthes. The technical resources were minimal but the films had complex story lines and editing (*Montage IV*, 1968, black and white and colour, 100 min) inspired from literature (James Joyce, notably) with also a taste for *photography in film* (light, contrast, frame). The first films were silent or with minimal sound tracks. I was also interested in the extremely simple and direct forms, practically without style, of ethnographic films. And I made a few films of real characters I met in the street (*L'homme de 5 h 35*, 1968, 14 min) or on imaginary characters played by non-professional actors (*Le règlement*, 1967-68, 45 min). I used to film the strange behaviour of the lonely figures in the streets of Paris; their personal rituals, as if they were individuals of an unknown civilisation being studied by an anthropologist. I was more interested in the contemplative than the narrative dimension of the cinema. Certain films recounted, for example, the long, fascinated contemplation of a woman's body (*Découpage*, 1969, 90 min) or the regular observation, daily and at a fixed time, of the same Parisian street corner from the same window for 366 days (*Un an et un jour*, 1972-73, 210 min). I prefer straight anthropological films which don't deal so much with the enigmas of a civilisation but those of an individual, and for pure contemplation, free from the obligations sometimes felt as obscene in storytelling.

AC: So how did you first get interested in the world of the visual arts?

AF: My meeting with an artist, Christian Boltanski, in 1968 and my collaboration on some of his films (just as he made the scenery and the props for an important scene in my first feature film) attracted my attention towards very short films (he wanted to make film-paintings which lasted from a few seconds to two or three minutes). As I had suspected, I discovered that there were indeed other possibilities in film than that of the industrial and commercial sort and that there were obvious points in common between the cinema of the independent and 'experimental' filmmakers like me, and the cinema imagined by artists who were still called painters. This meeting was a breakthrough for both of us: Boltanski discovered that one could make films with means accessible to a non filmmaker artist and I discovered that one could make art and be an artist without either having studied at the traditional Beaux-Arts school or being a painter in the strictest sense.

Funnily enough, I met Boltanski in a cinema where I'd gone to see a Godard film and where he was installing an exhibition. And it was in this same cinema that, some time later, I was to do my first exhibition as an artist. At this point, the two worlds of cinema and art were, for me, united in the same geographical area of Paris, the 16th arrondissement; there was the Palais de Chaillot where I used to go several times a week (or several times a day) to the Cinémathèque française run by Henri Langlois and where Jean Rouch lent me his editing table installed at the Musée de l'Homme for months on end (Boltanski used to visit me there and that's where he discovered display cases full of objects from primitive civilisations which inspired several works of his); and, a few yards further down, there was the Palais de Tokyo, ARC and the Musée d'art moderne de la Ville de Paris where the best exhibitions and contemporary art events took place. It was at the Cinémathèque française that Henri Langlois personally presented my first feature film in public, in front of an audience where there were a lot of people from the cinema world.

AC: I imagine this was a decisive moment for your career as a filmmaker?

AF: I feel rather immodest in saying that in his presentation to the public Langlois compared my film both to FW Murnau and Kenneth Anger, but if I do so, it is because I really owe it to that fantastic man and because it did indeed have a very decisive effect: two or three of the most important French film producers, present in the cinema, became interested in my work and it was my first contact with their world. From then onwards, I began my career as a professional filmmaker (in 1971 I made a long fiction feature called *Les rendez-vous en forêt*), and at the same time, I began making art works and the contacts I had with the art world were to be much more enriching than those within the world of cinema.

I began to make friends with artists: Ben (the first artist I met, in 1964, and who showed one of my first exhibitions in

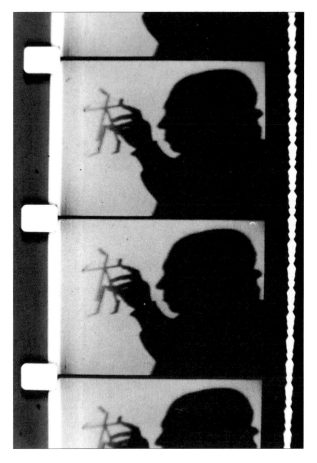

FROM ABOVE: Et pourtant, il tourne, *1980, installation, detail of the projected moving image of a record on the still turntable;* Tryptique, *1982, installation with a slide projection on a three-face mirror;* Quelques activités de Christian B, *1984, still*

51

FROM ABOVE: Le voyage du brise-glace, *1984;* Happy Days with Pernot, *1988*

Nice), Daniel Buren, Sarkis, Jean Le Gac, Jean-Pierre Bertrand, Anne and Patrick Poirier, Jochen Gerz, Claude Rutault, Annette Messager, etc. A few galleries were also reference points (Illeana Sonnabend, Eric Fabre, Alexandre Iolas, Yvon Lambert, Daniel Templon) but the most interesting events were initiated by personalities on the edge of the traditional art market, like Anka Ptaskowska and her galleries 1, 2, 3, etc, rue Campagne Première (where Jean-Paul Belmondo, shot dead, finishes his race in *A bout de souffle*), or Ida Biard and her Galerie des Locataires (of no fixed abode) and her French Window (a simple window on the ground floor of a Paris flat). The artists themselves used to intervene anywhere except in the official art market spaces: Buren with his striped posters on fences, Boltanksi in empty apartments where the keys were sent to a few hypothetical visitors, Sarkis on the Pont des Arts, Le Gac in a public park, Cadéré in all the places where he used to walk his *batons*, me inside an old car parked in the street – all that for a limited public, the permanent figures of which were Jean-Hubert Martin (who was later the Director of the Musée national d'art moderne at the Pompidou Centre) and Béatrice Parent (now curator at the ARC-Musée d'Art moderne de la Ville de Paris).

AC: When did you first start exhibiting your installations?

AF: I showed my installations for the first time in public at the International Biennial in Paris in 1980 (still at the Palais de Tokyo and in a space neighbouring the one given to Sophie Calle by the then young architect, Jean Nouvel, who had been asked to design the exhibition). Until then I had experimented with them in the studio and had shown them to friends over two or three years. They involved the projection of 16mm films onto objects, the first hijackings, the first transgressions of the classic cinema arrangement (a darkened space with a projector facing a white screen and in between, rows of seats for the spectators). A piece I have shown a lot since is called *Gone With The Wind*: the film of a young woman's face whose hair is moving slightly in the wind, was projected onto the blades of a moving ventilator which served as a screen. The ambiguity which interested me in this installation came from the uncertitude as to the origin of the movement: the movement of the hair being filmed, the movement of the screen itself, or the movement of both at once, and the relation between the wind as an image and the wind of the ventilator-screen. Another piece projected onto the still turntable, painted white, the image of a record spinning (the title was *But, It Moves*, taking up the famous 'Eppure, si muove' from Galileo). There also the result was an ambiguous object, physically present but of which the essential element, in movement, was just a film image. 'But it moves!' is what the spectators said as they touched the immobile turntable and, seeing it move, thought they could actually *feel* it move. A third installation, *The Film Projected from the Filmed Projector*, involved a film projector confronted with its

own image, filmed beforehand, the same image which it also projected: hence, face to face with its double.

Then I continued to explore different short-circuit devices between subjects and their images, between objects and their portrayal, between the materiality present of what could be compared to sculpture and the virtuality of film images. A few exhibitions enabled me to assemble, from 1981-82 onwards, a large number of film or photographic installations, the distinctive characteristic of which was that they all functioned in vast dark enclosed spaces. Hence the museum or the exhibition space was in a way disowned and effaced by the works themselves which called for the disappearance of the traditional walls. The public was surprised to enter darkened rooms, with only the lights captured on the looped films where the sound of the mechanisms of the film or slide projector motors could be heard. In these exhibitions the traditional relationship between the work of art to the museum or exhibition space was inverted: there was no longer a museum space indicating 'this is a work of contemporary art'; on the contrary, the works, to exist and be visible, threw the spaces and the museum into obscurity.

At the same time as I was turning the film projector towards surfaces other than the traditional white, neutral screen. Questioning subjects and objects submitted to the light of the projection and lit by their own filmed image, I began to get interested in the possibility of making 'moving stills', that is, works on the converging edge of photography and film. I made a number of installations where projected photographs were split up, reframed and redistributed in the space by all sorts of devices (articulated, mobile mirrors, mirrors manipulated by the public, mirrors installed in pieces of furniture, mirrors rebounding reflections from one wall to another, mirrors submerged under water, floating mirrors) which both disrupted the images and organised the way they were read, fragmented them and set them in movement, made stories from multiple, mobile images, the origin of which was a single fixed image. Simultaneously (and sometimes mainly,) I concentrated just on the cinema and made *Dehors-Dedans* in 1975 and *Zoo Zéro* in 1977, both of which were distributed in France and abroad; then, in 1982-84 *Histoire Géographie* and *L'aventure générale*, two films which are shown together as a diptych (a sort of fake-documentary and a sort of fake-fiction), which lasted for over three hours, and half-way between rather extreme cinema d'auteur and the artist film, Marguerite Duras and the Straubs on one side, Michael Snow on the other.

AC: So you were never locked inside one practice but always dealing with several issues at once. Where did this obsession with simultaneous experimentation between art and film come from?

AF: I found by experimenting with the cinematographic and photographic image, with the manipulations between the sub-

FROM ABOVE: Les voyages paralleles, *1990;* Derrière les paupières, *1989, installation, detail for the exhibition* 'Effets de miroirs', *Galerie Edouard Manet, Gennevilliers (Behind the Eyelids)*

ject and its portrayal, and in the presentation of these installations in spaces where they were not expected, an old taste for adventure. As a child I dreamt of being an explorer and consequently I have always looked to travel to new territories, sometimes at the extreme edge of disciplines and in no man's land where they brush against each other. The shooting of professional films with large crews also brought me the feeling of great collective adventures, like the expeditions of the 18th century.

As a general rule, I am only interested in art in as far as it remains an adventure (of the imagination, of the mind), which means that art without risks is for me of no interest, there are no stakes. Then when I look back, I realise that I have often questioned a specific characteristic of the images of photography and cinema: their *projectability*. Unlike painting or drawing, the images of photography and film are projectable, they can leave their original medium and travel, be transported, appear somewhere else, on any surface which can act as a screen. Hence I got a glimpse of a world lit up by images, a material reality not lit up by white light but by that of a projector, already loaded with pictures. I like showing that the cinema can fix a living being or a mobile object in its light and enclose it, a prisoner of its own image, and that photography can help the apparently imprisoned still to escape. In the end the cinema shows movement less (because it accompanies it and therefore covers it up) perhaps than photography which resists it, and gets injured in the process.

I therefore exhibited works of art in galleries and in museums and I projected films in cinemas and in film festivals. But I also projected films and introduced films into museums, and on the contrary, I sometimes presented art installations in cinemas, including the sanctuary of traditional cinema, Cannes. In May 1983, a few years after having presented my films in Cannes, I was invited to show an installation in the Palais des Festivals, where the spectators are used to the film projections of the official programme. Instead, they discovered a series of projectors installed in front of the screen and fixed onto them, projecting images which they could only see by sending them back to the screen, towards the walls or the ceiling of the cinema, with the help of little mirrors which enabled each of them to intercept and manipulate a fragment of the film, a portion of the image.

AC: You said that Boltanski wanted to make film paintings but you have also worked specifically on the film-painting theme.

AF: Another series of installations put the cinema and painting into dialogue on the one hand, and different story lines with each other on the other hand. In a piece called *L'Empire des Lumière* – meaning the Lumière brothers in this context – a 16mm film projected onto a copy of the famous painting by René Magritte *L'Empire des lumières* – here meaning lights – a moving cinematographic sky onto the fixed painting of the sky. This was a special effect which meant you could make clouds enter the frame on the right, pass in and out behind the painted tree and the roof of the house, and leave the frame from the left. Magritte had opposed the daylight sky in a night-time scene (lights at the windows and lampposts lit) and my installation linked the light of the painted image with the light of filmed images: the painting was lit by film. This installation from 1982 was presented in 1989 in Marseilles in the exhibition 'Peinture, Cinéma, Peinture', by Germain Viatte who asked me to make a fiction film on the same theme (*La nuit des toiles*, 30 min). The piece now belongs to the Cinémathèque française.

I imagined a more complex arrangement for an exhibition at the CREDAC, where three cinemas have been converted into a contemporary art space. The installation was called *Pentes Douces* (the gentle slope of the cinema towards the screen). Four film projectors grouped together in the projection room faced four different directions, projecting different films onto the lateral and far wall of the cinema hall. The images, deformed into a trapezium by the angle of projection, landed into frames of the same shape made out of the gold edging which serves to frame paintings. On each surface-screen where the images landed, a little mirror of a very specific shape and angle sent some images towards one of the other films where a scene and role was waiting for them. So there were four films with four stories in different places, each swapping their characters and visited by one another. Each film could escape from its screen towards another screen, towards another film through a sort of escape window. In the fourth film, the portion of image sent off by the mirror left freely towards an uncontaminated wall.

AC: You participated last summer at the Festival of Photography in Arles with a series of photographs and also a video film incorporating other elements . . .

AF: One evening, at the last 'Rencontres Internationales de la Photographie d'Arles', in the ancient Roman open-air theatre, I presented a piece called *Lumières Croisées*, a fiction film shot mainly in video but in which a short black and white, silent 16mm film was inserted as well as a series of projected slides. On the same screen, three projectors (video, film and slide) linked and fitted the images into the same story. The precise way in which the images were inserted and the way the public usually perceives things meant that in spite of the different textures and luminosity of the images, many spectators thought they were attending a traditional film projection.

AC: I would like to talk about another form of dialogue between art and film: your documentaries on artists, museums and collections.

AF: I had made some films very early on with Boltankski, Sarkis, Gerz, Cadéré, Devade, Klossowski, etc; later some private and public producers (in museums or in television

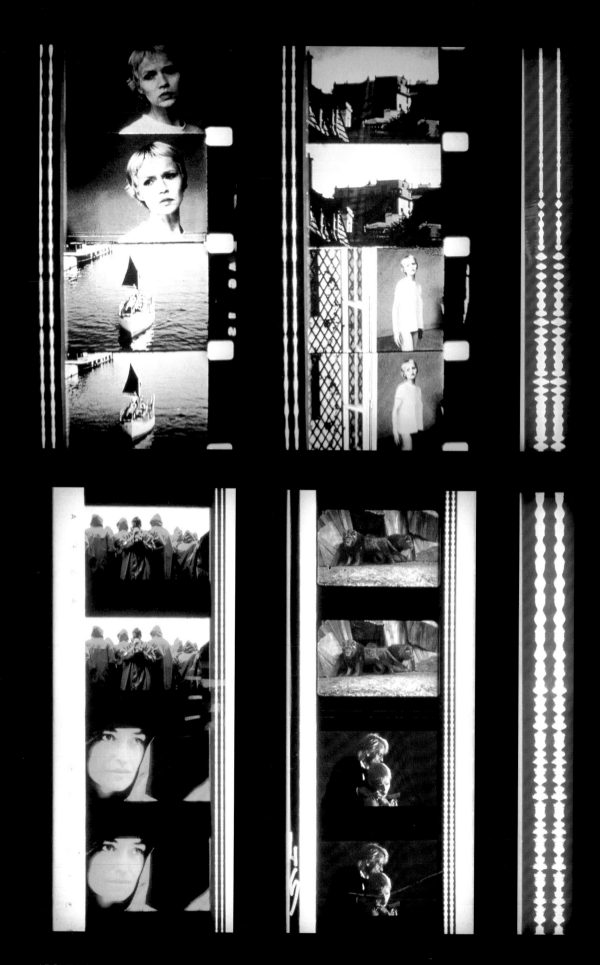

ABOVE left and centre: Film cuts, 1995 (Raccords cinématographiques) from L'aventure générale, 1982;
ABOVE right: Images du son (images of soundtracks), L'adieu (the sound of goodbye); BELOW left and
centre: Film cuts, 1995, (Raccords cinématographiques) from Zoo, Zéro, 1977; BELOW right: Images du
son (Images of soundtracks), Le rugissement du lion (the sound of a lion's roar)

companies) invited me to make documentary films, expecting a dual point of view, the double sensitivity of the filmmaker and the artist. With the film *L'art d'exposer*, (1982, 45 min) about the Musée Condé in Chantilly, commissioned by the Musée national d'art moderne, about the effect that the hanging of a collection of paintings had on the meaning of the presentation, I began a period during which I filmed a lot of museums according to different themes. For example, the Musée national d'art moderne (Pompidou Centre), when the original hanging of Pontus Hulten was replaced with an interior design conceived by Gae Aulenti, which meant the hanging of the same collection in a radically different way; or when the Louvre commissioned a feature film on the Grand Louvre for its inauguration and the celebration of the bicentenary of the museum – a very demanding film because of the stakes involved (the film was co-produced by French, American, Japanese and Italian television channels). I then made some more films with and about artists I knew: Anne and Patrick Poirer, Christian Boltanski, Daniel Buren, Jean-Jacques Lebel, as well as Daniel Cordier, a great French collector and art dealer whom I had already filmed in 1967-68.

At the moment I am working on a portrait of the writer and artist Pierre Klossowski for the France 3 television channel and for the Pompidou Centre, and a film on the Fine Arts Museum of Lille which is undergoing renovation works, during which its collection travelled the world (I filmed them at the Metropolitan Museum in New York, at the National Gallery in London, at the Nagoya Museum in Japan and in the galleries of the Grand Palais in Paris).

AC: So you stopped making fictional films ?

AF: No! I made *Rome Roméo* (1989, 90 min) which was shown in cinemas and on cable TV, *Grands artistes observés par un veilleur de nuit* (1991), which was shown on France 3 in its short 30 min version, *Niagara-on-the-tape* (1993, 30 min) which was made during a seminar I gave in a Canadian university, as a foreshadowing of the Fresnoy project.

AC: So how exactly did the Fresnoy project that you are supervising in Tourcoing come about ?

AF: In 1987, whilst I was a resident at the Villa Médicis, the Académie de France in Rome, I was asked to write a report by two people who knew my work as a filmmaker and multi-disciplinary artist, Dominique Bozo, (for whom I had already made films when he was the director of the Musée national d'art moderne) and Jack Lang, the Minister of Culture. Their idea was to entrust me with the task of imagining a new type of art school which would integrate the traditional artistic disciplines with audio-visual and new technology, taking into account current artistic developments and new horizons. I was asked to make a proposal to suit me, almost *carte blanche*, and

probably the only one which could have convinced me to return to an educational occupation, having accumulated over several years before my stay in Rome an experience in teaching, both at university (Paris III, Sorbonne Nouvelle in film theory), as well as in art schools (Nice, Cergy, near Paris), in schools of photography (Arles) and cinema (IDHEC which became the FEMIS, in Paris). These periods of teaching in different institutions were very fulfilling but they took up a lot of time and I had given what I could give.

The Fresnoy project was conceived both as an ideal reflection of my own personal background and interests and the conclusions I had come to, regarding the state of art and audio-visual training as I had known it. Out of this came a project which is unique of its type, although the ideas that I put forward in 1987-88 and made public in all sorts of circumstances and countries have inspired similar projects of a less ambitious nature which have materialised more quickly.

The artistic and teaching model of the Fresnoy is mainly based on two ideas: on the one hand, a training course for post-graduate art students based on full-scale production, with professional equipment and technical assistance, sometimes in collaboration with distributors or with different private or public partners (museums, cultural TV channels, art centres, galleries, film producers, theatre and dance companies, and so on); on the other hand, on the cross-fertilisation of all these disciplines on common territory – images and sound of all kind and on any support, that is to say the audio-visual field in the widest sense, from photography to virtual reality, from the art documentary to multi-media installations, from filmed dance to images used in theatre, from experimental cinema to architectural prefiguration in computer imagery, from art video to interactive stories on CD ROM . . . To this is added the fact that the lecturers are, in fact, well-known artists who are invited for periods of six months to a year, for a two-fold mission: the supervision and artistic management of the projects realised by the students, and the realisation of a personal project with the technical means of the Fresnoy, where the students become their assistants and collaborators.

AC: But the Fresnoy is more than a school . . .

AF: As part of the Fresnoy complex, there will be contemporary art exhibition spaces as well as two cinemas open to the public where the programme will be symbolic of the artistic and teaching concerns of the school.

Thanks to the continual support of the political and cultural authorities (at national, regional and local level), the Fresnoy will have all the technical and material means to realise its ambitions. The school which is currently being built according to my proposal (and which will open at the end of 1996) is the school that I would have like to have *done* as a student. But in that case, no doubt, I would have become another . . .

FROM ABOVE: Nose, *1993, oil on canvas, 47.5x55cm (photo Felix Tirry)*

LUC TUYMANS
CINEMA OF THE WAY THINGS ARE
David Moos

Ours is indeed an age of extremity. For we live under continual threat of two equally fearful, but seemingly opposed, destinies: unremitting banality and inconceivable terror.

Susan Sontag, *The Imagination of Disaster*, 1965

Unlike film, painting possesses in its process and modern history the prospect of an autonomous imagination out of which its image may arise. Within the recesses of a private imagination the painter may search internally for the substance of invented images. Philip Guston spoke of this method in painting, when, in a 1978 lecture, he remarked:

> To see what the mind can think and imagine, to realize it for oneself, through oneself, as concretely as possible. I think that's the most powerful and at the same time the most archaic urge . . . '[1]

For a first-generation Abstract Expressionist, such a technique of creation seems wholly within a practice of painting preoccupied with elucidating the Self as valid reflection of a larger context. Guston's emphasis upon self-investigation and realisation 'through oneself', posits painting as translucent carrier of the Self's preserve.

Flemish artist Luc Tuymans pursues painting from a different vantage point. He has referred to his work as 'authentic forgeries', indicating an approach that neither privileges the belief in originality nor, apparently, upholds overt claims to essentialist doctrines of the Self. Tuymans is preoccupied with showing the world as it is, a project different from painting the world as it appears. His painting depicts objects, rooms, people, landscapes – parts of the world – but in a manner which deliberately impedes or hampers direct access to these chosen subjects. Obfuscation, however, is not a trope his painting employs; there is no deliberate marring of material or postmodern eclipse of the subject. Rather, Tuymans is concerned with articulation; with an emblematic focusing of details which enunciate a specific view of reality. If the self appears in his work, then it resides along an elusive surface, alighting in brushstrokes that dart furtively with a diffident remove from their subject.

A painting entitled *Nose*, from 1993, for example, presents a canvas almost entirely covered in a near-monochromatic flesh-tone. Only a faint shadow of the nose's contour appears along the left side, descending to the grey geometric forms of the nostrils. These forms appear as a triangle, and, along the bottom centre of the canvas edge, a curving grey arc. At first

view, we are challenged to decode this sparse image as a nose. Tuymans has scaled his image exactly to the height of the canvas, thus cropping the nostrils or any of the face's surrounding features. Such sharp closure on the image relates to the film screen; explicitly, in rhetoricised terms, to cinema's ability to achieve close-up images of the face.

The close-up in film serves direct narratological purposes. It is used to arrest attention, or employed as a device to amplify emotive ends. With regard to the face, the eyes most often receive treatment in close-up. 'The enormous eyes on the screen', film theorist Charles Affron observes, 'intimate that even their surfaces can be penetrated as they, mirrors of the character's feelings, penetrate the dramatic and emotional fiction they scrutinize'.[2] For what purpose would Tuymans present a close-up of the nose; why feature this relatively banal, inexpressive element of the face? By curtailing the painted image, Tuymans remarks upon the body's other faculties of apprehension, proposing an olfactory intervention to the mind's claim for encounter with the world. Materially the canvas seems stretched to its maximum, like flesh that can, hauntingly, only improperly cover the skeletal support that upholds it.

Such terms of painting's inability to cover its surface – the nostril strokes mar the taught unified flesh of the surface – suffice to metaphorically sketch Tuymans's view of painting. A magnified eye would too obviously invoke the metaphors and mechanisms of seeing. Although Tuymans is concerned with the gaze, his main objective is to unsettle the primacy of sight; to question the role vision plays in constructing our reading of the world. With Tuymans any myth about an objective lens – whether turned to history, society or biography – is forcefully undermined. His work questions how we employ narrative as a means of situating ourselves within the world, interrupting (without entirely fracturing say, in the manner of Dada collage) the sequential flow of image followed by image. Each of his paintings depicts a subject or scene where the flow of time/image has come to accumulate, to accrue within chosen images. There is no outside the frame, no necessary before and after: simply, there is the painted image and its engaged density.

In the multi-panelled *Die Zeit* (1988) Tuymans considers the sequentiality of filmic time, mimicking yet dismantling a scene-by-scene construction of narrative. The left panel shows a deserted town square, its buildings cast in a raking light that produces stark shadows which enforce the eerie evacuation. Across the top of the canvas are the painted words 'Niets te

ABOVE: Die Zeit, *1988, oil on cardboard, Panel One: 30x40cm;* Panel Two: *39x40cm;* Panel Three: *37x40cm;* Panel Four: *41x40cm;*
OPPOSITE, FROM ABOVE: Blacklight, *1994, oil on canvas, 55x82cm;* Gaschamber, *1986, oil on canvas, 50x70cm*

zien' (Nothing to be seen). The second panel shows some shelves, apparently in a shop window, with absolutely no commodities displayed. The third panel continues this progress of the zoom, and reveals two tablets. The fourth and final panel reverses sight's direction and presents a portrait of a suave individual, shown to be wearing dark sunglasses which blot out the eyes. These four black and white images, held in suspense yet bound together through their linked presentation, create a narrative of emplotment. It is, as one continues to look at the painting, a hermetic scenario played out in black and white.

To decode its meaning and properly write the story one would need to read the 'script' underlying the painting. All representational painting maintains narratological claims and the extent to which we are able to unpack the story depends upon accessibility of the 'script' (our familiarity with the artist, our knowledge of his motives, access to commentary discussing the work, or any combination of these informing strategies). The critic Dominic van den Boogerd has, correctly one assumes, related *Die Zeit* to a Nazi narrative: the first panel shows an army barracks and camp; the second depicts wartime shortages; the third reveals two spinach pills, the first concentrated food developed by the Germans during the war; and the final panel portrays Jozef Heydrich, somewhat incognito.[3] My interest here is not in re-reading the work along lines admonished by the artist (via the critic) but in thinking about *Die Zeit* as painting detached from textual assistance.

Rare as it is to read the script of film prior to viewing, my motive for this approach to Tuymans's work is that as paintings – paintings representationally tied to the world – each of his often small-sized panels possesses a degree of impacted information encoded within the paint that operates like an imploded, sedimented narrative. Hermetic as the images often appear, prolonged looking comes to furnish narrative clues of emplotment. These cues need not be specific in any verifiable sense, for that is not the aim of painting. Rather, with Tuymans's work, narration tends to become self-conscious of its mechanisms and uses, aware of why we urge to undertake such sequencing in the first place.

The question is succinctly raised in the painting itself, for how else should the words 'Nothing to be seen' be interpreted. If vision will not supply meaning, then to other faculties we must turn as viewers, in our effort to reckon meaning from these images. The task concerns the complexion of narrative, and separate orders of time that must operate to enable it to function properly. 'A salient property of narrative is double time structuring', literary theorist Seymour Chatman asserts:

all narratives, in whatever medium, combine time sequence of plot events, the time of *historie* ('story-time') with the time of presentation of those events in the text, which we call 'discourse-time'. What is fundamental to narrative, regardless of the medium, is that these two time orders are independent.[4]

Tuymans's work privileges 'discourse-time' where the intricacies of how the so-called plot of the picture is being told receives emphasis. The plot, which refers to what I have called the 'script', may either relate to something highly specified or be an ambiguous circumstance requiring speculative engagement. Two examples serve these seemingly contradictory, perhaps almost corrupt claims to painting's role in the world: *Gaschamber* (1986) and *Blacklight* (1994).

Gaschamber, as its title instructs, pictures what has only been seen in photographs. Tuymans, as should now be apparent, frequently works directly from photographs, using these images as the platform with which to prompt painting.[4] In this manner his method sharply differs from a painter such as Guston, who evolved a highly personalised, idiosyncratic lexicon of form with which to envision similarly horrific subject matter. Also, unlike Gerhard Richter's photographic blur which remarks upon the improper information supplied through photography, with Tuymans approximation becomes an asset deployed for a more specific, more intense view of the subject where extraneous details are emptied out. With the portrait of Heydrich, for instance, the man's face is rendered with acute specificity while the body and background is simply lined in pencil and black outline. It is the face of this man Tuymans wants to examine. Similarly, with *Gaschamber* the aqueous ground of the painting is left sparsely painted. Our eyes move to the nozzles on the ceiling, to the grate on the floor and the black door in the corner. Other details are left underarticulated; why light falls across the floor and why shadows are cast in their given shape against the chamber's surfaces is unexplained within the painting. The geometry of these shapes – the murky shadow leading from the grate to the lower left corner, and the almost rectangular highlighted shape thrown onto the floor – are seen to conclude at the picture's edge. Thus, there can be no outside logic informing these aspects of the painting. Tuymans forces the answer to be found within the painting, implying that the way these applications of light/ shadow appear cannot be reasoned through the import of some external narrative apparatus, such as a script, text, or another painting.

It is here that any suspicion of a relation between painting and the film-still is ruptured.[5] Cindy Sherman's *Untitled* film-still photographs from the early 80s were precisely so evocative because of their implied narrative outside the frame of the image. In each of her photographs there is a before and an after to which we maintain transparent imaginative access. With Tuymans 'story-time' falls away. We are put in the presence of the imploded present where the duration of the painting's narration continually circles back onto itself. The painted image is never still, but rather becomes transitive, invoking a vision that flickers to create presence.

Within this semiotic of narrative any implied history or continuity must be discerned within the painting. *Blacklight* is a

painting that referentially relies upon itself to construct complete narrative closure. The drama between the nude body lying on the sofa and the objects within the room (lamp, chair, television) represent the assertion of a scenario as a complete or sufficient narrative. The objects arrayed within the painting are each depicted in their own frontal perspective. What we initially regard as seen from one single, lens-like view, is rather split into a slightly adjusted multiple perspective. The feeling that one may see around the back of the chair to the figure's head, or behind the back of the television to discern some informative clue, is generated by Tuymans's subtle shifts of perspective. More than one camera lens would have to record such a depiction, and it is here, with the splitting and multiplying of viewpoint, that the perpetuality of narrative is attained within a single frame.

Such a process exactly accommodates the four-part sequence of *Die Zeit* – where 'the time' of the painting involves separate temporalities of perspective and historical/object location. By merging such disparate viewpoints, and also by shifting the relative scale of his focus between paintings (from the nose or tablet close-ups to renditions of entire rooms), Tuymans sees the world through multiple lenses. The depth of field is almost always constrained, shallow, forcing painting to transact its depiction with tightly controlled surfaces. Within these surfaces there arises what Roland Barthes's discerned as a 'third meaning', a significance produced beyond any narrative content or depicted subject matter. For images that ignite a 'filmic' chain of signification, Barthes notes, we are able only to locate this meaning 'theoretically but not describe [it]'. The image then opens, an 'armature of a permutative unfolding',[6] where meaning circulates through anterior texts of approximation, a studied evocation.

In these terms any project of self, such as Guston's older version, is opened up to fluctuation and fracture – the unsteady grip of surfaces slipping from focus. The larger narrative trope underlying this vision concerns memory and the picturing of remembrance – as both process and image. Tuymans grounds memory in some tangible place that is separate from the preserves of imagination and the resolve of history, if such a distinction is possible to picture, possible to uphold. Aroused by photographic traces, the very real remnants of history upon which memory relies, painting modulates the spaces and absences upon which imagination may festoon its pictorial articulation. By offering a mute poetry, Tuymans presents enigma that must be negotiated, confronting the prospect that the close-up of a face may not reveal more information, nor bring us closer to the essence of a person. While cinema manages to rewrite and re-photograph the world in order to plot events, spaces and people into structured sequences of a narrated reality, Tuymans offers this view in the singular images of painting. His work presents a return to the way things are, to how we come into contact with the world, at least in painting.

Notes

1 Guston, Philip, lecture given at the University of Minnesota, March, 1978, ed Renée McKee, in *Philip Guston, 1969-1980*, exhibition catalogue, Whitechapel Art Gallery, London, 1982, p52.

2 Affron, Charles, *Cinema and Sentiment*, University of Chicago Press, Chicago, 1982, p68.

3 van den Boogerd, Dominic, *Blow Up: On Cinematic Vision and the Paintings of Luc Tuymans*, exhibition catalogue, Galerie Paul Andriesse, Amsterdam, 1995, pp24-25. Boogerd's approach is highly informed and prompted through conversation with the artist.

4 Chatman, Seymour, 'What Novels Can Do That Films Can't (and Vice Versa)', *Critical Inquiry: On Narrative*, Vol 7, No 1, Autumn, 1980, p122.

5 Numerous critics have regarded Tuymans's painting as excerpts from film. For instance, Hans Rudolf Reust, observes: 'In the lasting time of painting, fleeting images are captured with the same abrupt tension and static persistency as a still from a sudden cut in a film'. See Reust, 'Presence in Remembrance' in *Luc Tuymans*, exhibition catalogue, Art Gallery of York University, Toronto, 1994, p81.

6 Barthes, Roland, 'The Third Meaning: Notes on Some of Eisenstein's Stills', *Artforum*, Vol XI, No 5, January 1973, p50. As Barthes continues: 'The filmic is that which cannot be described in the film. It is the representation which cannot be represented. The filmic begins only where language and articulate metalanguage cease . . . we can perceive it only after having traversed – analytically – the 'essentials', the 'depth' and the 'complexity' of the cinematographic work – all treasures belonging only to articulate language, out of which we constitute that work and believe we exhaust it. For the filmic is different from the film: the filmic is as far from the film as the novelistic or the fictive is from the novel (I can write novelistically, fictively, without ever writing novels, fiction).

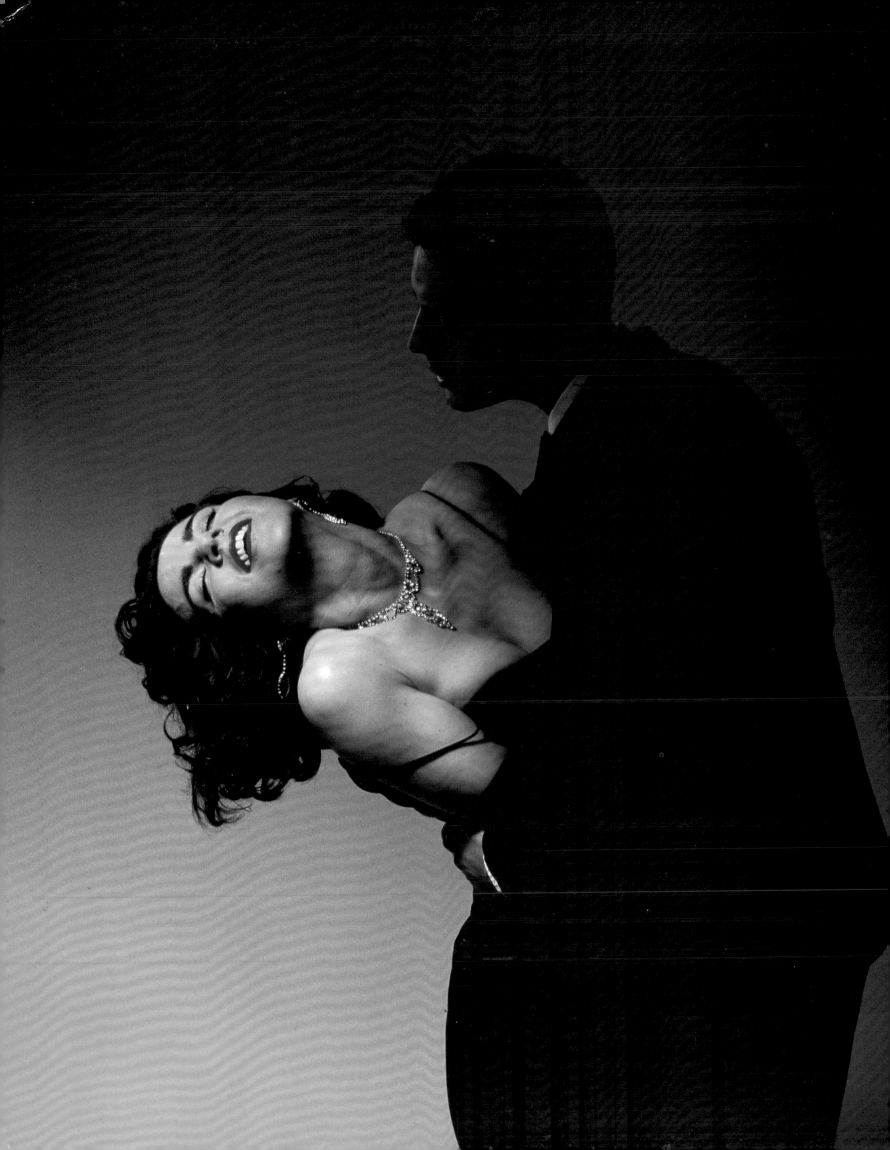

THE ART OF APPEARANCE
ANNIE GRIFFIN AND THE FILM STAR(E)
Marie-Anne Mancio

Annie Griffin came to England from New York in 1980 'to be an actress'. After working with an experimental theatre troupe she devised her own *solo* show *Blackbeard the Pirate* which she performed at the 1986 National Review of Live Art. She has recently made documentaries and short films for MTV and Channel 4 and has been involved in curating two exhibitions. As performer, live artist, filmmaker and curator, Griffin's bodily presence within the 'artefact' is an integral part of her practice. This article seeks to trace its appearance(s) . . .

The female body has been implicated in discourses around film and visual art. It has quite literally been *framed,* found guilty of inciting voyeurism, fetishism and display. But what happens when this body finds itself between disciplines; what possibilities can this conflation of reel and real, of mediated and live, offer the female performer and her viewer? It is precisely this border zone that Annie Griffin negotiates. Whether making short films, live performance or work that involves the two, she establishes a series of complex dialogues between art and film. The intricacy of these dialogues becomes apparent when we attempt to read Griffin's practice: we are confronted with a live performance that is most fruitfully de-constructed through film theory, or a film that demands reference to fine art traditions. And, punctuating all these texts, are the body's acts of appearance and disappearance.

This question of visibility versus invisibility has been much rehearsed in feminist aesthetics. Peggy Phelan, for instance, advocates a review of the notion that increased visibility in cultural representation necessarily advances empowerment; yet she claims 'there is real power in remaining unmarked'.[1] By not imaging the female, a film like Yvonne Rainer's *The Man Who Envied Women* sought to frustrate what E Ann Kaplan identifies as 'mechanisms the dominant cinema uses to *construct* the male spectator';[2] a parallel strategy in visual art can be observed in Mary Kelly's infamous *Post Partum Document* which, again, denied us an image of the (mother's) body. Griffin, however, chooses to experiment with invisibility as just one means of undoing representational coherence, as a kind of marker against which to test the exposure of her body. Her practice succeeds in recouping the *desirable* woman without replicating the limitations of bounded canvas or celluloid. In short, her boundary-hopping disturbs the scopophilic gaze.

In a section of her live performance *Almost Persuaded* (1988) Griffin exposes and explores the theatrical space by posing questions directly to her audience about their visibility and her own. She asks us whether or not a particular spot in the performance area is 'charged': 'Am I strong here?' then moves to a different part of the space 'Or over here?' and repeats the dilemma. In so doing she forces us to acknowledge that our position as spectators is compromised by an unwitting voyeurism: 'Can you see me?' she begins; then 'Can you all *see* me?' 'Can you see *all* of me?' 'Can you see my underpants?' Played out within a construction of desire, our gaze is made to seem intrusive. It is precisely this ambiguity that Griffin recognises in the female performer, what she calls 'the power of glamour . . . the fact of presence that only a woman can have'.[3]

If Griffin's glamorous persona would seem to encourage desire though, she frustrates it also; partly, as I have said, by making our act of watching that much more overt and partly by removing what might be perceived as the determining components of pleasure. *The Art Casino* – an interactive event curated by Griffin and installed at the Barbican Art Gallery for three days in May 1995 – is a clear example of her ability to simultaneously promise and deny. Bringing together several artists working in different media (including John Maybury, Mark Wallinger and Tilda Swinton) it reproduces the gambling aesthetic but omits its main feature: money. Thus we find reconfigured fruit machines that can be played for nothing and consequently guarantee nothing, even with a winning score line; a roulette table where players simply request more chips when their pile runs low; speakers involved in the gambling industry being interviewed and, as with Brough Scott (ex editor of *The Racing Post*), being asked for betting tips that then cannot be placed without leaving *The Art Casino*. Whilst the event rehearses the gambler's spaces (complete with turf covered floor) it is incapable of giving its players the gambling experience. Playing with nothing at stake, indeed nothing *to* stake, might be fun but not gratifying.

In her film/live performance *It Is For My Mouth Forever* (1995) Griffin achieves a comparable sense of simultaneous participation and alienation. We see her as a live body post-syncing the dialogue of her (silent) film. The performance opens with her speaking about the technicalities of filmmaking and the meaning of its jargon whilst Betty Page films play on a screen behind her. The lights dim slightly and as her own film runs on the large screen, Griffin (with her back to us) and foley artist Jack Stew proceed to dub the actors and the sound effects, with pianist Nicolas Bloomfield performing his own score. The

Annie Griffin and Franck Loiret in Skylark, *1990 (photo Chris Nash)*

film's protagonist (played by Joanna Scanlan) is an undiscovered diva – a large, imposing and sensual singer with deep red lips. She and her newly acquired husband – National Lottery winners both – spend their winnings ordering food from a smooth pizza delivery man. The couple rarely leave their flat; she gives birth to a bunch of guinea pigs. There are hilarious scenes of the diva, book in one hand, guinea pig in another, reading bedtime stories to her litter. The empty pizza cartons pile up, the children scrabble amongst them and when she can no longer stand the way that they have taken over her space, the diva drives to a wood and dumps them.

Although narrative, *It Is For My Mouth Forever* refuses to consign its female bodies to any sort of closure. It makes problematic the sexualised female body by denying a homogeneous reading. Whilst there is ostensibly one female character, she is played by two different bodies, neither of whom acts as we would need it to, to consummate the scopophilic gaze. This becomes clear when we examine the positioning of sex scenes in the performance's overall structure: the Betty Page films, for example, emphasise not the seen but the almost-seen. Griffin has likened them to the child's view of sex;[4] that is, they contain all the signs (the suspenders, the coyness) but nothing really occurs in them. It is as though sex cannot be imagined (or imaged) beyond those signifiers; their promise remains unfulfilled. By showing these films before her own, Griffin also mitigates any shock on behalf of the audience at seeing nudity or partially-clothed figures. Equally, she defuses the anticipation of sex through inverting the classic realist text's climactic placement of such scenes. Thus, when the scenes do occur, they are more likely to be interpreted as intended: as an adult, female view of disappointing sex.

After an unsatisfactory sexual encounter for the diva (she is prone and still in her underwear when her husband masturbates by the bedside and ejaculates in her belly button), she turns up the edge of her knickers so that they once more cover her navel. In that moment we are made to focus on the live sound of the emphatic snap of elastic and the filmic image of an uncontrollable *male* face, as opposed to the female face which is the usual signifier for, and locus of, pleasure and surrender. Just as Griffin effectively deconstructs the process involved in the studio addition of sound by making visible the labour of the foley artist, so she dismantles the pernicious – because seamless – apparatus of the male gaze. There is a refusal of totality here, as evidenced by the fragmentation of the diva's character between the performer we hear on stage and the one we see on screen; and also between the sound effects' and live dialogue's occasional failure to be in perfect sync with the film's miming mouths.

These strategies recall Kaja Silverman's perception of synchronisation. Silverman sees the latter as something that not only confines woman to the story which is a 'safe place', but to the 'safe places *within* the story'.[5]

Once the woman is contained within the diegesis, the extra-diegetic realm is privileged as a male domain. (Exactly these arguments have been presented in relation to the female nude in Western art aesthetics). Silverman suggests that in order to reclaim extra-diegesis and to circumvent the transparent association of female voice with female body, we might make use of the disembodied voice. This tactic would effect an escape from 'that anatomical destiny to which classical cinema holds its female characters'.[6] With its reworking of the disembodied voice, *It Is For My Mouth Forever* achieves this disorientation. Whilst seeming to give us a narrative, the work actually destabilises it by showing us that it is not a safe place to be. It will not provide the pleasure typical of the classic realist text because it does not cohere, thus as audience we must negotiate instead the multiple viewpoints Griffin provides.

Conversely, Annie Griffin's film short, *Out Of Reach* (1994), appears to privilege one viewpoint and is reminiscent of fine art preoccupations. Although it is ostensibly a documentary, the film could be said to re-interpret the aesthetics of traditional portraiture. The work takes as its premise the exploration of Griffin's personality in the form of the off camera questions that she poses to members of her family. The film opens with a close up of Griffin's face in a childhood photograph but thereafter we do not see her until the final frames. This disappearance from view of the subject matter was effected by Sophie Calle's artwork *Les Fantomes*. Calle was concerned with recreating paintings that were on loan from a museum and therefore absent from its walls. She asked museum staff to describe the missing pictures and then 'made a text which was a kind of portrait, like a puzzle which emerged through all their descriptions'.[7] Griffin's absence prompts the same doubts as to the authenticity of the collated fragments.

Whilst Calle's portrait was admittedly an unusual one, *Out Of Reach* also mimics the more traditional portrait format in its use of the camera. Each interview occurs with the participant sitting down, usually facing us. We see only the surroundings of their immediate spaces. The shots are mainly in close-up or medium close-up with no overt special effects. Griffin's family members' names appear in simple captions at the base of the frame, like picture titles. In the same way that the portrait is generally a selfconsciously posed representation, Griffin leaves us in no doubt that her family too are being *presented*. She does not edit out the prelude to her questioning her father over the phone; instead we hear the telephone ring on his desk and then Griffin's voice telling him to pick it up. 'Oh God', he mutters, half-smiling at the artificiality of the situation and at the fact that she is now on his secretary's phone. In this way it is as if the documentary were framed by a giant pair of quotation marks, with Griffin quietly undoing its pseudo-realism.

By the film's closing frames, the style has shifted to an approach that is more recognisable as fiction. We finally see Griffin just as she is leaving. She bids a silent farewell to her

parents then walks quickly after a small plane that appears to be about to fly without her. We watch her, belongings in hand, motioning for it to wait then running, running. For an audience who has had to image Griffin for themselves through the stories of her family, this is an important moment. Yet Griffin takes the opportunity to present herself as even more posed. No longer sister to, daughter to, aunt to, she is instead a wholly glamorous, almost magical, woman. Dressed in a long red flowing gown, Griffin's exit recalls those Joshua Reynolds's portraits of society women in impossible, mythological poses.

The red dress is a motif common to several of Griffin's works. Her live artwork, *Almost Persuaded*, does not incorporate film or video as such but evokes, I would suggest, a film aesthetic through its protagonists. These characters (all played by Griffin) recall those of the so-called women's films of 1930s and 40s Hollywood. Unlike their predecessors, however, Griffin's personae avoid being compromised by the monocular stare of the camera. Her child, Country and Western singer, single mother running a farm somewhere in the USA's Deep South do not charm or seduce us so much as move us, Griffin's solitary presence in the performance space magnifying her vulnerability. Although *Almost Persuaded* earned Griffin a reputation as a comedienne, most of its humour is barbed. There is an unnerving intimation of violence as the text is suffused with the echoes of absentee males and the threats that they pose. Tenacious against the odds (of being poor, of being female), her personae act like icons of agency.

The merits or otherwise of women's films have been debated at length but it is indisputable that they were enjoyed by a great many spectators. Jeanine Basinger advocates a positive reading of their quasi-subversive potential; she notes:

[They] are cautionary tales of a particularly desperate stripe, but they contain real passion, real anger . . . well-dressed stars act out the woman's form of heroism: living outside the rules of correct behaviour which in story terms is realized by living outside the rules of logical narrative construction.[8]

Although Basinger is speaking primarily of what she sees as *contradictions* in the films' plots, rather than wholesale abandonment of narrative linearity, the fact that they disrupt logic reminds us of Griffin's own play with the components of a theatrical performance. For cutting across the work's various narrative threads is the presentation and eventual resolution of a dilemma: a woman is offered a lift home by a man, does she go or does she wait for a cab? So that even as we see one of her personae surviving, another is disturbed by this question of whether she should or should not allow herself to get picked up.

At the end of the first half of the performance Griffin informs us that there is going to be an interval during which she will change into a red dress. She asks her audience to think, in the meantime, about 'why a woman wears a red dress'. Again the reference invokes comparison to the woman's film in which, as Basinger notes, costume was so central that 'women *were* defined by their clothes'.[9] Even though the red dress is obviously a code made explicit by these films for a certain type of female (sexual, dangerous) we might also see it as an indication of escapist fantasies. This reading is borne out by three films, released in consecutive years, in which a red dress features strongly: *The Bride Wore Red* (Dorothy Arzner, MGM, 1937); *Jezebel* (William Wyler, Warner Bros, 1938) and *Gone With The Wind* (Victor Fleming, Selznick International, 1939). The wearing of a red dress in each of these films signals a development in the drama that announces a shift in the power relations between male and female protagonists. This subtle movement is played out in the context of the superfemale's sexuality.[10]

The Bride Wore Red has not received the critical attention of Arzner's other films, neither on its release nor since. Set in Trieste, it stars poor girl Joan Crawford who, in a variation on the Pygmalion theme, is paid to pose as a society woman and to 'capture' a rich husband. As Basinger notes, the one indicator the audience has that Crawford's deception will not succeed is her desire to own 'a red shiny dress'.[11] Whilst *The New York Times'* film critic, Frank Nugent, was not impressed by the film, stating, 'If it is anything at all, it is a woman's picture – smoldering with its heroine's indecision and consumed with talk of love and fashions'[12] even he did not fail to note the importance of the red dress within the film's structure and spoke of 'the red gown for a climax'. That the red dress was used to signify an excess of woman's sexuality is obvious; more interesting is Arzner's foregrounding of the discourses around image.

The heroine's realisation that the dress she ultimately cannot resist buying is 'too red, too loud, and too cheap. It's a portrait of me' and her subsequent decision to marry the local postman instead may disappoint the viewer, but I would say that it emphasises the same notion of costume *as performance* that Griffin is expounding. In other words, Arzner illustrates the power of signification at different levels of engagement with and within the text. Whilst she appears to use the red dress in a straightforward way to signify her protagonist's specific attributes to an audience, she also makes explicit the unconscious associative process on which signification relies by having her protagonist explain it. So we know (as the Bride knows) that to wear a red dress is to engage in fantasy; and that the persona created by such a dress can be shed along with the garment.

A similar pivotal role is assumed by the red dress in *Jezebel*. Southern belle Julie Marsden (Bette Davis) almost irretrievably ruins her reputation by the one act of wearing a red dress instead of a white one. Filmed in black and white, the actual dress worn by Davis in *Jezebel* was brown as this was easier to light; thus it impacts on us as 'not white' (when it

FROM ABOVE: Annie Griffin in Almost Persuaded, 1988 (photo Kevin Cummins); Annie Griffin in It Is For My Mouth Forever, 1995 (photo Hugo Glendinning); Annie Griffin and Franck Loiret in Skylark, 1990 (photo Chris Nash); OPPOSITE: Annie Griffin in Was She There, 1995 (photo Hugo Glendinning)

should be, like those of the other unmarried women). Yet it is essential to Julie's whole characterisation that we read the dress not just as 'not white' but more specifically as *red*, and indeed the replica dress created in red for publicity stills reinforced this. Determined to assert her independence, it is red that Julie insists on wearing. Her entrance in the dress marks the beginning of her alienation by her fiance. As in *The Bride Wore Red*, the dress hints at the possibility of a future (albeit not a happy one) without a man.

Scarlett O'Hara was perhaps the ultimate female character to emerge on screen in this period. In terms of characterisation and audience-performer identification, Griffin's performances might be considered to resurrect Scarlett (and indeed critics have made the comparison). *Gone With The Wind* has nourished a mythology all of its own but what emerges most strongly from stories of its production is the enormous appeal for women that the character of Scarlett held – in excess of 7,000 auditioned for the role. Whilst the film is still not considered a women's film as such, in retrospect it seems impossible that it could be anything else. Scarlett's survival skills earn her the superfemale epithet; we see her suffer war-time horrors where she is left to run Tara, her home plantation. Exactly 50 years on, Griffin's character in *Almost Persuaded* echoes the heroine's despair. Addressing her absent husband, Luther, who may be dead or who may have fled, Griffin speaks of her farm and her land: 'The farm's gonna mek it . . . I don't know how we broke even but we did'.

The red dress appears in *Gone With The Wind* when Rhett coerces Scarlett (accused of adultery) to attend Ashley's birthday party. Rifling through her closet, he orders her to wear a deep burgundy velvet gown with plunging neckline: 'Wear that! Nothing modest or matronly will do for this occasion. And put on plenty of rouge! I want you to look your part tonight'. Accounts of *Gone With The Wind's* filming reveal that Vivien Leigh's relationship with director Victor Fleming was not always cordial. He had earned himself the reputation of being a 'man's director' and had been brought in to replace 'woman's director' George Cukor who had initially been hired for the picture. Rhett's directorial role in designing Scarlett's image mirrors that of Fleming who demanded that Leigh's breasts be taped to give her the cleavage the red dress required. The gauze wrap accompanying the costume was added at Leigh's insistence because she thought the look, as it was, too 'tarty'. Where the relations between male and female in both the film's narrative and the narrative of its production recall the traditions of artist and model, the red dress becomes a battleground over the depiction and reception of female sexuality.

These particular women then wear their red dresses because they will not subscribe to the rules, because their sexuality is to be flaunted, because they do not know any better. So when Griffin asks us to think about 'why a woman wears a red dress' we presume that it is to do with mitigating hardship and vulnerability, or as proof of sexual autonomy. But ambiguity has been seen as the hallmark of the women's film (what Basinger calls a process of simultaneous endorsement and undermining of ideals). Although this allowed filmmakers to advocate contradictory moralities, it often meant disappointingly moral endings – the Bride's sanitised future, the pleasure that Julie finds in remorse. *Gone With The Wind* is a classic example: whereas morality dictates that Scarlett's selfishness be punished by the loss of a man's love, the film's climax – a montage of voices, music that soars to a crescendo, the close-up of Scarlett's upturned face, her last lines 'I'll think of some way to get him back. After all, tomorrow is another day!' – all point to an 'optimistic' ending. Scarlett's solitude, we are reassured, is just a temporary state.

Whereas these women's films were obliged to temper their females' power, Griffin's own personae refuse to apologise. In *Almost Persuaded* they, unlike their predecessors, do not need to find their happy ending. They cannot because the mechanisms – narrative, the camera's voyeuristic gaze – are not in place. Griffin does not allow her stories that much compulsion; she intervenes to deny them authenticity. So at the end of the performance, with a brutality quite in keeping with the tone of the work, she strips away the fictions that she has spent 60 minutes constructing. She refuses to make excuses for not wanting to be picked up: 'Tomorrow night I could go back and *be* persuaded. But there is no other man on the other side of town. But I have no little babies. There is nobody else. There is somebody else'. In her glittery red dress, far from the gaze of the film's male star(e) she recuperates the sell-out futures of the Bride, Julie and Scarlett: 'I was *almost* persuaded. I *was* almost persuaded . . . ' she tells us, 'But I was *not* persuaded'.

If *Almost Persuaded* is grim but positive about women's potential to argue their position, then Griffin's *Was She There* (1995) is more disturbing. A short film featuring an even shorter red dress, it concerns a woman (Griffin herself) who takes a train from London to Blackpool. With her long black hair and big sunglasses she flirts appallingly, she whispers in the ticket inspector's ear, she has furious sex with a stranger in the train toilet, she sits in the front seat of a taxicab, she plays coy with an icecream and two lads on the pier, she ostentatiously drinks a bottle of champagne in a hotel restaurant populated by Blackpool's retired, then charges out when laughed at. Outrageously behaved, she makes the antics of contemporary art's 'bad girls' look decidedly tame. Perhaps it is because they are *girls*: Sam Taylor-Wood blushing like an adolescent at her lovebites in *Slut*, Tracey Emin displaying the names of *Everyone I Have Ever Slept With 1963-1995* with the enthusiasm of one young enough to want to keep count, or Sarah Lucas's *Receptacle of Lurid Things* – a plaster cast of her middle finger frozen in an abusive gesture. Their badness is always defiant in a teenage way. They have sex, they have tempers, they have attitude, but do they have *fun*?

Griffin evidently does, and is so likeable that she invites a conspiratorial delight from her viewer. Her audience comes to approximate that of the woman's film who 'could watch while their favourite female stars wore great clothes, sat on great furniture, loved bad men, had lots of sex, told the world off for restricting them, destroyed their enemies'.[13] Yet *Was She There* is also as articulate about the disposability of women in our visual culture as any of Lucas's works; the following day it sees Griffin – now attired in a smart trouser suit, her hair short – repeat the London to Blackpool journey. As she does so, she attempts to piece together fragments of information gleaned from the previous day's witnesses. There is a disturbing scene where those boys on the pier refuse all responsibility and Griffin (frustrated) argues that the woman was last seen with them. What have they done with her? She makes us question their dismissiveness and construct our own narratives; did they take her away and murder her, didn't they care that she had disappeared?

Then again, these elements of memory are complicated by the blurring between reality and fiction: nestling amongst the 'real people' in the work are 'actors' playing at remembering. As Griffin's discussion with the boys on the pier becomes more heated, a considerate passer-by mistakes the scene for a real event and attempts to intervene. His interruption is allowed to remain in the final cut. (Or was that event staged as well?) There is a particularly satisfying self-reflexivity in this; Hugo Glendinning for instance, whose photograph of Griffin advertises the film, now features in the same film. Recast as a sexy biker complete with mobile phone, he remembers the woman in the red dress as a pitiful attention-seeker. Thus Griffin's image (as siren) is destabilised in the fiction by the same man who had a hand in its making, the difference lies in his change of *focus*.

As with many of Griffin's works, *Was She There* stresses the difficulty women face in reconciling their various roles (why can't we be sexual and serious?) Her dual performance revises that spate of 1940s 'good twin versus bad twin' women's films; except in this scenario the polarities are less distinct. Her suited persona is guilty of patronising an unsuspecting fortune teller, even as her alter ego reveals a surprising sensitivity. But in this film it is the latter woman who triumphs. Griffin's 'body missing' in the red dress is last seen at the end of the first day: alone, she strides through the sea with a sense of purpose, suitcase in hand. Guilty of staging her own (dis)appearance, she has succeeded in evading *arrest*, her body absent from the frame at the film's close. In its place we see her trouser-suited counterpart, also rushing through the sea. Literally pursuing a line of enquiry, she asks bathers for clues to the woman's whereabouts.

Griffin's practice *performs* this crossing-over again and again. Concerned with traversing the boundaries of live art and film, it threatens disciplinary integrity. She has even implied that differentiation between the two is redundant since film can be live art as long as it refuses to allot 'a preexisting role' to its audience.[14] Hers is an aesthetic that takes into account the hybridity of our current situation and reinvigorates it from a feminist perspective. If the female body is to hold on to its own gaze it needs to continue to employ such deconstructive strategies. Without subscribing to permanent invisibility, it could disappear from view occasionally to remind us that the act of looking, however encultured, is a privileged one. This, it seems to me, is one way of re-introducing a sense of enjoyment into that postmodernist cliche *play*, whilst still exploiting its potential. And nowhere is this refusal of closure more effective than in our unresolved question at the end of *Was She There*: what has happened to the woman in the red dress?

Suffice it to say she remains under suspicion of being on the look out for a good time . . .

Notes

1 Phelan, Peggy, *Unmarked: The Politics of Performance*, Routledge, London & New York, 1993, p6.

2 Kaplan, E Ann, *Women and Film: Both Sides of the Camera*, Routledge, London & New York, 1983, p30.

3 Interview with Annie Griffin, London, 24th October 1994.

4 Annie Griffin speaking at a post-performance discussion of *It Is For My Mouth Forever* at the Royal Court Theatre, London, 3rd June 1995.

5 Silverman, Kaja, *The Acoustic Mirror: The Female Voice in Psychoanalysis and Cinema,* Indiana University Press, Bloomington, 1988, p164.

6 *ibid*, p130.

7 Calle, Sophie in Adrian Searle (ed), *Talking Art*, ICA, London, 1993, documents 12, p36.

8 Basinger, Jeanine, *A Woman's View: How Hollywood Spoke to Women 1930-1960*, Chatto & Windus, London, 1994, p6.

9 *ibid*, p116.

10 Molly Haskell has defined the superfemale as epitomised by 'a self-exploiter, [who] uses her sex (without ever surrendering it) to gain power over men'. See G Mast, M Cohen & L Braudy (eds) *Film Theory and Criticism*, Oxford University Press, New York & Oxford, 1992, p362.

11 *op cit*, Basinger, 1994, p132.

12 Nugent, Frank 'Review: The Bride Wore Red', *The New York Times*, 15th October 1937.

13 *op cit*, Basinger, 1994, p6.

14 Interview with Annie Griffin, London, 24th October 1994.

FOOTPRINTS IN THE AIR
MECHANICAL PERCEPTION, THE MEDIA ARTS, DIASPORA AND SOUND

Sean Cubitt

History 1: Mechanical Perception

It cinema is the medium of intermittent motion, the film strip and the lens, it has scarcely a hundred years on its shoulders, and cannot be expected to have achieved anything to place beside Hildegard of Bingen or Poussin. But if cinema is the art of movement, it is the oldest art of all: the art of the firewatcher, the sputtering of torches over the unfurling comic strips of Lascaux, the ancient abstract art of pyrotechnics, the watergardens of the baroque. Film celebrates that history of sheer pleasure in the upwelling of light in motion, the joy of perception which it seems is as old as perception itself.

One might look to the Impressionists for the last pre-cinematic yearnings: the demand that life exceed death, that death be annihilated in the pure contemplation of living perception, became the obsessive pursuit of the quintessence of motion, the flutter of light over water, the whisper of wind over cornfields. While Seurat moved towards the scientific optical mixing of colours, impelled by just such a joy in the manic clarity of photons juddering into the retina, Pissarro unravelled the anarchic principles of composition by contingency, unravelling light until form emerged from the ragged hazard of looking, an art of subordination to the force of perception. Of course the Impressionists found themselves in a double bind: how to be recordists of light whilst also passionate interpreters of life. Photography, and more so cinematography, took on the work of pure perception when painting pursued expression, translation and the formal objects of painting itself.

The first projected movie was shown just 102 years ago, at the end of a lecture in which the Lumière brothers, Louis and Auguste, were demonstrating their Autochrome process for colour photography, based on the same perceptual-physiological principles as divisionisme. How much they owed to the Impressionists! – the suitability of a factory for a film, the midday sun, the escape from work (not a moralised return to it), the modern devices like the bicycle, the ordinariness of the workers, the precision with which daily fashions are recorded, the randomness of the frame, the casualness and serendipity of the dog wandering off and back on screen. If there is the rudiment of a narrative here, it is like a narrative of Pissarro's peasant girls, taking their break from toil to emerge, blinking, into the anarchist sun.

If divisionisme shattered light across the space of the canvas, film shattered it along the film strip, acting on the same aesthetic of submission to the physics of light moving in time.

If film can be said to become at any one moment a spatiotemporal art, an art that clones the eye to its mechanical prostheses, it is in the work of Eisenstein, whose *Potemkin* defined the art of cinema for a generation. Here the swooping of angles and images, their assemblage with regard only for their aesthetic and emotional power, their relative freedom from the ordering of real time and logical space, paradoxically makes it possible for them to explore reality in a greater depth than ever the still and single frame could achieve. Indecorous, self-consciously mechanical, in Eisenstein's montage we see continuing the emergence of a kind of vision which is still in formation, a bold leap, on the back of historical reconstruction of an obscure mutiny, into the future of human perception as an inmelding of machine and organ, camera and eye, into the first forms of the digital hybrid, the cyborg.

When sound recording first shattered this total and global art, adding only recorded dialogue to cinema's existing repertoire of effects, it brought with it a deadening subordination to dialogue. Editing, lighting, camera movement and framing, all shuffled themselves about the sovereignty of the word, and almost entirely the narrative word. Film found itself bound to communicating information. Mainstream cinema only really emerged with sound: until then, cinema had been able to experiment, even under the constraints produced by the huge budgets of a von Stroheim or a Keaton. Suddenly the experiment ended, the classical script-driven cinema emerged, and promptly fell victim to its own success.

History 2: Music, Dialogue and Silence

For more than 35 years, the only genuine struggle within dominant cinema came in the war between music and dialogue. Welles's famous 'discovery' of deep-focus cinematography added little that had not been exploited by Stroheim, Renoir and James Wong Howe; his *mise-en-scène* added little to Dreyer. But his twist of the soundtrack from the articulation of information in the individuated dialogue to a clattering, mussed-up, cacophonous crashing of voices and sound effects, was the breakthrough that *Citizen Kane* built on the back of *La Règle du jeu*. Sadly no one would take it up for another 30 years, when Robert Altman began to use the new multi-tracking technologies to layer dialogue upon dialogue. In the meantime, music and dialogue, the pleasures of pure hearing and of eavesdropping, the fetishism and voyeurism of the audiotrack, provided the dialectic for a generation's finest films, from Brecht

and Dudow's *Kuhle Wampe* to the orientalist dystopia of *South Pacific*. Nowhere was this tension more fully wrought than in the Indian cinema, where music and image rocket apart and hurtle together at crossed angles to one another, the clear separation of one from the other allying the divine with the auditory, the human with the visual. The truth, and the eternal, are all on the side of the soundtrack. Just so, in the dialogue movie, vision was subordinated to the literary culture of the script and the absolute truth lurking at the completion of the tale was always voiced in words. So powerful, so successful was this style, that cinema had no further need to evolve. Unsurprisingly, the first attempts to kick it out of its self-made gravity well were articulated in the negative.

Stan Brakhage's essay, 'Metaphors on Vision' (1963) proposes mechanical perception as a recovery of the pre-Lapsarian vision to the young child: 'How many colours are there in a field of grass to the crawling baby unaware of "Green"? How many rainbows can light create for the untutored eye? How aware of variations in heat waves can that eye be? Imagine a world alive with incomprehensible objects and shimmering with an endless variety of movement and infinite gradations of color. Imagine a world before "the beginning was the word" '.[1]

In *Mothlight*, one of his best-known films, Brakhage creates an Edenic visual language through a collage of moth wings, insect parts and garden debris glued directly to the film strip and printed. The mechanisms of printing and projection have logged their own amnesia onto the visible. This is a profoundly synthetic vision, hybridising the eye with the cinematic apparatus to produce an all but haptic experience, reducible if you will – but only if you will – to a quasi-narrative representational scenario, yet the better for a more relaxed, intuitive and otiose imbibition. Brakhage sought a mode of freedom that could only be ascertained from the far side of informational film. This is one reason why the film has no soundtrack. In projection, its only accompaniment is the soft hammering of the projector, that pristine din that passes for silence in the cinema. This mechanical accompaniment, purest sound of the movies, is formally as beautiful, and as formally dead-ended, as the music-dialogue dialectic it evades. From here there is only visual autonomy, only the liberty of the eye: cinema as a visual art.

And why not? While film sound was dominated by dialogue, the aural culture at large was dominated by music, a music which, from the futurism of Russolo to Cage's zen-Fluxus art of chance, had assimilated noise to its own, highly organised,

highly articulated mode of listening. Most filmmakers in the post-war avant-garde devoted themselves to films either without soundtrack or with music bolted on more or less arbitrarily, subservient to the image. The soundtrack languished.

This dialogue of the deaf demanded someone like Jean-Luc Godard, for whom sound and image only make up a seamless whole if one is forced to submit to the other. In his films, music, dialogue and sound effects attack each other in incestuous, fratricidal assault. Sound from one shot invades the space of another, dialogue is drowned by machine noise, volume and timbre are grating, music is as suddenly gone as it arrives, dialogue is read, re-recorded, elicited by interview, commented on by those who exist only in voice-over. The ease with which a unified world can be inhabited in films is torn open and the bleeding heart of cinema lies beating among its broken ribs.

Who learns from whom? Or does a historical moment beguile its inhabitants with a common spirit? Bill Viola's video works and installations, like Godard's, should be heard loud, at a volume which, in Viola's case, makes the very sound of recording audible. In *The Passing*, part of the work which prefigures the themes of the *Nantes Triptych*, now in the Tate's collection, the plashing pearls of water dripping from the lens cover are matched by the shift in sound quality as the camcorder emerges from the sea, evidence of an inscaped presentness of the recording apparatus to the recorded medium as to its referent, its external reality of water and air that have physically touched and left their audible marks upon the tape. Sound, after all, involves, far more than light, a physical proximity, and the caress of air's vibrations on the inner ear. Amplification brings the recorded into the audio equivalent of the close-up, the intimate space of a whisper or the sound of a lover's or a child's breathing. Later in the tape, as Viola records his mother's dying breaths, the tenderness of hearing and its cruelty are more powerful than even the terrible gentleness with which he records her face among the pillows. In a work paced by the metronome of the dreamer's breathing, that broken rasp, mirror of the child's puff extinguishing a birthday candle, the moving image finally deserts the theatre.

Sound Design as a Spatial Art

Playback and projection reintroduce the sonorous into the material world.[2] I no longer hear music in acoustically perfect surroundings but in my kitchen. It is not that the kitchen is less perfect than the concert hall or the recording studio, but that

the concept of an ideal acoustic has no material reality. Sound is physical: it can only be heard. It occupies, and in occupying it creates space, and if that space is genuinely sculptural or architectural, it becomes a habitation, a place.

Music had organised sound as time. Dialogue, as information, devoted itself to the geographical problem of moving information from point to point. The emergent aesthetic of sound design organises it as place, but a place which shares its physical shape with the duration of playback. The new soundtrack, in exploring the spatiality of sound, discovers that time is no longer something movies fill or waste but that time has become itself a sculptural-architectural mode. Sound recording and playback in the installation becomes the fracture line which denudes statuary of its pretence to that permanence in which Europe has for so long sought the proof of presence. In its stead we have time/space as distance, the distance within a film, and the distance between it and its worlds – the world where it was recorded, and the world where it is played back.

The neo-classical mainstream cinema today interests itself in the exploration, rather than the analysis, of fictional spaces. Journalistic belief in the predominance of fast edits is quite unrelated to the dominance of fluid camerawork, long takes and deep focus in the new Hollywood. In sound design depth of field made possible by multi-tracking and digital clarity directs sound design towards the analysis of off-screen space, the world beyond the screen. In this novel form, sound has finally subordinated itself to the visuals. But in the evolving audiovisual arts, sound no longer can subordinate itself to vision but must enter into a new relation to the screen. That relation is profoundly spatial: it emerges both from the transmissions of recording (playback time, playback place) and broadcasting (simultaneity of dissociated spaces, temporal parallelism) and links it to the ontology of film as a medium which transports images through time and space: projections. Sound is a projection, learning from the mechanical dispersal of images across time and space, to perform its own art of dissemination by radio, recording and telecommunications: a dissemination increasingly global in both its ambition and its sources. Sound enters space not to imitate sculpture or architecture, but, through electronic webs, to weave a geographic art that understands too that the passage of time is the matter of history: a diasporan art.

The Audiovisual as Diaspora

A fictionalised account of the aspirations and degradations of the group around Michael X, the ambiguous fraudster and black power hate-object of the UK and Trinidad, Black Audio Film Collective's *Who Needs a Heart* (1991) is traversed by one of Trevor Mathison's characteristically dense sound designs. Built up from overlapping musics (gospel, blues, free jazz, Buddhist chants), electronic effects and samples, sound effects subtly unanchored from the image, direct, recorded and re-recorded dialogue, the audio track operates across as well as alongside the image, marking the diasporan scattering of meanings and peoples in repetition and polyrhythms. Swamping the dialogue track, that focal bond that sources sound within the image and subordinates it, inveigling the viewer into the visual space of the screen, the sound design for *Heart* stands between viewer and image, tracing oblique trajectories around both. Inspired equally by the improvisational and the repetitive, the temporal and spatial, Mathison's work not only discovers an archeology of John Cage's (already orientalist) modernist fascination with pure sound and duration in diasporan musics, but carves for the film a space which is already distanced, outside the image, a geography of its location.

Such distances – the distances of diaspora; distances which are also the times of historical movement – open up the spaces of a contemporary hybridity, denying the transparency of multiculturalism by insistently mapping the plurality of differences and differentiations. As the visuals detail the minuet of gender, class and 'race' in a formative moment of Black British politics, the soundtrack obliterates the ease of judgement that would stamp the film as 'psychological'. The voice occupies a double position here. It works as the broadcasting of identity from within to without, itself a scattering and a performance, and one radically incomplete, as Mercer observes, without the welcoming ear of a recognising other. But it is also the symbol of an impossible authenticity, a truth of the self to itself, a symbolisation of the very idea of placelessness.

Michael Chanan suggests that when those early spectators fled from the onrushing train in the Lumières' *Arrival of a Train at La Ciotat* (1895), the train did not stop coming at the edges of the screen, but flew on, driven by the imagination of a new space, to throw itself beyond the sky in Méliès's *Voyage à travers l'impossible* (1901).[3] The cinema had begun an exploration of its powers to invent space from its earliest moments. That space would be restrained in the classical and neo-classical style to what might be imagined beyond the screen. It was juxtaposed by every significant film critic with the quotidian world of work, love, childbirth and housing problems. For the greatest of them all, André Bazin, the purpose of cinema was 'that it should ultimately be life itself that becomes spectacle, in order that life in this perfect mirror be visible poetry, be the self into which film finally changes it'.[4] However, this has not been cinema's fate, not yet: what has happened is the transfiguration of the quotidian into spectacular consumerism, and cinema has had to take its place, in its development as a spatial art, as a supplement to the real, a material presence contesting the validity of the film/reality distinction not through the transformation of cinema, but the invasion of the real.

Sound is never disembodied. Tallulah Bankhead is said to have responded to the old Zen query, 'What is the sound of one hand clapping?' by slapping her interlocutor smartly on

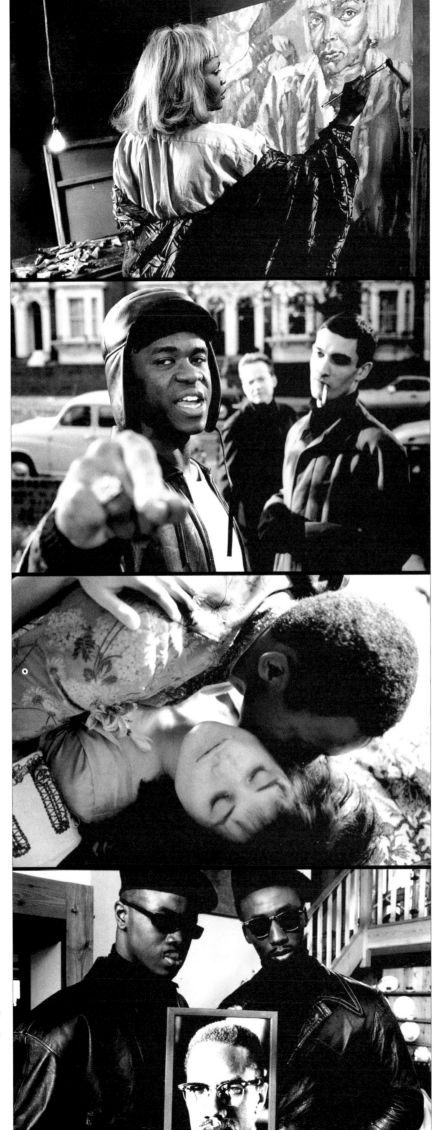

*Black Audio Film Collective,
Who Needs a Heart, 1991,
stills; OVERLEAF: Black Audio
Film Collective,* Mothership
Connection/The Last Angel of
History, *1995, stills*

the cheek. The ambiguity lies in the word 'sound', for there is no sound that is not heard. Skin produces and receives sound; it is the intimacy of body on body. Skin is our final barrier against the world but it is porous, traversed by the energies of others, vibrating in sympathy with a complex world.

The body, after all, is the first sound source: the womb, the eructating infant, the way a voice sounds different heard through the bone. The body is a medium for sound: the chest and the soles of the feet 'hear' not as acutely but as viscerally as the ear. Sound moves not only the volumes of the air but the mass of the body. Sound, as an art of distance, of space and time, is an art of movement. To have added recording and transmission, to have doubled and redoubled the number of sounds in the world, has remade not only an imaginary external acoustic universe, but transmuted movement through four dimensions. It has invented a dance of populations.

The Mothership Connection

Not every step is synchronised. The processes of translation – in its senses of transmutation, of bringing across from another culture, and of moving from place to place – are time-bound performances. Transmission revivifies ancient rituals for intercultural congress, and in so doing reveals itself as a mode of translation. In the musics of the Black Atlantic such translation holds together understandings of distance and mechanical perception in the complex interchange between diasporan communities, in their hungry reinvention of the most sophisticated tools, 'making', as Mathison says, 'the technology sing with new voices'. The wired world only hastens, it has not instigated, and sometimes hampers with its crass designs, the global musics. The figure of the data-thief, a futurological Anansi, builds the mosaic of Black history in Black Audio's *The Last Angel of History* (1995) out of the shards of Black science fiction, linking Robert Johnson's hellhound to the extraterrestrial longings of Sun Ra, George Clinton, Lee Scratch Perry and Goldie, each musician also on the cutting edge of technological innovation. How to work a soundtrack for such artists?

The tools are interviews and dialogue, archive and composed music, and 'atmos', the wildtracks recorded on locations to battle cinema's – and even more so, television's – dread of silence. In Mathison's hands, as in those of all good sound designers, the atmos track becomes more than the ambient support for dialogue. It is a material that can be moulded or carved, as occasion demands. Indeed, Adrian Stokes's metaphors begin to waver in the digital recording studio, where extrusion might be a better metaphor at one point, or whatever name you give to the process of analysing a sound by slowing it, filtering it, disassociating timbre from pitch, twisting and weaving it into new redolences. Some source material derives from years developing musical compositions which can be drawn on for installations, dances, performances and films. In this instance, the destination is TV: one version (*Mothership Connection*) for Channel 4, a longer one (*The Last Angel of History*) initially for ZDF in Germany. Just as the capital to make a work is spread across national boundaries, the theme pursues interpenetrations and zeitgeist as they circulate across the Middle Passage, and the work is dedicated to fostering its further travels across years and continents. The diasporan cultures have already found a road to Amin's 'polycentric world'.[5]

Cultural translation is a practice which the film both documents and practices. The question is no longer of the West's domination of global culture, or even of the impact of non-Western cultures on the West, but the patient transperipheral hybridisation of cultures. Its startpoint is the 'impossible, imaginary musics' of the studio, themselves perhaps the fruit of more than a century in which old musics were lost in enforced isolation, and the new had to be imagined in the mould of a lost original. These mutual imaginings then take the form of science fiction not just because of the experience of being alien, nor because 'the line between everyday reality and science fiction is an optical illusion', but because every imagined world that is not seated in the past must share its mode of non-being with the future, which by definition does not exist. In Black music, from the New Thing onward, the future grows from negation to become the not-yet.

Mathison's electronic variations on found and generated sounds, weaving through the fractured narrative, moulds and disseminates the samples it discovers. To imagine pastiche as 'postmodern' shows shocking historical naivety: originality has only ever been one facet of the modern, which has prided itself on looting the supermarkets of popular tradition from Wordsworth to Warhol. A gambit in Anansi's trickbag has been to steal back from the European what can be bricolaged into the necessary novum. Another has been to redefine the territory, as Mathison's soundscapes create a space which, intersecting with the filmic, traverses it at angles. The principle of borrowing and remaking includes, then, a borrowing from the film's soundworld, borrowing that links the film's two domains together in a bond of mutual debt. Images comment on and expand the sound; sounds interpret and open up the funnel of the image. Visual and aural motifs oscillate in patterns that traverse but rarely map over onto one another, extracting from a gesture or an apparently serendipitous noise the maximum value of statement, understood as both the documentary impulse *and* the statement of musical theme. So the soundtrack, composed of samples treated in EQ, loops, filters, slowed/speeded, discovers within the sounds their own patterns and rhythms, each manipulation a step away from the source.

Crucial to this procedure is the movement of sound from its location, disturbing the expectation that a sound's source and its playback match in some way. The convergent electronic media make the likelihood of hearing sounds directly ever less, just as the world returns the favour by reducing to practical zero the chances of hearing broadcasts and recordings in

the acoustics in which they were designed. These sounds are nomadic. This is not the same as to say that they are portable: the Walkman and the in-car stereo are portable but closed media that conform listening to the ideals of consumption.[6] Here sounds migrate from microculture to microculture, assembling new lines of communication as they go.

This work is not music in the sense in which it has been accepted in the Western canons. It is not a matter of the faithful interpretation of authenticated scores, the approach to an absolute ideal which Glenn Gould, in a classic article on recording, documents as a spiralling delirium of artifice.[7] It takes its roots in diasporan mixology; its criteria are not ideals. Instead the whole environment becomes material for the mixing desk, an instrument in which manipulation, layering and erasing are the modus of tuning found sounds to new ears. It is dialogical, engaged in the vast, eternal conversation of the species, an art in which the movement of sounds is the sculpting of distance and our trajectories through it.

Installation and Internet

If I have concentrated on Mathison's work with Black Audio, it is not only because these are wonderful works which in some way redefine the concept of cinema – the mark of any film worth making, but also because they are exemplary in the ways in which they articulate the missing dimension of sound. They bring into sharp focus the issue of spatiality and its relationship with time. To show a film is to occupy an architecture and make it your own: increasingly, architects are discovering the need to accelerate their buildings with smart connections, VDUs, monitors and panel projectors. We expect our buildings to be fast: to interact, to work for us and with us. The artworld has to be as swift and cinematic innovation has this at least to offer. The recreation of a cinema auditorium as the venue of dreams when once the projectors start to roll has been transformed by moving the speakers from behind the screen into the hall, making the room more spatialised. The step from here to installation work is small, as Mathison and Edward George have found in their 1994 installation, *The Black Room*, at the ICA in London, where cubicles haunted by memories of Fanon's regretful leave-taking of Algeria are recycled in digital sound and image, and in recent performances with The Drum in Birmingham. Other diasporan artists – Pervaiz Khan

and Felix de Rooy's *The Garden of Allah*, Bashir Makhoul and Richard Hylton's *Yo-Yo*, works of Keith Piper and Mona Hatoum – evidence an intense engagement with the ways in which sound, more than sculpture or film, occupies a space.

An image in motion will always capture your look, inscribe you into a direction. Sound, however, as long as it is not contained by headphones or an individuated space, must be approached, walked into; and as your body subtly moulds the acoustic around it, the sound will penetrate you. Even as it does, the openness of this space, its architectural quality, becomes apparent: an open soundscape is a world which is shared. This combination of intimacy and publicity is the space of the dance and of all the richnesses of communication and mutuality of which the dance, however measured, is capable.

Beyond the arts of architecture, beyond the movement into urbanity marked by the installation and performance artists moving beyond the cinema and the gallery, there lies the emergent spatial art which even now is just becoming possible, the art of transmission. For most of the century, access to transmission technologies has been scarce, and the gatekeeping of broadcasters censorious and exclusive. But the emergence of new arts of the telephone and the answering machine, fax art and artist radio, artist-controlled websites and TV stations begins to alter that constellation. Given the overuse of the word 'interaction', it's hard to phrase what such an art might be. It relies less on the machinery than on the ability to interface old and new technologies, and crucially to converge the visual and the aural on a new plane of equality. An art of movement in the new millennium must apprehend the intimacy, the unconscious interactions and inminglings at the level of the body and the local, but it must also go beyond this traditional sphere of art to intervene in the global flows of people and pollution, sounds, images, religions and diseases, which constitute us as people at the very sites of our most private intimacies. The new spatial arts of movement will be global and the massive act of translation which is now beginning to re-establish the relations between audio and visual is a key to its understanding. The second fragment of the Data Thief's code will be diaspora, the cultures which have already mapped the informality of the world and learnt that there is no mainstream that is not composed of a thousand tributaries. Only in this chaos, is there a chance that the not-yet may yet become.

Notes

1 Brakhage, Stan, *Metaphors on Vision*, special issue of *Film Culture*, no 30, Fall, 1963; partially reprinted in Sitney, P Adams (ed), *The Avant-Garde Film: A Reader of Theory and Criticism*, Anthology Film Archives, New York, 1978.

2 Altman, Rick, 'The Material Heterogeneity of Recorded Sound' in Altman (ed) *Sound Theory/Sound Practice*, Routledge, London, 1992.

3 Chanan, Michael, *The Dream that Kicks: The Prehistory and Early Years of Cinema in Britain*, Routledge Kegan Paul, London, 1980, p32.

4 Bazin, André, '*Umberto D*: A Great Work' in *What is Cinema?* 1971,

Volume 2, trans Hugh Gray, University of California Press, Berkeley.

5 Amin, Samir, *Delinking: Towards a Polycentric World*, Zed Books, London, 1990.

6 Cubitt, Sean, 'Sound: The Distances' in Chantal Charbonneau (ed), *Modernist Utopias*, Musée d'art contemporain, Montréal (forthcoming 1997).

7 Gould, Glenn, 'The Prospects of Recording' in *The Glenn Gould Reader*, ed Tim Page, Viking, New York, 1990.

monkeydoodle

Tailback for miles, a trafficjam of words – squashed, skewed and stretched into anamorphic images. He called it a rebus.
We thought he meant rhesus, a blood group or something. But it was the short-tailed beast of meaning monkeying about
between word and image. Having written volumes, up to the eyes in words, Walter Benjamin cried:
'I have nothing to say, only to show'. *Sarat Maharaj*

'To reveal art
And conceal the artist
Is art's aim.' *
Myself
In the monkey's
Tricks.
All art is such
Baboonery.

* Oscar Wilde, *The Picture of Dorian Gray.*

perspective – *n.* **1a** the art of drawing solid objects on a two-dimensional surface so as to give the right impression* of relative positions, size, etc **b** a picture drawn this way. **2** the apparent relation between visible objects as to position, distance, etc. **3** a mental view of the relative importance of things (*keep the right perspective*). **4** a geographical or imaginary prospect.

get the
(right)
impression?

* **impression** - *n.* **1** an effect produced (esp on the mind or feelings). **2** a notion or belief (esp a vague or mistaken one). **3** an impression of a person or sound, esp done to entertain. **4a** the impressing of a mark **b** a mark impressed.

" the honeymoon killers "

Stuart Brown, Louise Veryard and John
Paul Thurlow *holosthesia*

Matthew Booth, Amy Cheung,
Anna McCrickard and Verity Woolf

Ann Infield and Giles Lane

Kavitha Gilkes

Emily Clarke and Louise Clarke

Jonathan T and Jo-Ann F
'unspeakable products No 1'
Feb 1996 photographs by Xavier Young

Barbara Barclay, Jette Bjerg and
James Taylor

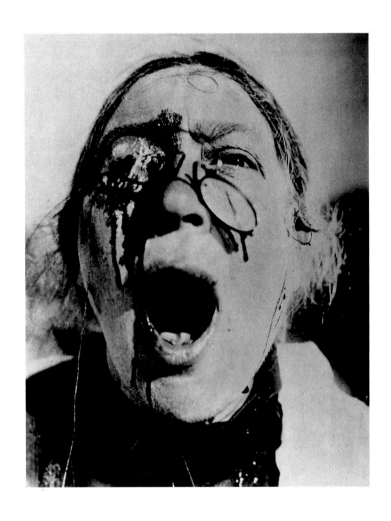

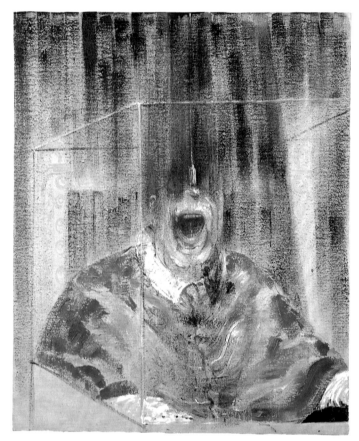

L to R: Sergei Eisenstein, The Battleship Potemkin, *1925, still of screaming woman; Francis Bacon* Head VI, *1949, oil on canvas, 93.2x76.5cm*

SPATIALISED TIME, UNCHECKED DURATION
FILM AND VIDEO WORK BY CONTEMPORARY BRITISH ARTISTS
Andrew Wilson

In 1955 Francis Bacon described painting as 'a method of opening up areas of feeling rather than merely an illustration of an object . . . A picture should be a re-creation of an event rather than an illustration of an object; but there is no tension in the picture unless there is the struggle with the object. I would like my pictures to look as if a human being had passed between them, like a snail, leaving a trail of the human presence and memory trace of past events as the snail leaves its slime'.[1] Much of this still holds good today in highlighting the strategies and processes to which some artists submit film and video within their work. These artists are not concerned with the passive illustration of either a narrative story or an 'object', and their intention can be more exactly described as the crystallisation of an event and its capture in duration. In this respect the work is formed within a dialectic between the object and the object with a moving face. Time becomes spatialised so that the event can be apprehended within sculptural, rather than in strictly filmic, terms.

One aspect of what this might mean is suggested by the work of Adam Chodzko. Through the variously different processes that his work is made subject to, he is concerned in unlocking those hidden or disregarded areas that might provide a closer mapping of the contemporary condition than might be gleaned from society's surface. His awareness of the part that is played by sub-cultural codes in the forming and deformation of a logic of identity has led him to the cinema on more than one occasion. Given the traditional reading of the cinematic gaze,[2] film offers a privileged site in which images are made and re-made between watcher and watched within the space of a durational event. In *Stealing Moons* (1995-96) Chodzko proposes an archaeology of this event, taking a video camera into the cinema to capture those background, and often ignored traces that actually provide a filmic constant; the moon and its echo as lights, a reflection in the eyes and a pearl earring. The moon, it might be suggested, has an unrecognised, yet controlling fix, on events that surround it. Always there, always looking, always being seen. By stealing these moons and showing them to be moons that steal, Chodzko has captured an event – between the frame of 'Pearl and Dean' and a 'natural' moon-capture – that also holds within it the basis of narrative content.

Bacon achieved his capture of the event – a spatialisation of time – strictly within the confines of paint, wherein film is used as a referent within a pictorialising structure removed from the space of filmic narrative. The close-up of the head of a screaming woman – glasses shattered, blood streaking down her face – from Eisenstein's film *The Battleship Potemkin* (1925) was grafted by Bacon into a number of portrait paintings of the late 1940s and early 50s, such as *Head VI*, (1949 – Arts Council Collection), or *Figure with Meat*, (1954 – Art Institute of Chicago). In itself this does not signify a great deal as artists manipulate such source material every day. However, what is significant here, is Bacon's ambition to still time and hold it captured in space. In both these paintings this is underlined by the way in which the image is pictured as if it is held within a type of space-frame box construction.

The narrative duration of Eisenstein's film is reduced by Bacon to one still image that is rendered in spatial rather than purely illustrational terms. Furthermore, in *Figure with Meat* an arrow has punctured the dark space, pointing towards the Pope's face which is also the face of Eisenstein's screaming woman. What this arrow does is create a pictorial loop within the space created by the painting's internal space-frame in which the stilled image can still refer to a moment as a trace of an event and of human presence. Such a sense of duration, however, only exists within the captured space that is signified in the moment of the arrow. Bacon made similar use of images from Muybridge's *The Human Figure in Motion* to capture and hold progressive duration in spatial terms. However, for Bacon the significance of the stilled image of the screaming woman was that it could stand as indicative of the broad sweep of Eisenstein's film by pointing to the slippage between history (fact) and non-coincident detail; '*The Battleship Potemkin* by Eisenstein . . . made a great impact on me when I saw it. You remember that scene where the child's pram roles down the steps, that screaming woman, and the rest of the film . . . Oh, yes, cinema is great art!'[3]

The correlation that can be drawn between Bacon's procedure and those of younger artists today who have grown up faced by the fast-cut of the MTV pop-promo or the narrative longeurs of the soap-opera, may seem trite but points to a truth. Art has always had to come to terms with a relationship between the moving, or living, image that surrounds us in daily life, and its stilled transformation within a static space. Cinema – and since the 1960s, video – has only provided another sort of movement that is fictional (even when supposedly true to life) and artists' use of the medium has engaged with this contradiction; movement's spatialising function creates a gap

or slippage within film whereby duration can be treated as much as a sculptural or spatial term as in any other way. This conceit can then become the field in which concern for content can also be addressed.

Although Fiona Banner, Douglas Gordon and Henry Bond have all used film as a source for some of their work, they do not make work that is about film or video and this is an important point that can be made of all the artists I discuss here. They are film-literate enough to be able to detach themselves from the specific qualities of the medium and use it to new ends. Banner's work does not have film as her subject but instead investigates questions of scale and frames the act of perceiving an object as problematic within the context of a duration that has been written into the perceptual act. *The Desert* (1994) consists of a large canvas, the same proportions of a wide-screen in a cinema on which she has written out the sequence of events that make-up David Lean's movie, *Lawrence of Arabia*. As a result, not only is this epic movie reduced to one object that can be perceived in one 'take', the epic scale of *The Desert* actually confounds its reading. After the first few lines the eye gets lost, able to pick-out scenes and images rather in the way that the image of the screaming woman could stand for Bacon, for *The Battleship Potemkin*. *The Desert*, and other work by Banner, highlights the duration in the watching rather than in projection. It is not just that movement is both represented and held by a frame, but how represented duration is stilled through its objectification while, at the same time, its perceptual reception is drawn-out. This is in stark contrast to the way in which we watch TV in real-time, in which the time we spend watching TV is the same time as screen-time.

This is made painfully clear in Douglas Gordon's *24 Hour Psycho* (1993) in which the speed of Hitchcock's film is slowed down to take 24 hours to run its course and is projected onto a huge 15-foot screen, suspended so that it appears to float within the gallery space. By slowing down the film Gordon forces a refusal of narrative progression in the eyes of the viewer and, in a film about voyeurism, we are thrown headlong into the detail of the gaze and how this constructs space. The mechanics of the gaze are objectified not just through the work's sheer monumentality but through the conjunction of its size with the stilling-down of the screen's gaze in the face of the viewer's response; a point of view which in itself reverses the controlling spectacular space of cinema.

This question of time in the forming of a durational language of perception is also upset within the work of Henry Bond which he has positioned under the generic title *Workstation*. Bond creates video-works for broadcast television in much the same way as a desktop publisher. He is unable to ignore the contextual demands of the system he has grown-up watching and now works within; nevertheless trying to subvert and problematise the codes of televisual experience.

Working within the belief that the transformation of the everyday (as opposed to the extraordinary) provides the correct subject-matter for artistic production, to a large extent Bond films sequences of life 'as found' within a broadly analytical context. The images he frames are unremarkable except for the fact that he has turned his camera on them at all. *Deep Dark Water* (1993-94) was made as 18 one-minute films that can be broadcast as 'free-floating interventions' into any TV schedule. Its subject was not so much the River Thames (although that is the films' central motif) but the hardly noticeable gestures of those who work and live around it. Using a juxtaposition of fast-cutting and extreme cropping with momentary blank screens, Bond not only creates an atmosphere of disquiet among the images of extreme normality he has captured, he also problematises the viewing experience by making it less seamless and so overtly disrupting the 'real'-time nature of his footage in a seemingly arbitrary and cavalier way that consistently questions the relationship between what we see (arbitrary multi-focus lateralities) and the one-point focus provided by the video screen. The whole equation rests on artifice. Reality, he seems to be suggesting, is found not in what we watch but in the way we watch something; we see, for instance, a video monitor that is always itself situated in a place removed from that which we see pictured on the screen, and it is this particular shifting space that exists between two separate perceptual spaces, as much as the edit-space itself, that has provided fertile ground for a number of artists' work.

In a very different way from the work of Henry Bond, what we watch and the way we watch, is also at the heart of the recent work of Hilary Lloyd. In *Nuala and Rodney*, Lloyd, approximating what the critic Peter Gidal has described as, variously, 'unending duration' or 'unstopped duration',[4] describes the interactions between a hairdresser, his assistant and client throughout which time the camera remains in a fixed position with no internal edits at all: 'real'-time. Narrative here (such as it is), at its most basic level, becomes dissolved into incident and gesture that is, itself, magnified beyond the larger event. What this provides is a narrative space that exists beyond the video screen, formed out of a perceptual, as opposed to presentational, act. The video camera might obsessively scrutinise that which is in front of it, but in doing so always passes by the larger event. Time rolls forward, unchecked except by the limits imposed by the viewed event and by the recognition that, after an hour or two, when the event ends the tape will loop to start over again. It is at this point of recurrence within the supposedly 'real-time' larger event, as much as by the disjunctive projected space (defined by the fixed camera position) and viewed space, that the incidental collapses into something more akin to the performative.

A similar dynamic can also be observed through the work of Graham Gussin, Christina Mackie and Cerith Wyn-Evans, where the incidental collides with the performative, ('real') time with

(looped) duration,[5] projection with that which is watched, and description of space with its dissolution. In *Beyond the Infinite* (1994) Gussin describes a moment in which recognition and sight are placed in an unstable position, out of phase, both within the installation (two monitors running the same tape-loop out of synchronisation) and in terms of the complex dialogue between duration and time that is enacted within the work's source, the film *2001 A Space Odyssey*. What we watch is the projection of an act of seeing in which the co-ordinates of duration and space have fallen away to the demands of the odyssey. *Road Movie (Op)* (1993) can be simply described as a 33 min, 16mm black and white film that was shot from a fixed position on the roof of a car, while it drove from Oporto airport to the entrance of a disused flour mill – the Edificio das Antigas Moagens Harmonia – on the outskirts of Oporto. The resulting film was then projected onto a large screen inside the mill.

Where Lloyd's *Nuala and Rodney* could be described as one long establishing shot, Gussin's *Road Movie* provides a swift succession of ungrounded establishing shots that, out of an unchanging structure, provides a sense of narrative governed wholly by durational progression. However, against this, the camera does not move from one place to another but just keeps moving, the loop providing not so much an end but a new beginning in which space has collapsed. This conflict between time and duration has also provided the basis of his video-loop *Solaris* (1995). The camera pans up the body of a sleeping figure again and again and again. Its rhythm is like that of the heartbeat: never-ending like time, but structurally durational in its effect as it is watched and felt. The effect here is coincident with that of Banner's *Desert*; the filmed and looping duration is stilled as a result of the video's objectification while, at the same time, its perceptual reception is drawn-out.

This conflict is also the case with Mackie's work. Where *Foo* (1995) provided a fast-frame mapping of her workspace to a trance-inducing soundtrack, in which glimpses and glances, when repeated and re-ordered, create a sense of a tangible space formed through an accretion of time but ultimately held still, *Road* (1995-96) creates the illusion of an emotional space within the durational space of the glance. Standing at a bus stop, bored, you gaze into the road and follow the path of the traffic as it passes-by both ways, mesmerised; lost in space. Mackie has made a rig for three cameras that move in a panning action to track the movement of the cars as they pass. These images are then fed to two monitors (one of which produces a solarised image) as the panning action repeats and conflicts to describe a space of sight as much as of durational movement.

If Mackie has projected a loss of space as an emotional as much as a durational problematic, Cerith Wyn-Evans in his *Les visiteurs du soir* (1994-96) shows how such loss allows narrative to be consistently re-made by occupying a truly fictional stage so that, through a process of re-editing and loop-

Adam Chodzko, Moon Stealing, *1995-96, stills*

FROM ABOVE, L to R: Fiona Banner, The Desert, *detail, 1994-95, ink on paper;* Douglas Gordon, 24 Hour Psycho, *1993, still from the exhibition* 'Spellbound: Art and Film', *Hayward Gallery, London (photo: Mike Fear);* Graham Gussin, Road Movie, *1993, still;* Hilary Lloyd, Ewan, *1995, still*

FROM ABOVE, L to R: Christina Mackie, Foo, 1995, *still; Cerith Wyn-Evans,* Les visiteurs du soir, 1994-96, *still; Jane and Louise Wilson,*
Normapaths, November 1995, *still, courtesy of Chisenhale Gallery; Angela Bulloch,* Solaris, 1993, *still*

ing, duration and space is folded back on each other. Finding by chance a segment of the film *Les Enfants du Paradis*, Wyn-Evans has re-edited it into a new, 40 minute, two-screen, video projection. As the narrative is repeated, re-shuffled, re-played in differing orders and sequences, and as the two screens move in and out of phase with each other, Wyn-Evans describes a durational circuit that is constantly stilled through the action of a compulsive looking (ours, the viewer's as well as the film's characters). The original film's shaping of sight, loss, longing and desire occupies an hermetic field which is exploited in the video projection so that each glance loops back onto itself to form a new element out of its own combinatory, yet disjunctive, narrative, propagating a history of misunderstanding and confusion.

Writing about his film Wyn-Evans has enlarged on Lacanian notions of the gaze and mirror-stage that have traditionally informed film theory, to emphasise its spatial dialectic; 'What might be in question here is the relation between a film and its double, such that what you see is not the film, nor the other, but the film through the screen of its double, its reflection . . . The double relation is then a parallel – between theatre and "life", film and theatre, film and text, text and critical text . . . My body simultaneously sees and is seen . . . It sees itself seeing . . . Framed threshold, with its implications of spatial and temporal dimensions, occasions a location that negotiates opposing directions, inside and outside, immanence and transcendence, beginnings and endings'.[6] Such a description of the act and space of watching puts the hermetic nature of film and video into a state of jeopardy. Mark Wallinger's *Royal Ascot* (1994) underlines the extent to which national narratives are formed in the space between projection and reception where meaning can only exist on the level of fictive myth. By showing each successive day of Royal Ascot's Royal Parade folded back on itself as a performative gesture, Wallinger reveals that 'what denotes stability and gravity of meaning is paradoxically emptied of almost everything, apart from the formal elements and this strangely enervated choreography'.[7] Similarly, *Regard a mere mad rager* (1993) revels in a similar spatial and temporal dislocation so that meaning and logic runs away through the gaps and folds of its own doubling; a videotape of Tommy Cooper's hat-sketch runs backwards and in front of the monitor is placed a mirror into which we watch for sense to right itself. Although Steve McQueen's *Stage* (1995) achieves this dislocation through the representation of a disconnected internal narrative of contact and sight that allows only the sound of the film projector to puncture the silence, it is also a state that can be further exacerbated by placing the screen or monitor among, or apart from, other objects.

The video work of Jane and Louise Wilson plays on the juxtapositions and separations inherent within such spatialisations which open up the field to a use of narrative that, like Wyn-Evans's *Les Visiteurs du Soir*, does not respect accepted filmic conventions (even though it might draw on the vocabulary of film). In *Hypnotic Suggestion '505'* (1993), a video projection shows the sisters being submitted to hypnosis in both Portuguese and English. Language makes no difference and the result is the same: deep sleep. In an adjoining room, the empty set where the hypnosis took place suggests a state in which normal reason disappears: vacant chairs, lights yet no camera, microphone yet no sound recorder. The actuality of the film set cannot, in its temporary, unfixed and impotent positioning, offer a validation to the choreographed state of psychic suspension witnessed by the film. Anything grounding the reality of the event has been shifted and cut-off. Similarly with *Normapaths* (1995), the construction of the kitchen-set is installed at a distance from the two-screen corner projection of the video. The narrative, such as it is, offers a durational accumulation of images, events and gestures from which little logic is allowed to take root, and the set that is constructed in the gallery is not allowed to occupy a position except one defined by its dysfunctional, dislocating and artificial purpose.

The video-work of Jane and Louise Wilson – as much as that of Georgina Starr, Sam Taylor-Wood, Angela Bulloch, Wyn-Evans, Craig Richardson or Gillian Wearing – emphasises the ways in which artists have used the space of video, the relationship between watcher and watched, the disjunctive space constructed by the conflict between time and duration and the real and artificial, as means of objectifying a scrutiny on a theatrical and performative content formed within a structure that is predominantly spatially defined and process-based. A comparison of Bulloch's slide projection *The King of Comedy* (1991) with her *Joso New Town* (1995) and *Solaris 1993* (1993) suggests ways in which the performative opens up the space of watching. In *The King of Comedy* we are confronted by images of a silent audience who are, however, represented as appreciative of the viewer, clapping and laughing soundlessly. Roles and viewpoints are also reversed in *Joso New Town* where a group of Japanese teenagers uncharacteristically throw stones at old televisions and laugh in the heat of their transgression (against the technologically-based power of Japanese cultural coding). This is redoubled when the teenagers, on being shown the resulting video, take pleasure at the recognition of their act as they would any television show. The acts of watching and taking part are constantly being exchanged. With *Solaris 1993*, the original film has been shortened to 15 minutes to encapsulate the relationship between the scientist Kelvin and the repeated death and reanimation of his wife Hari. Bulloch has also cropped the film's image-frame, had the sound dubbed into English that cannot match the characters' lip movements and installed the monitor opposite two pairs of spheres which are illuminated in a sequence that is out of phase with each other. The light from the spheres, reflected in the monitor's screen, at certain points even obliterates the screen. The spheres provide a counterpoint to the

relationship enacted in the film, just as Bulloch scrutinises that dialogue which completes the circle set-up between viewer and image.

Bulloch's concern with a problematised narrative, enacted as much in the space of the viewer as in the space of the screen, is a strategy that has been adopted to a different end in the recent work of Gillian Wearing such as *Homage To The Woman With The Bandaged Face Who I Saw Yesterday Down Walworth Road* (1995) or *The Unholy Three* (1995-96). In both these works multiple narrational viewpoints intersect to construct a space in which the viewer's ground shifts at the same time that notions of behavioural identity are interrogated and stretched. It is not just that candid admissions or gestures take on a different shade when filmed and projected but that such constructions of the self occur all the time. Similarly the 'stars' of Hilary Lloyd's video work do not perform but instead have performative personalities that emphasise the extent to which we are all on a stage in which we watch and are watched.

It is this spatial dynamic between watcher and watched that has occupied the heart of Craig Richardson's work. His sculpture plays with the language of Minimalism and its assertion of a spatial power and threat over the viewer. By posing the question, 'is there ever any work of art that is so violent as to threaten the viewer?' Richardson, at the same time, admits the impossibility of such an aim, and forces the condition of his work into a state of contradiction that puts demands on the beholder's reception of it. This approach is underlined by his video *Lethal Enforcer (You've Been Framed – Version)* (1994) that splices a young boy rushing towards the camera and happily pretending to shoot a gun, or fight and punch with the real sounds of gunfire and fighting. By putting this soundtrack to images of play, what seems comic becomes tinged with horror and the projected framing of an innocent state on the child turns to guilt as the reality of the gunfire overwhelms the unproblematic nature of the child's mimicry. By taking this line in his work, Richardson does not intend to dictate a particular moral line to the framed viewer. Instead of making work that might initiate comforting and positive thought patterns in the viewer's mind, he would prefer it if the work just initiated thought patterns. As a result, the viewer's capacity for choice and responsibility – faced by a neutral, if loaded, image – becomes a crucial element in the work's success.

A comparable manipulation of contradictory juxtaposition sits at the heart of Sam Taylor-Wood's recent work. In *16mm* (1993) a woman dances repetitively within a film-loop to the sound of gunfire. In *Travesty of a Mockery* (1995) a professional actor and someone who isn't, enact a dislocated and internalised psycho-drama within a two-screen corner video projection, only one of the characters had a script and the precise cause of the argument is left unstated. In *Killing Time* (1994) four video projections focus on four young club-goers who sit bored, fidgeting and self-obsessed, their minds gaze into space

FROM ABOVE: Craig Richardson, Lethal Enforcer, *1994, still; Gillian Wearing*, Homage To The Woman with the Bandaged Face Who I Saw Yesterday Down Walworth Road, *1995, still from a seven min video projection; Tacita Dean*, Girl Stowaway, *1994, 16mm film, eight min, still*

as they mime to the *fortissimo* opera soundtrack. The durational space of each of these works opens up in an unsettling way so that beyond the presentation of a simple binary opposition between high and low culture, Taylor-Wood's exercise taps into the arbitrariness of contemporary experience, in which degrees of truth become displaced by the fakery and artifice of artistic practice which ultimately provides the only benchmark and semblance of key.

Georgina Starr's *Hypnodreamdruff* (1996) exists firmly within the space that has been opened up by artifice, provided not just by the fantasy of film but through the topology of dream-analysis and the particular siting of the viewer as a removed participant in the projected event as a result of the proximity of privileged objects. Each element of this video-work exists within a specific recreation of its set-dressing. We sit at the kitchen table at which Tricia discusses her dream with Emma, we can walk among tables and props apparently from *The Hungry Brain*, sit in Pauline's bedroom as she goes through her role as Frenchy in *Grease* and watch Dave make balloon animals in his caravan while sitting in 'his' caravan.

Such a strategy, found also in her *Visit to a Small Planet* (1995), in which video leaks into the viewer's space through the disposition of objects as evidence of a semblance of reality can be replete with problems. Their status as objects on their own, as traces of a fictional or actual occurrence, as real objects masquerading as objects from a fictional narrative where one validates the other, has always to be put into question in a way that is different from Jane and Louise Wilson's use of such objects in *Hypnotic Suggestion '505'*, as a creative point of actual and imagined separation. As a result Starr, in a different way to Wyn-Evans or Jane and Louise Wilson, also upsets representational codes while at the same time giving the viewer a cushion of belief that everything is alright and, in some twisted way, normal. The various elements of

Tacita Dean's *Girl Stowaway* (1995) – film, photographs, film dubbing-sheets, newspaper cuttings – act in a similar way to cumulatively reframe the work's narrative as something found and re-presented, offering a multiplicity of sometimes conflicting readings; meaning and truth always being relative terms when perceived in the context of transformation and artifice (however convincing).

Jaki Irvine's *Margaret Again* (1994), a five-part video installation, exists in that transformational space also occupied by Wyn-Evans's *Les visiteurs du soir* and Dean's *Girl Stowaway*, where a source narrative is overturned and remade through the deployment of spatial and durational codes that render problematic the actual reading of the work. Irvine offers a new life, as a double, to Margaret, the focus of tragedy in Richard Brautigan's *In Watermelon Sugar*. Although the viewer is confronted by a narrative in which the double becomes joined, Irvine's installation – in the gaps and overlapping looping between the four video-monitors and single video-projection – provides a dislocated, unstable and disunified space in which such a joining together (Margaret to Margaret, watcher to watched) is rendered difficult. Ultimately, the meaning of such work – and it is true of all of the artists under discussion – cannot be discussed as if it is solely defined by space or duration but only as a destabilising of such terms (just as the work destabilises filmic codes) and out of which language can be formed (rather than just reflected on) and stories told. Similarly, although work such as Starr's describes a relationship between filmed space and actual exhibition space, the viewer is not presented with images of metonymic certainty but instead with a richness of metaphorical uncertainty that is painfully close to an actual state of being – the more so for being the product of extreme artifice in which the watched is impotent without the watcher having been implicated within durational space.

Notes

1 'Notes by Bacon' in *The New Decade* exhibition catalogue, Museum of Modern Art, New York, 1955, collected in John Russell, *Francis Bacon* Methuen, London, 1964, unpaginated.

2 The eyes of the audience look at the screen (the object) while the screen (or what is projected on the screen) is already gazing at the audience (the subject) and from a point that the audience's eyes cannot quite see, the screen becomes a mirror where the projected image is accepted by the subject as its own image, or initiates a process of desire for that projected image. Even though the spectator can be absent from the screen it is understood that one can find one's own image in that of another. Such an orthodox outline of film theory as this takes its cue from the grafting together of the Lacanian notions of the gaze (see especially Jacques Lacan, 'Of the gaze as *Objet Petit a*' in *The Four Fundamental Concepts of Psycho-Analysis*, Penguin, Harmondsworth, 1986, pp65-119) and the mirror stage (see especially Lacan, Jacques, 'The mirror stage as formative of the function of the I

as revealed in psychoanalytic experience' in *Ecrits, A Selection*, Tavistock, London, 1980, pp1-7).

3 *Francis Bacon in conversation with Michel Archimbaud*, Phaidon, London, 1993, p16.

4 Gidal, Peter, 'The Thirteen Most Beautiful Women and Kitchen' in Michael O'Pray (ed), *Andy Warhol, Film Factory*, British Film Institute, London 1989, p118.

5 In this text, time, as a progressive unlimited movement, is contrasted with duration which describes a movement from one point of rest to another. Gidal's notion of 'unstopped duration' is one that, as contradiction, is informed by the mechanics of illusion found in the 'real'-time, one-to-one, film.

6 Wyn-Evans, Cerith, *Inverse Reverse Perverse*, unpublished notes on *Les visiteurs du soir*, 1995-96.

7 Wilson, Andrew, 'Interview with Mark Wallinger', *Mark Wallinger*, exhibition guide, Serpentine Gallery, London, 1995, p5.

Inside Covers: Georgina Starr, The Hungry Brain, *1995*